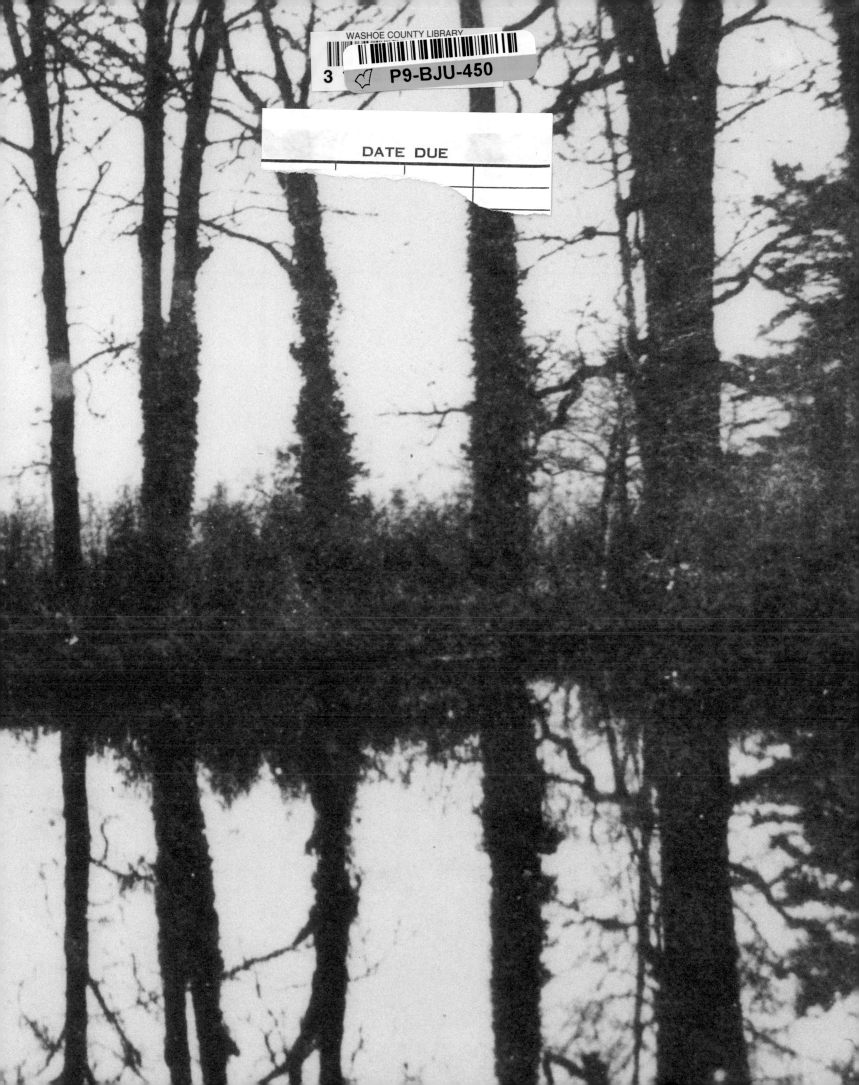

FIRST PHOTOGRAPHS

William Henry Fox Talbot and the Birth of Photography

FIRST PHOTOGRAPHS

William Henry Fox Talbot and the Birth of Photography

Texts by Michael Gray, Arthur Ollman, and Carol McCusker

powerHouse Books

New York, NY

In association with the Museum of Photographic Arts, San Diego

INTRODUCTION

The dawn of the Industrial Revolution, in the early nineteenth century, spawned thousands of commercial and scientific inventions; photography was one of them. The negative-to-positive, multiple-image paper photographic process is undoubtedly among the most influential inventions of the modern era, impacting our world (then, as now) from the sciences and arts to politics and advertising. There were many people involved with photography's invention, and its early manifestations took many forms. But William Henry Fox Talbot's negative-to-positive paper process, the one we celebrate in this exhibition and attending publication, has been the most enduring. *First Photographs: William Henry Fox Talbot and the Birth of Photography* is an exhibition in appreciation of this incomparable inventor, the images he made, and the time in which he lived. Its intention is to add breadth and depth to existing scholarship on Talbot's art and far-reaching legacy by exhibiting his work, archived at Lacock Abbey, his home, where the science and art of photography was born.

Lacock Abbey, current home of Talbot's great-great-grandson, Anthony Burnett Brown, is the repository of many of the world's first photographic images, some of which have not been out of the archives for over one hundred and sixty years. We are indeed fortunate that Mr. Burnett Brown wanted to create a definitive exhibition about his ancestor, furthering knowledge of Talbot's legacy for novice and connoisseur alike. For those interested in the beginnings of things, particularly the nascent stage of such a powerful, popular invention as photography, it is gratifying to see these rare and fragile images. Such a firsthand, first-rate resource lends not only authority but an unprecedented personal touch, since the exhibition contains Talbot's own notebooks, early processes, letters, sources of inspiration, and finally, his startlingly beautiful compositions. His images bear the graceful weight of an intelligent and sensitive eye. Not only did he invent the language of photography, he understood it to be both a document and an aesthetic interpretation of reality.

Talbot had a sophisticated understanding of what photography could do. *The Pencil of Nature*, produced between 1844 and 1846, was essentially an encyclopedia of photography's uses; he knew it could serve the scientific and academic communities as well as the commercial and artistic. "[It] would be a mistake to imagine that Talbot's production of images was ever simply arbitrary or acci-dental…He was, like Daguerre, anxious to promote the infinite variety of possible uses to which photography could be put," writes photo-historian Geoffrey Batchen in *Burning with Desire*. Talbot also demonstrated a keen understanding of how photographs themselves were products, replete with their own means of representing the world. In *The Real Thing*, Ian Jeffrey notes, "The unmis-takable subject in most of [Talbot's] calotypes is nothing more than the photograph itself….They declare their own premises."

<div align="center">*　　　*　　　*</div>

First Photographs: William Henry Fox Talbot and the Birth of Photography and this accompanying publication are designed to give the viewer a perspective on Fox Talbot, his domestic environment, and on the social and political times in which he lived. We are fortunate that he kept exquisitely detailed journals and properly stored many of his images. What emerges from these artifacts is a record of photography's birth, and an intimate portrait of the Victorian Era.

First Photographs is a collaboration between the Museum of Photographic Arts, San Diego, and the Fox Talbot Museum in Lacock, England. We celebrate the legacy of this man, William Henry Fox Talbot, who was as passionate about art as he was of science, and whose invention continues to this day to inform, beguile, and transform our world.

—**Michael Gray**, Director,
Fox Talbot Museum

—**Arthur Ollman**, Director
Museum of Photographic Arts

—**Carol McCusker**, Associate Curator
Museum of Photographic Arts

Respectfully Dedicated to the Memory of Anthony Burnett Brown

ACKNOWLEDGMENTS

First Photographs: William Henry Fox Talbot and the Birth of Photography is an exhibition of extremely rare and fragile images preserved in the Fox Talbot Museum in Lacock, England, the birthplace of photography. Many of these images have been in Lacock for over one hundred and sixty years, and have never been seen by the public. Photographers, historians, scholars, collectors and museum-goers owe a debt of gratitude to Anthony Burnett Brown, Talbot's great-great-grandson, and to the British National Trust for their endorsement of this historically important exhibition.

To the two institutions out of which the energy and intelligence came to see this exhibition through, from concept to gallery walls, deep gratitude is extended. At the Fox Talbot Museum we would like to personally thank Roger Watson, David Gray, Joe McNeilage, and Karen Gilbert. At the Museum of Photographic Arts, many thanks are extended to Carol McCusker, Anna Rogers, Barbara Pope, Scott Davis, Gaidi Finnie, Margaret Smeekens, and Tomoko Maruyama for their contributions and dedication. At the British Library, thanks go to John Falconer and Annie Gilbert. Bath Central Reference Library, Wiltshire County Record Office, and the National Museum of Photography, Film & Television also contributed their generous time and knowledge to this project. Barbara Gray, scholar of Talbot's time and technique, was an important diplomat and friend to this exhibition, without whom the depth and richness of *First Photographs* would have suffered.

In addition to the images provided by the Fox Talbot Museum, we gratefully acknowledge photographs lent by internationally known collectors Michael Mattis and Judith Hochberg. Many thanks also go to Dr. Larry Schaaf, Hans Kraus Jr., Michael Wilson and Violet Hamilton, Dr. Mike Ware, Dr. Sara Stevenson, and Tim Macmillan for their generous support, knowledge, and time.

To the Legler Benbough Foundation, Peter Ellsworth, and Thomas Cisco, and to Molly Cartmill and Sempra Energy of San Diego, we extend our gratitude for your repeated support of the Museum of Photographic Arts, and the larger community of San Diego. Also thanks go to Bostick & Sullivan for their contributions to a seminar on Talbot's early processes in sun and salt printing.

A group of trustees from the Museum of Photographic Arts, chaired by Dr. Michael Axelrod, formed the "Talbot Committee" whose mission was to ensure the financial viability of the exhibition. The list of members (following page) includes museum trustees, collectors, and arts patrons. In an unprecedented collaboration with the museum directors—Michael Gray of the Fox Talbot Museum and Arthur Ollman of the Museum of Photographic Arts—the Talbot Committee was invited to observe the curatorial process in Lacock, as well as the great institutional photography collections of the Scottish National Portrait Gallery, Royal Scottish Museum, the National Museum of Photography, Film & Television in Bradford, and the British Library. We acknowledge the committee's vital contribution to the success of this exhibition.

Talbot Committee Members

Dr. Michael and Joyce Axelrod

Mike and Sally Bixler

Lowell and April Blankfort

Julia R. Brown

Dr. Stephen and Sandra Dorros

Dr. Gerald and Myra Dorros

Nancy K. Dubois

Drs. Edward and Ruth Evans

Dr. John and Birgit Ford

Murray and Elaine Galinson

Cam and Wanda Garner

Alfred and Patricia JaCoby

Drs. Lewis and Pat Judd

Timothy Clark and Dr. Virginia Killby

Mel and Gail Mackler

Constance Massey

Drs. Joseph and Elaine Monsen

Dr. William and Sue Ann Scheck

Donald and Roberta A. Schwartz

Robert and Sara Skousen

Morrice and Dr. Lorna Swartz

Leonard Vernon

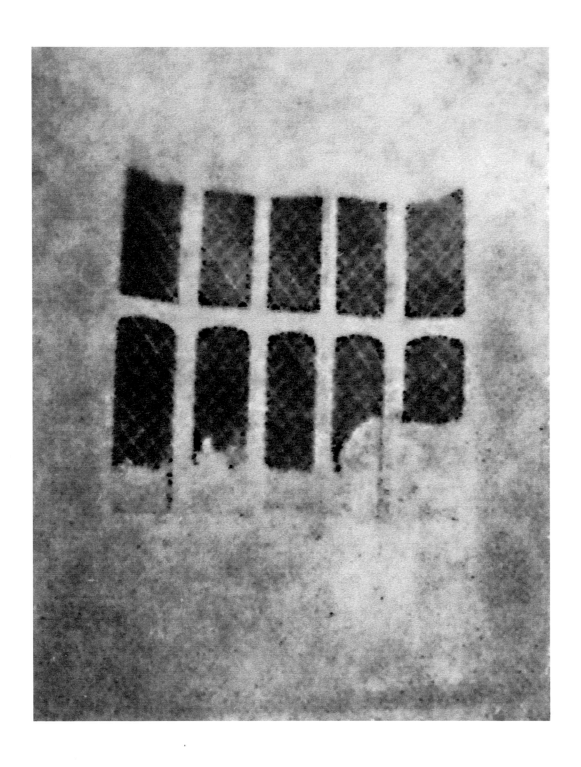

Oriel Window
Lacock Abbey, Lacock, England, August 1835
Camera paper negative
(Taken from a copy gelatin glass negative by Lambert, 1921)
Original in the National Museum of Photography, Film & Television
the Science Museum, Bradford, England

HENRY TALBOT, THE MAN WHO TAMED LIGHT

ARTHUR OLLMAN

It was a time of possibility, a time when scholars of consequence thought unusually grand thoughts. The British 1830s were a decade when privileged and well-educated men believed they could alter nature and perfect society; a moment of hope that intelligence and diligent application of one's energies could solve the problems and mysteries of life. William Henry Fox Talbot was well aware that the world was changing and that scientific discoveries would stimulate much of the change. In the 1830s in England, an individual might forget his cosmic smallness and grasp with shining certainty that his efforts mattered.

Leaning back in his chair, Henry Talbot closed his eyes. The warm autumn sun on his face reminded him of light's transformative character. The light poured through the windows and into one of his tiny box cameras, which his wife called his "mousetraps." The lens, which was pointed directly at the window, had been uncovered several minutes earlier.

He was curious about sunlight. How was it produced? What caused the colors in the light spectrum? Were there parts of the spectrum that we could not detect? How did one prism break light apart and another reassemble it? Did light produce heat, or was it the other way around? He never doubted that these inquiries would lead to practical solutions. He never doubted science as a pathway to the future, as some others did. John Keats (1795–1821), the Romantic poet, had fretted that "science was trying to unweave the rainbow."

Henry Talbot was satisfied to see the sun warming the southern façade of his great and austere home in Lacock. Until he was twenty-seven, his family's financial difficulties had forced him and his mother to live with relatives and away from the ancestral abbey. The efforts of his brilliant and energetic mother had relieved their debt, reestablishing a comfortable degree of wealth. Depressed by the cold damp and dark of Lacock Abbey's halls, Talbot rebuilt the south side of the building, adding the large graceful windows that were then fashionable among the upper classes.[1] Three protruding bay windows of differing size gathered the early and late exposures, brightening the South Gallery and the adjacent rooms. Bringing light into the dark rooms was a fine victory indeed for Talbot.

The light fell on the accumulations of a family of high standing: bookshelves of leather-bound volumes about art, literature, and religious thought; books in several languages—Latin, French, German, and Spanish. Here were generations of exploration in science and discovery. The light illuminated porcelain figures, exotic floral displays from their greenhouse, tapestries, and copies of old family portraits.[2]

From the window Talbot looked out over his beautiful fields, saw the cattle grazing amongst the lawns and graceful trees, which he could readily name in Latin. From here he could watch the seasons turn. The Avon, a slender stream at Lacock, wound through these pastures. It swelled in winter and spring, and appeared shrunken and weak in the late summer and autumn. His southern exposure did not include the village of Lacock, with all of its problems—medieval houses in need of repair, the difficulty of finding good tenants. Henry Talbot's view was of nature, of his lands cultivated wisely by intelligence and the requirements of agriculture. Warmth in autumn and even some solar respite from the dreary winter were as sure a sign of success as any. Henry Talbot was pleased with his work.

These moments of self-congratulation were rare and of short duration. Talbot's intellectual curiosity continually interrogated the natural world. He had a life-long fascination with the mysterious qualities of phenomena not easily observed. Victorian scientists studied the microscopic world of atoms, discovered new elements (oxygen was discovered in 1767 by Joseph Priestly in the home of Talbot's uncle, the Marquis of Lansdowne) and new synthetics with industrial applications, found and named new species of plants and animals (Darwin's *Voyage of the Beagle* and his subsequent theory of evolution), explored the cosmic world (partly inspired by the discovery of Uranus by William Herschel, the father of John Herschel, a great friend and mentor to Talbot), and researched electricity, magnetism, and the properties of crystals. The world, it became clear, was far more complex and fascinating than had previously been supposed. Engineering advances also thrilled the British populace. Many of the great mechanical advances of the Victorian period were enlargements on principles of engineering that had been useful for centuries in smaller forms. Great bridges, huge ships, large military armaments, and iron building supports allowed projects on a scale that could never before have been contemplated using wood or small foundries. It was the scale, however, not the scientific possibility of such accomplishments, that amazed the public.

1. Seventeenth-century taxes levied on windows kept the homes of the poor dim and cold. One could avoid these taxes by bricking in windows. These laws were repealed in 1851. Even today in villages all over England one encounters old houses and barns with the telltale shape of windows clearly delineated with newer masonry in ancient walls.
2. In a display cabinet was one of the four original copies of the Magna Carta, given to William Longespee, illegitimate son of King Henry II, and one of the Barons who led the revolt against King John, and who was present at its signing in 1215. He was married to Ela, the Countess of Salisbury, who founded the Abbey at Lacock in 1229, becoming its first Abbess. She was given the document for safekeeping. She seems to have acquitted herself well as it was eventually given to the British Museum.

Social theorists were also actively attempting to solve society's problems. Issues of poverty and its products—disease and crime—were addressed by thinkers of every persuasion. In 1789 Jeremy Bentham established the theories behind Utilitarianism, a dominant middle class political philosophy of the early Victorian period. Its catch-phrase was provided by Joseph Priestly, who had more than the discovery of oxygen on his mind when he proclaimed that Utilitarians believed in "the greatest happiness for the greatest number." The movement held that self-interest is the only motivation of the species and that avoiding pain and achieving pleasure were its only components. One can easily see how Darwin's thinking would dovetail with such ideas.

In 1844 Friedrich Engels wrote *The Condition of the Working Class in England*, later to become a foundation of Communist thought. This work was partially inspired by the typhoid epidemic of 1832 that killed 16,000—mostly poor—people in England. This episode was followed in 1849 by a larger typhoid epidemic, which killed as many in London alone. Many other social changes were afoot as well. In 1829 the world's first municipal police force was established, to replace the inefficiencies of night watchmen. In 1840 Parliament introduced a fund for public parks, which for the first time relieved the squalor of the city slums all over the country. Several years later, large public art collections were opened, which along with public libraries and parks were expected to keep working classes from being attracted to "demagogues and dangerous causes."[3] Debates on society's problems and solutions attracted Henry Talbot and they nourished within him a desire to apply his energies to the political world.

Though Henry Talbot (his own preferred name, rather than the more poetic William Henry Fox Talbot) could see little of the village of Lacock and its life from his windows, he could not leave his home without passing through it. His stewardship and tithing policies were enlightened and liberal enough to earn him the respect of the villagers. At the age of 21 he paid for the building of Lacock's first school, which is still in use today. His own interest in politics, which was considerable for a brief period of time, peaked between 1831, when he lost a bid for election to Parliament, and December 1832, when he succeeded and took his seat as an M.P. in February of 1833. But by 1835, when elections were again held, Talbot chose not to stand. This brief foray was an interesting and seemingly anomalistic diversion, and serves to broaden our notion of his encyclopedic interests. Bringing enlightenment to the darker sides of British society, Henry Talbot, M.P., voted for measures to regulate and reduce child labor in factories, on the emancipation of slaves, and several other bills to reduce the burdens of the poor.

Talbot was more attracted to the solitary pursuits of science, mathematics, and translation of ancient texts. It was these studies that launched his nomination to become a Fellow of the Royal Society in 1831. He was well regarded to be in the vanguard of the study of optics and theoretical mathematics. Sir David Brewster and Sir John Herschel both strongly encouraged him to let politics go for the infinitely more useful realm of science.

In June of 1833, shortly after taking his seat in Parliament, Henry and his young wife Constance took their extended honeymoon and arrived in Bellagio, Italy, on the shores of Lake Como. It was here that the Genesis story of photography began. Joining friends and family on an outing to sketch the beauty of the landscape, Talbot became frustrated by his remarkable inability to draw. While the rest of the group was producing fluent recordings of the exquisite topography, his own dismal output depressed him. He later claimed that it was then that he postulated the notion of asking the scene to draw its own image on light sensitive materials.

Like Genesis, the legend of Talbot's discovery of photography explains by leaving out all of the most essential details. The story tells little about the ideas that prepared him to approach such problems. Unlike Genesis, which does not provide the question to which creation was the answer, photography was Talbot's scientific effort to accomplish what his hand could not. Myths are as important as facts when they come to be believed. Talbot's fluency in chemistry, in optics, and in the properties of light supported his sense of possibility. Ironically, Talbot's story, like the first Biblical passage, explores the essentialness of light. Even today, photography has much magic inherent within it. The marvel of its phenomena has intrigued everyone who has practiced it. Henry Talbot's capturing of light, taming it, and in the process putting a stopper in the relentless flow of time has a connection to the obscure, even to the "dark arts." He could read Assyrian and Egyptian cuneiform and hieroglyphics, which placed him in a very elite society of people capable of deciphering markings that others could see only as strange designs. He read Latin fluently, and did a passable job with Hebrew and Greek. He could also manipulate the mysterious symbols of advanced mathematics and was comfortable with arcane laboratory procedures related to invisible writing, a theoretical precursor to the latent image idea in photography, and bringing imagery forth from light by mixing various chemicals. He understood chemical composition of substances by the colors of flames they produced when burned. This was an important period in the advancement of modern science, since it began to distinguish the province of science from the realm of alchemy, necromancy, and magic. It was Herschel's playful message to Talbot in 1841 that stated, "I always felt sure you would perfect your processes till they equaled or surpassed Daguerre's, but this is really magical. Surely you deal with the naughty one."

3. Robert Slaney, MP for Shrewsbury, quoted in Eric Evans' *The Forging of the Modern State: Early Industrial Britain 1783–1870* (London: Longman Group Limited, 1983), 310.

By harnessing light's powers, Talbot was straddling science and magic, literally spanning the dark arts and the light. The writer and curator Dave Hickey has written: "Pure light in any photograph is a white cipher, a smear or splotch of burned-out nothingness. Pure light, like true love or good grammar, is one of those subjects that is only perceptible in its defects. We perceive light on the surface where it falls, the atmosphere through which it is refracted, the enclosure it informs, and the medium through which it passes. In other words, pure light is eternal, imperfect light is historical and the subject of photography."[4]

After Sir Isaac Newton's publication of *Optics* in the early 1700s, light gained nearly mystical properties in the public imagination. It became synonymous with beauty. It was the first among God's creations. The "white light" remains a spiritual metaphor even today. Scientists, then as now, occupy a role as secular priests and shamans, or—as our fear of scientific advancement grows—as devils. Talbot's fascination with light might be called an obsession. Of his forty-two published scientific papers, thirty-two deal with light.

The culture into which photography was born craved scientific progress, but it had mixed feelings about art of any kind. Jeremy Bentham, the father of Utilitarianism stated, "Poetry is misrepresentation," and Thomas Babington Macaulay, a writer, historian, orator, and Member of Parliament wrote, "As civilization advances, poetry almost necessarily declines." Even Darwin complained that reading Shakespeare made him nauseous, and that he had lost his taste for pictures and music.[5] Inherent in this thinking is a fear of the senses, as they may lead one astray, distracting one from the supreme effort of preparing the soul for heaven, or of doing something more useful with one's time. Art lovers had a need to couch their passion in terms of social value or moral instruction. In the 1830s science and rationality were on the ascendance. As postulated by Ruskin, ideas should be provable and faithful to human experience. Victorians saw value in photography for its ability to speak of reality with veracity and clarity.

Joel Snyder, in *The Art of Fixing a Shadow*, proposes that throughout its history, photography has always been identified in relation to what is generally and equivocally termed "reality." It is often assumed that photographs are merely recordings: "But whatever else a photograph is it is also a picture and as such has a direct and inextricable link to all picture making and to the history of art. Commentators have always tried to position it between art and nature…Photography was invented to do what other media had accomplished for centuries…to make exact renditions of something observable."[6]

Henry Talbot consulted his pocket watch and noted the passage of nearly an hour since he had uncovered the lens on his little box camera. He recognized the poetic metaphor of light entering his eyes to enlighten the sensitized mind and soul, and the light flooding through the oriel window. Covering the lens, he wondered if the image had drawn itself on the paper. He could not have known then, as we do now, what he had accomplished.

There are those who are thrilled at the discoveries of Talbot but remain unimpressed by his art. For some, it is not enough that Talbot invented the process of paper photography. He is also expected to have invented the "art of photography." He never, in fact, thought of himself as a great artist. However his work is far more than the identification of light, textures, and a few well-placed objects. Talbot's vision is one of dignified, if understated and economical, elegance, manifested in his ability to show just enough while leaving out the extraneous. That he was aware of such issues is extraordinary.

Well before it was at all certain that there would be many branches on the tree of this technology, Talbot recognized that there would be an art limb, and he began to develop an aesthetic vocabulary, partially from the history of art but also separate from painting. We can see him growing as a "photographer" at the very moment when he was inventing photography. He produced thousands of images, often several variants of a single idea, as he worked toward its most potent realization. The economy and assurance of his work from 1843 to 1845 offer eloquence not visible in 1841. He established a vocabulary in those years that is not in any salient way different from notions of depiction today. Henry Talbot gave us not only a medium but also a substantial description of his place and his time. The small, indistinct paper scraps of his earliest experiments are, in their neonatal form, difficult to use to predict photography's mature manifestations. Yet even in his first tentative efforts, we seem to be witnessing the sketches for something that, in its complete form, has changed us no less than it has altered the world.

4. Dave Hickey, "Introduction," in Richard Ross' *Gathering Light* (Southampton, England: John Hansard Gallery; Louisville, KY: Speed Museum; distributed by University of New Mexico, 2000).
5. Richard Altick, *Victorian People and Ideas: A Companion for the Modern Reader of Victorian Literature* (New York: Norton, 1973), 271.
6. Joel Snyder, "Inventing Photography," in *The Art of Fixing a Shadow: One Hundred and Fifty Years of Photography* (Boston: Bulfinch, 1989), 3-34.

Silver Spoons and Crinoline:
Domesticity & the "Feminine" in the Photographs
of William Henry Fox Talbot

Carol McCusker

Here is an odd and paradoxical truth: many globally transformative events often happen in small, remote places. The extraordinary discoveries in communication, engineering, and manufacturing that ignited the early years of the Industrial Revolution—the era we celebrate here—often spread throughout the world from small villages or townships previously unheard of. In the first half of the nineteenth century, a symphony of invention was literally and figuratively in the air (factory smog / Lord Byron, railway trestles / Karl Marx). For those integral to that century's changes, who could easily move from active urban centers to countryside estates where knowledge taken from the former could be applied in the solitude of the latter, opportunities for invention abounded. "For a gentleman amateur scientist, the influence of having such a country residence should not be underestimated," writes Talbot scholar Larry Schaaf. "Such houses were designed to be self-sufficient and thus had on-hand diverse supplies, an ample kitchen (often the source of chemical sundries), and well-equipped workshops. In the days before dedicated laboratories, the simply availability of space—very generous space—was helpful."[1] Amidst these privileged spaces, as well as the general noise of the Victorian Era, there was Lacock Abbey, the haven of polymath William Henry Fox Talbot, who also spent considerable time abroad, as he did in London at the Talbot's two London homes on Sackville and Queen Anne Streets, as a Member of Parliament and various Royal Societies. A considerable amount of his time from 1834 to 1841, however, was spent in Wiltshire County where the village of Lacock and its abbey reside. Here, he satisfied his scientific curiosities and a particular brand of enterprise specific to gentlemen scholars in Victorian times. In quiet reflection Talbot began "a long and complicated, but interesting series of experiments,"[2] the ways and means toward the invention of one of the world's most singularly influential and globally transformative discoveries—the photograph. As early as 1857, Lady Elizabeth Eastlake, a photographer and writer on photography, wrote about the far-reaching utility and significance of Talbot's discovery, which in the mid-1830s he could not have imagined:

> Photography has become a household word and a household want; is used alike by art and science, by love, business, and justice; is found in the most sumptuous salon, and in the dingiest attic—in the solitude of the Highland cottage, and in the glare of the London gin-palace, in the pocket of the detective, in the cell of the convict, in the folio of the painter and architect, among papers and patterns of the mill-owner and manufacturer, and on the cold brave breast on the battlefield.[3]

That said, the purpose of this essay is not to explore so much Talbot or his discovery but to place the man within his remote haven—the abbey, the "self-sufficient" household in which he worked—and to draw a more inclusive image of the domestic climate that nurtured him. Needless to say, this environment included the presence and influence of many women whom he photographed frequently: his mother Lady Elisabeth Feilding, half-sisters Caroline and Horatia, wife Constance, aunt Mary Lucy, cousin Mary, a host of visitors and friends, and Lacock's governess (and Elisabeth's companion), Amelina Petit. In the larger sphere of professional influence and support were the late eighteenth-century chemist Mrs. Elizabeth Fulhame, science writer Mary Somerville, author Maria Edgeworth, Bessie Raynor Parkes (grand-daughter of Joseph Priestley) and botanist Anna Atkins (both of whom learned early photographic processes indirectly from Talbot, with Atkins publishing the first photo-illustrated book), Lady Eastlake, and later, the enterprising photographer Julia Margaret Cameron. As early as April, 1839, even Queen Victoria joined in support of the new medium. Significantly, Talbot's sister Caroline, after she married the Earl of Mt. Edgcumbe to become Lady Mt. Edgcumbe and mistress to an "estate of considerable importance and great beauty...used her position in the royal household to show her brother's progress to the Queen...who praised the 'exactness of similitude' of a photogenic drawing of a gauze ribbon, describing it as 'very curious,' and proclaimed herself ready to try to do some herself!"[4]

I would like to thank Michael Gray, Director of the Fox Talbot Museum at Lacock Abbey, for graciously sharing his broad knowledge of William Henry Fox Talbot, the Talbot women, and life at Lacock in the mid-nineteenth century; and for recommending Norman Bryson's *Looking at the Overlooked: Four Essays on Still Life Painting* as framework for my discussion on the "feminine" within Talbot's photographs.

1. Larry Schaaf, *Out of the Shadow: Herschel, Talbot & the Invention of Photography* (New Haven: Yale University Press, 1992), #59, 165.
2. Graham Smith, *Disciples of Light: Photographs in the Brewster Album* (Malibu: J. Paul Getty Museum, 1990), 16.
3. Lady Elizabeth Eastlake, from an unsigned essay in the *London Quarterly Review* (1857). Eastlake wrote passionately and frequently about photography, and was the wife of Sir Charles Eastlake, director of London's National Gallery, president of the Royal Academy, and the first president of the Royal Photographic Society.
4. Larry Schaaf, *The Photographic Art of William Henry Fox Talbot* (Princeton: Princeton University Press, 2000), 228, 87. Queen Victoria would champion photography throughout her life, becoming an avid collector for many reasons, not least for what photographs could "report" of her colonies abroad.

Introducing these women into a discourse on Talbot is not a simple bid for their inclusion into the history of photography. Rather it is meant to serve the women *alongside* the men—Fox Talbot, Sir John Herschel, Reverend Calvert Jones, Sir David Brewster, and Nicholaas Henneman—by locating both under the same "roof," as it were. By way of their letters and recorded shared experiences, an educational system more inclusive of them, and not least, an enthusiasm for the world of ideas through the aesthetic filter of the Romantic Movement, this essay hopes to convey something of the collective input—the intellectual and artistic liberation on the part of both genders—that helped shape the years surrounding the advent of photography.[5]

Talbot's photographs become more complex when read within this context and for what they point to beyond their frame. They are made not just of silver and salt but of semantic signs. Refracted through his lens is a way of life. Not only was he creating groundbreaking imagery, his photographs act as historical records, each one pointing to a set of choices, fashions, and circumstances. Narrowly autobiographical, they provide us with a view into his class, and his relationships, which reference the environment in which they were made. A correlation exists between the objects pictured and their scientific, materialist, and aesthetic equivalents. The rows of leather-bound books, silver candlesticks, or the array of bonnets reflect particularities of not just Talbot's, but his family's interests and tastes—their collective sophistication, excesses, and modesty. These objects and their display provide us with a measure of their self-perception, and how they wished to be perceived by others.

Talbot's letters from the period reveal much in the way of the active interest and support the women at Lacock provided him. These women have been described as formidable ambassadors and crusaders of Talbot's work, as his conscience and motivation, and as eager participants in his photographic practice and scientific recognition. On a spring day in 1841, for instance, Lady Elisabeth noted in her diary that "Henry went with Horatia and Caroline to make Photographs at Corsham," an estate three miles from Lacock, home of their friend Paul Methuen, who had assembled a massive art collection from the Continent. A lovely and sweetly touching image still exists of that day, of the two women walking with parasols on the grounds of Corsham.[6] There are letters attesting to the women's promotional ideas and activities, their deciding who should see the calotypes and when, and handling requests from colleagues, as well as their sensitivity toward Talbot's emotional needs. At the beginning of September 1845, Caroline encouraged her brother to keep taking photographs. Inviting him to Mt. Edgcumbe, she wrote: "[I] would be delighted to have you here, & pray bring Mr. C. Jones too, & Nicole [Henneman], & all the apparatus."[7] In another letter from Talbot's wife dated "Monday", July, 1842, Constance described to Lady Elisabeth a welcomed change in her husband's disposition. Occasionally exhibiting introverted behavior (indeed, Talbot was very shy and would seem to have suffered from occasional depression), Constance wrote, "Henry seems to possess new life" due to a long visit from Sir Brewster:

> When I see the effect produced on Henry by Sir D. B.'s society I feel most acutely how dull must our ordinary way of life be to a mind like his!—and yet he shuts himself up of choice...I feel certain that were he to mix more frequently with his own friends we should never see him droop in the way which now so continually annoys us.[8]

Constance expresses what seems to be household exasperation toward Talbot's remoteness, at the near-hermetic seclusion he needed for his scientific study. His decision must have lead, at times, to further dependence on the women to see to the running of the house and village. Either way, his "choice," as Constance puts it, was for the remote haven where he could either brood or pursue his work. However, the level of activity evidenced in the thousands of images he made infers that Talbot could and did work prodigiously (he was the most prolific among early photographers), with the household rallying around him when he emerged from isolation. There are also references to him not caring to venture too far from the familiar (although travel he did, and often). He relied, instead, on a basic core of props for his photographs, using local views, familiar household objects, and close friends and family members as his subjects, each arranged in still life or *tableaux vivants*. His uses of Lacock's picturesque cloister, the South Gallery, courtyard, and willing friends speak to a simpatico atmosphere within the household that belies Constance's annoyance.

A picture of compatibility follows, since his experiments with "the little mousetraps" could have easily disrupted the delicate balance between undisturbed study and the family's daily demands: the preparation of meals, the posting of letters, education of the children, maintenance of the house and land, receiving guests, managing accounts, and overseeing domestic staff. Most of these duties fell to the women and Nicholaas Henneman, Talbot's valet, who was well liked by the women of the household, and who became an important mediator of theirs' and Talbot's daily needs.

5. This essay acts as a mere introduction to, rather than a comprehensive view of, the Lacock women as "subject," and as an affirmation of a certain society of women who made significant contributions to nineteenth-century scientific inquiry, politics, public policy, and the arts. My hope is that it might motivate future research, so that Lady Feilding, Mrs. Elizabeth Fulhame, Anne Atkins, and Bessie Raynor Parkes, in particular, enter the discourse of nineteenth-century Victorian Women Studies, such as Philippa Levine's *Feminist Lives in Victorian England: Private Roles and Public Commitment* (1990), Patricia Phillips' *The Scientific Lady: A Social History of Women's Scientific Interests*, 1520–1918 (1990), Mary Creese's *Ladies in the Laboratory? American and British Women in Science 1800–1900* (1998), and *Uneven Development: The Ideological Work of Gender in Mid-Victorian England* by Mary Poovey (1988).
6. Schaaf (Princeton), 114.
7. Ibid, 228.
8. Schaaf (Yale), 20. Letter, Constance Talbot to Lady Elisabeth. As Schaaf notes, Sir Brewster also enjoyed the visit with Talbot: "A few hours later after arriving at Lacock on August 15, [Brewster] wrote his wife that 'this place is a paradise—a fine old abbey, with the square of cloisters entire, fitted up as a residence, and its walls covered with ivy, and ornamented with fine evergreens.'" Ibid, #99, 166.

Despite all this, or perhaps because of it, the atmosphere surrounding the *making* of Talbot's photographs, which we can only infer—their planning, implementation, and choice of content—intimates an affinity between all involved, a congeniality, even a playfulness, similar to those recorded by Julia Margaret Cameron. Particularly since Talbot's failures, which were inevitable, could easily derail the most enthusiastic collaborators. Constance, his daughters, mother, and sisters willingly sat motionless in the sun for fairly long exposures dressed in bonnets, corsets, and crinolines. Talbot controlled the terms of these photographs, and placed people and things in relation to the sun or ambient light. One assumes the women played a equal role in choosing which household items were presented to the camera. Each of the women was noted for her ability to draw and paint (it was, after all, Talbot's desire to surpass his wife's artistic abilities that led him to the invention of the camera), with Caroline executing the most accomplished works. Did they arrange the bonnets and statuettes on the portable shelf regularly rolled out into the cloisters? Or, when friends dropped by, was it Horatia or Elisabeth who determined the lyrical line and rhythm of figures, hands, turns-of-the-head, the spaces where each stood or sat, as well as the spaces in between, keeping with the ideals of good composition?

Talbot could have done so; his education included as much science as it did the history and appreciation of art. Lady Elizabeth saw that young Henry was taught the *Chemical Catechism* alongside Maria Edgeworth's *Practical Education*, a liberal teaching tool that taught watercolor and needlepoint, even to young boys. The family took their fine art cues mostly from the Continent, which meant France, the capitol of aesthetic refinement, and the Mediterranean countries of the *Grand Tour*. Uncle William Horner Thomas Fox-Strangways owned a substantial collection of early Italian Renaissance paintings. He corresponded at length with Henry about the merits of individual artists, and was responsible for bringing Uccello's "A Hunt in the Forest" (c1470) to the Ashmolean Museum at Oxford in 1854. Ultimately, William Talbot was a man of the Romantic Movement as well as the Enlightenment. He owed an aesthetic debt to the feminine sensibilities at Lacock. At the same time, his subjects conceded to his relentless and exacting focus, the means for a masculine retrieval of Lacock's domestic spaces into images and realms of great ambition and achievement.

Talbot was "an intensely private person," the antithesis of his "lively, opinionated, artistic, intelligent" mother.[9] Yet it was her encouragement, social connections, and artistic vision that aided many of Henry's successes and public campaigns. Elisabeth's presence contributed significantly to the mood at Lacock. She counted among her confidants Madame Anne Louise Germaine Necker de Staël, the formidable French author and *salon* mistress whose engagement with contemporary life through literature and the arts lead, no less, to public verbal sparrings with Lord Byron, and who threatened Napoleon enough to have herself banned from Paris. In her progressive writing on the social limitations imposed on nineteenth-century women and men, de Staël observed, "The more I see of men the more I like dogs...[however] I am glad I am not a man, for if I were I should be obliged to marry a woman."[10] Her piercing observations of sexual inequity railed against chauvinism of any stripe, and called for emancipation on the part of both sexes. In all likelihood, this attitude was shared by her friend from London. To engage an intellect like de Staël's, Lady Feilding had to be as spirited and willing to realize an alternative view of womanhood as her French counterpart. Through her opinions, personal style and habits, Elisabeth (as recorded in her many letters to family and friends) shaped Lacock's daily life and activities, even when living on Sackville Street, as seen in one of her letters concerned with Lacock's upkeep. She admonished Talbot to not "forget the Dutch proverb that Paint costs nothing. Quantities of things here are going to decay for want of it. The Dutch live in a climate as damp as ours, which made them find it out."[11] In a more passive state of reverie, less inclined toward action than his mother, Talbot mused, "The Abbey I think a fine old pile, the front next the road is unfortunately much the plainest and defaced with modern windows irregularly placed."[12] More than a day's journey from London, Lacock Village, its Manor Farm, Bewley Common, and the abbey, were architectural holdovers from the Middle Ages, seen in their simple stone buildings, stone-tiled rooflines, and the abbey's cross vaults, spandrels, and foliated pillars. But, like the Victorian Era itself, it was in transition. Obviously appreciative of Gothic tracery, but irked by past travesties that violated the abbey's architectural integrity, Talbot nonetheless installed a window unique in scale to let in the necessary light for the pioneering experiments with which Lacock would soon become synonymous. Of such luxury Sir Brewster wrote enthusiastically in 1833 about a home he had just inherited through the death of a relative, where he would have "an uninterrupted passage within the house *ninety-two feet long*, with an East Window at one end and West one at the other. This length of transit for the Solar Ray was almost necessary in using the five feet Achromatic telescope which I have got the use of from Sir Jas. South."[13] Similarly, Lacock's long South Gallery, now opened up by Talbot's oriel window, provided him with a flood of natural light for the numerous, long exposures he would make when not in the cloisters or surrounding fields.

The political and industrial revolutions of the late eighteenth and early nineteenth centuries stretched the social fabric of Great Britain and France significantly enough to include the education of women, producing writers and social activists like Mary Shelley, Ann Radcliffe, Jane Austin,

9. Schaaf (Yale), 10.
10. Madame de Staël, "About Equality" and "About Marriage," (Internet: http://home8.swipnet.se/~w-80790/Works/Staël.htm).
11. Schaaf (Yale), #60, 165. Letter, Lady Elisabeth to Talbot, 14 December 1837.
12. Ibid, 12. Letter, Henry Talbot to his stepfather, Captain Feilding, 30 January 1824.
13. Ibid, #59, 165. Letter, Brewster to Talbot, 8 July 1833.

Elizabeth Barrett Browning, Amelia Jane Murray, George Eliot, the Brontë Sisters, George Sand, and Florence Nightingale, who addressed, through their work, not only the intellectual needs of women, but the larger social and political inequities of the nineteenth century. "Women suffer from too rigid a restraint, too absolute a stagnation," wrote Charlotte Brontë in her fictional autobiography, *Jane Eyre*. "It is narrow-minded to say they ought to confine themselves to knitting stockings and playing the piano. It is thoughtless to condemn them, or laugh at them, if they seek to do more or learn more than custom had pronounced necessary for their sex."[14] Brontë's literary success is an important index of the degree to which women could exercise their abilities, and be recognized even from such remote places as Haworth. Life at Lacock worked similarly in that its women, unrestrained by their "purse," or their travel, associations, and opinions, were not solely tied to the regular routines and local spaces of the house and village. They were also aided by the tenets of the Romantic Movement, then very much in vogue, which allowed a not-insignificant loosening of gender expectations.

Romanticism brought personal expression to new heights. It acknowledged physical and emotional desire as never before—an embrace of the senses through a more acute corporeal awareness that could actually be discussed in polite society. Men were accorded a measure of emotional freedom; for women, the capacity for intellectual improvement. The acknowledgement of *feeling*, spearheaded by Milton, Byron, and Blake, conceded an appreciation of what the mind and heart could experience through the contemplation of Nature. In an appreciation of the Divine imagination, and the necessity of "mortal vision" to do so (which would, in time, be aided by photography), Elizabeth Barrett Browning wrote:

> And in this twofold sphere the twofold man
> (For still the artist is intensely a man)
> Holds firmly by the natural, to reach
> The spiritual beyond it,—fixes still
> The type with mortal vision, to pierce through,
> With eyes immortal, to the antetype
> Some call the ideal, better called the real[15]

Romanticism stood for a male/female duality in the lives and creative output of those who professed it, as in the lifestyle and prose of George Sand or the delicacy of Chopin's music. It gave pride of place to personal passion, overstepping the distant and historical subject matter of grand painters such as Gainsborough or David. Talbot and his colleagues exercised the rigors of science, its linear thinking and cerebral heroics, alongside an appreciation of the "feminine" manifested in the surface grace, visual harmony, and expressivity of many of their photographs. Women were given inroads toward a professional and/or public life, a "web of sunny air, spun out of our quiet, restricted lives," wrote Charlotte Brontë. In appreciation of this new freedom, which she "owed" to one of her own male characters from *Angria*, Brontë noted:

> I owe him something, he has held
> A lofty, burning lamp to me
> Whose rays surrounding darkness quelled
> And showed me wonders shadow free[16]

As with many artists and philosophers of his generation, influenced by the allure of Romanticism, Talbot employed a decidedly subjective way of exploring and pursuing his ideas through his new invention, as on a trip he made to France in 1843. The trip's purpose was to demonstrate and advertise his discovery to a French audience. En route, he stopped in Rouen to photograph the harbor and a newly completed chain suspension bridge, to show to those waiting for him in Paris. However, he was trapped indoors by heavy rain. He wrote of his frustration, but, undeterred, prepared his paper, set his camera, and exposed a view from his hotel window. The image has the effect of a mid-afternoon idyll when one sits or lays on the bed looking out in quiet reverie. It is among Talbot's most modern and enigmatic photographs (at least to this viewer). Taken, no doubt, for several reasons, not least to satisfy his restlessness, it possesses an awesome, even melancholy stillness that addresses the era's preoccupation with optical reality as a means of transport into the Infinite. For the Romantic sensibility, such stillness, and the requisite aloneness, facilitated inspiration derived from Nature and the Divine, as in the work of Turner, Shelley, or Caspar David Friedrich, whom Talbot admired. The "eternal" space beyond the photographer's camera and window frame (a frame within a frame) is suggested through the thin veil of curtain (a surrogate photogram or man's consciousness). The image "quotes" a similar view painted by

14. Charlotte Brontë, *Jane Eyre* (Stamford: Longmeadow Press, 1994), 284.
15. Elizabeth Barrett Browning, *Aurora Leigh* (1856) in George Landow, *Victorian Types, Victorian Shadows: Biblical Typology in Victorian Literature, Art, and Thought* (Brown University), [Internet: http://www.victorianweb.org].
16. Brian Wilks, *The Illustrated Brontës of Haworth: Scenes and Characters from the Lives and Writings of the Brontë Sisters* (New York: Facts on File Inc., 1986), 44.

Friedrich and contains classical and Christian iconography: the crosslines of a window pane; the outline of a ship's mast intimating a safe haven or port-of-call, of arriving and leavetaking, the open sea, and transformative journeys into unchartered territory; lastly, a sky leading heavenward, projecting thought, desire, and humility into the awesome distance. Such iconography would be well-illustrated in Baroque Emblem Books, a part of any upper-class education and artistic heritage, alongside such books as *De l'importance des opinions religieuses*, *Leisure Hours*, Mrs. Smith's *Rural Walks*, and Mrs. Barbara Lepas' *Evenings at Home*, listed as essential for young Henry's rearing in Lady Elisabeth's *"Pocketbook Diaries."*[17]

Like Rouen, Lacock, due to its remoteness, was at times a lonely place. But, for the Talbot household, which was decidedly in sync with its time, Lacock also agreed with the Romantic's inclinations toward medieval ruins and picturesque countryside. The Romantic urge also valued private experience, and the delicate, physical world as seen in Talbot's early botanicals, his linen-draped tables, his specimen-like display of lace and satin bonnets, or groups of elegant women and their gentlemen companions sipping tea lawnside. Each took the sensuous details of daily life to a higher, more symbolic ground. Such images were also pragmatic in their examination and celebration of the commonplace, dovetailing Romanticism to Realism—the latter being an aesthetic and philosophical movement riding close on the heels of Romanticism that prized optical clarity and a direct, even confrontational (when applied to politics) engagement with the world. Thus, Talbot, his family, and friends lived in a bifurcated age that respected sublime inspiration alongside fact and application, embracing their era's contradictions of "imagination in the highest degree fervid and active...supplied by incessant study and unlimited curiosity."[18]

Norman Bryson, in his insightful book, *Looking at the Overlooked: Four Essays on Still Life Painting*, examines the domestic space that "finds the truth of human life in those things which boldness (i.e., the masculine) overlooks;" in other words, the ordinary anonymity of daily routine and "the creatural life of the table."[19] For Bryson, nothing addresses this better than seventeenth-century Dutch still life painting, which he divides into three cultural zones—easily applied to Talbot's domestic imagery:

> 1) the household interior, the creaturely acts of eating and drinking, surrounding domestic spaces...Not momentous History, but small-scale trivial, forgettable acts of bodily survival and self-maintenance

> 2) the domain of sign systems which *code* the life of the table and which relate it to other domains (i.e., gender, economics, class)

> 3) the technology of *photography* [my insertion for Bryson's "painting"] as a material practice with its own specificities of method, its own developmental series, its own economic restraints, and semiotic processes[20]

Talbot's lawnside fruit sellers, set tables, botanicals, and bonnets fit comfortably into these zones; each address and describe a more feminine rather than masculine environment. His photograms fit the last category as they address the specifics of technique, with the specimens serving the material practice of his own "developmental series." The latter's simplicity speaks to the Romantic's response to the tactile, and Talbot's appreciation of feminine delicacy, as in the photogram he made of a simple strand of ribbon. Instead of using a piece of loosely woven rope, easily available in the stable outside, Talbot arranged a piece of gauze ribbon on his sensitized paper, suggesting that the interior, domestic spaces of the house and small-scale routines of sewing were closer to him than any other. Similarly, bits of lace, sunlit objects on a window ledge, a woman's jewelry case showing carefully draped pearls, Horatia's harp in the library, china vases and statuettes—all these are decidedly uncoded for (or by) masculine preoccupations. Such images refuse the "unitary world ruled by one sex only, and presided over by the single masculine gaze,"[21] as one might see in Vermeer's "Soldier and Young Girl Smiling" (c1658), or in Willem Claesz's "A Breakfast Still Life" (1643).

In comparing Talbot's numerous set "Tables" with Claesz's or Willem Kalf's (another formidable Dutch still life painter), one sees similarities in their near-obsessive love of surface detail and luster. Yet even with the painters' delicacy of touch, their displays of food are decidedly masculine ones—gastronomy for a tough constitution, with half-empty wine glasses, and tilted pewter plates laid over and under others holding oysters, lemon shavings, or half-eaten meats. By contrast, Talbot offers up floral cups and saucers, a centrally placed silver urn and tea server, several creamers, candlesticks, and shiny-ribbed bowls, all meant to multiply the reflections of silverware. Here, eating and drinking seem unlikely, with an invisible feminine etiquette and protocol embracing the china cups. It is an image of orderliness and household management, a female rather than male sensibility. When a domestic still life (whether in a fresco, painting, or photograph) strikes a tone of

17. Many thanks to Michael Gray for providing me with Lady Elisabeth's list of educational books from her early diaries, 1803 and 1810.
18. John Ruskin in George Landow, *Victorian Types, Victorian Shadows*.
19. Norman Bryson, *Looking at the Overlooked: Four Essays on Still Life Painting* (Cambridge Harvard University Press, 1990), 15.
20. Ibid, 14.
21. Ibid, 161.

order and serenity such as this, it is a fair assumption that a sympathy exists between the male and female occupants of the house, says Bryson, a synergy between their everyday spaces. So that Talbot's science, his "material practice...specificities of method...[and] developmental series" combine with "small-scale acts of survival and self-maintenance," becoming "sign systems of [both] gender[s], economics, and class" all at once. It is the collision of these attributes that make Talbot's first photographs so visually compelling and sweetly melancholy in their record of daily lives lived.

Talbot could easily have recast the linen-draped tables in terms of male dominance and social power, laying out items emblematic of his preoccupation with matters beyond the household, taking pains to record the routines that set him and his male companions apart from the women, such as laborer's tools, half-empty wine decanters, maps indicating a study of navigation and travel, or fresh game spilled out on a table in disarray, "signaling the unruly habits and pleasures of men exercising themselves outside the domestic realm."[22] But one can *see* that this was not how Talbot lived. His sensibility, which collaborated with the feminine (either within himself, or with the women around him), downplayed male bravado. The hands that placed the silver spoons and floral cups were his own, and another's close by. If part of the function of masculine vision is to "prioritize men's personal position, to colonize sight, to invade, control, or deny domesticity and the feminine,"[23] Talbot's vision demands a more complex gender designation: not either/or but both/and.

In his "The Milliner's Window," there is no single motive behind its making; it is both/and. The image is a show of commercial potential—Talbot made it, perhaps, to demonstrate to a draper how he might use it commercially to advertise his wares in a catalogue or broadside. Lady Elisabeth, who titled and owned the image, kept it in an album created specifically for her son's photographs. One presumes that, given her attachment to it, Elisabeth was integral to its creation; a few of the hats correspond to those in portraits of her, Caroline, and Horatia. It is a picture of a milliner's pride, carefully arranged on a narrow, four-tiered bookshelf set out in the abbey's sunlit cloister. Their layout is not unlike Daguerre's "Arrangement of Fossil Shells" from 1837 that Talbot, during a trip to Paris in 1843, may have seen. It is as fascinating in its commentary on fashion history as it is a tender image—like worn shoes, the caps hold the shapes of their wearer's heads. The folds of fabric, and the varied textures and sheen speak to the handiwork and pleasure of women. Circular folds, lateral pleating, fine stitching, plaids, and artificial flowers billow and slump as they parade themselves in linear formation.

Bonnets were among the nineteenth century's primary signifiers of taste and social position. Innovations in style, degrees of luxury fabrics, novelty dyes, and the expectation that a woman *must* own the right bonnet for the right occasion acted as an index of her status, wealth, and sophistication. As with Abigail Adams, Queen Victoria, and Empress Eugenie, most women turned to France for the latest in fashion. Lady Elisabeth was no exception; her intimate connections to Parisian life informed her of the latest trends among the powerful, fashionable set. Content aside, they become masculine in their bravado. As with many bountiful, masculine Dutch still life motifs, Lady Elisabeth, like Claesz, displays her rank and privilege through her personal belongings. Supplanting tobacco pouches with satin, lace, and crinoline, she invents a kind of "*Wunderkammer*, a place of the extraordinary and exceptional; it is taken over by the drive towards personal uniqueness, as expressed through unique possessions...and annexed to the merchant dream of riches."[24]

As collaborator, Talbot enters his scenes of domesticity invisibly, not unlike the French Romantic painter, Jean-Baptiste-Siméon Chardin, whose images of domestic interiors were contemporary with, but distinctly different from, Dutch still lifes. As Chardin sought "to capitulate, to make himself and his canvas *porous* to female spaces,"[25] so did Talbot. In him, predictable gender expectations are confounded by his immersion in a preoccupation with perception, and the Romantic's pursuit of subjective expression. Talbot's domestic photographs pay homage to several art-historical precedents—the frescoes of Pompeii, the near-photographic accuracy of seventeenth-century Dutch painting, the tender domesticity of Chardin and Vermeer—but with an exception. Talbot circumvents the *action*, the muscular gestures made by painters as they worked their canvases and subjects. Instead, Talbot quietly became a part of his arranged scene, hyper-aware of time, and slow, if not altogether still, in his role as Recorder and Romantic. "From the pace of the household he takes his rhythm...to the point where the work of the women is the *comparant* in a metaphor for the work of the artist....The respect he accords his own labor passes into the labors around him, with which it is continuous."[26]

22. Ibid, 160.
23. Ibid, 164.
24. Ibid, 161.
25. Ibid, 167.
26. Ibid, 168.

PLATES

All titles in quotations are the original titles created by William Henry Fox Talbot.

The Domestic World of Lacock Abbey

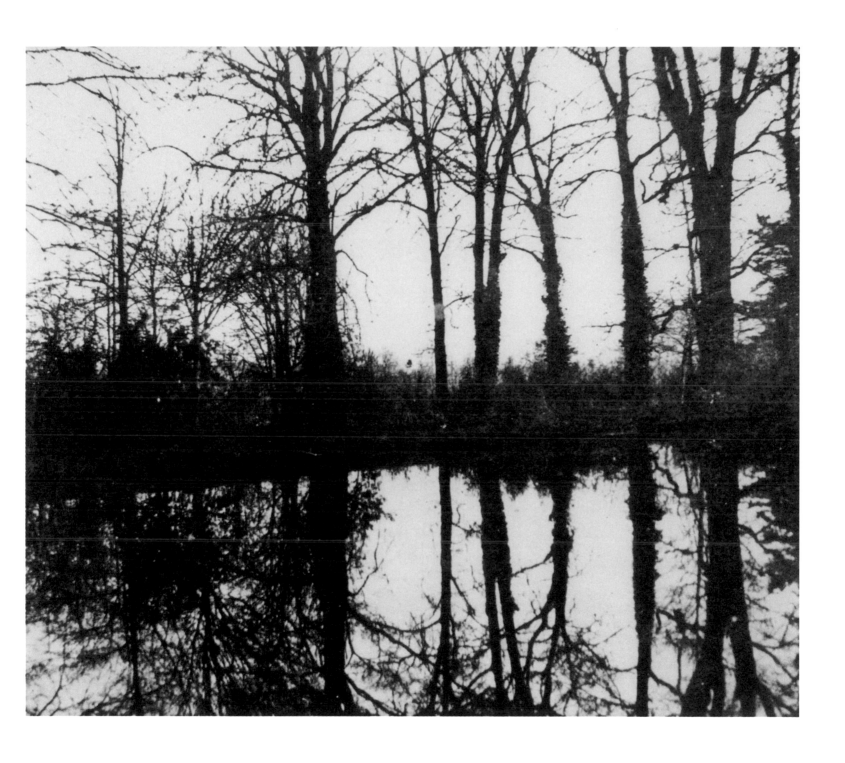

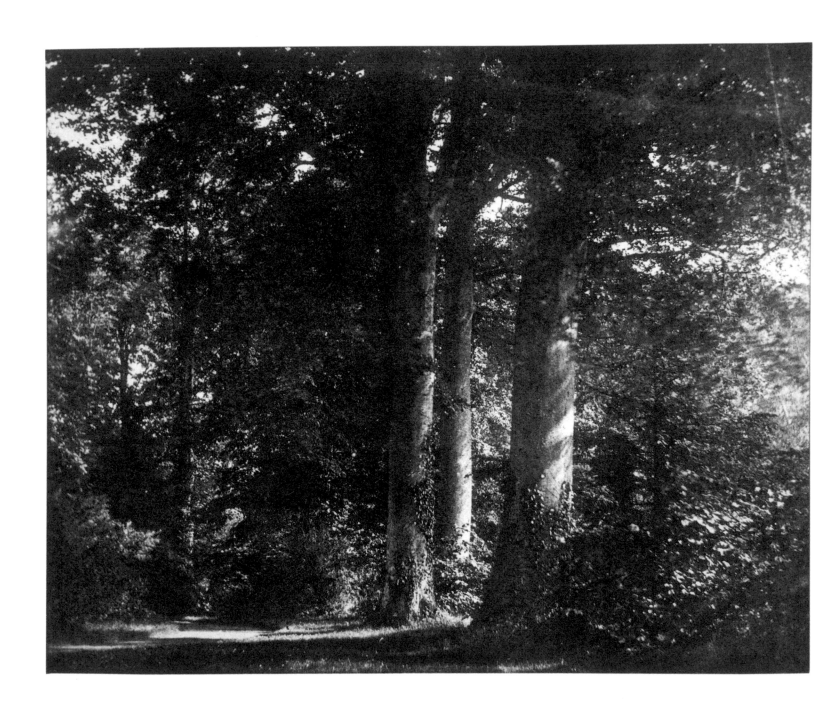

Previous page:
A Line of Trees Reflected in a Pond
Lacock, England, early 1840s
Salt paper print from a calotype paper negative
19.6 x 22.8 cm
(detail)

"Beech Trees in Sunlight"
Lacock, England, early 1840s
Salt paper print from a calotype paper negative
19.7 x 24.8 cm

Wooden Bridge and Leafless Trees
Lacock Abbey Estate, Lacock, England, early 1840s
Salt paper print from a calotype paper negative
18.7 x 22.6 cm

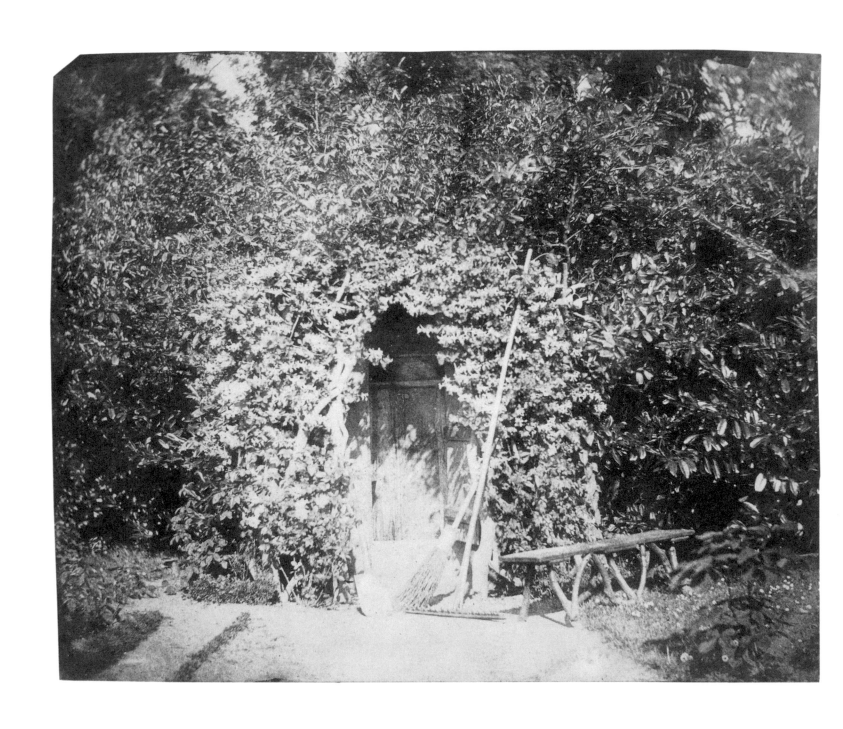

Wall, Ivy, Rake, Basket
Lacock, England, ca. 1842
Salt paper print from a calotype paper negative
18.6 x 22.5 cm

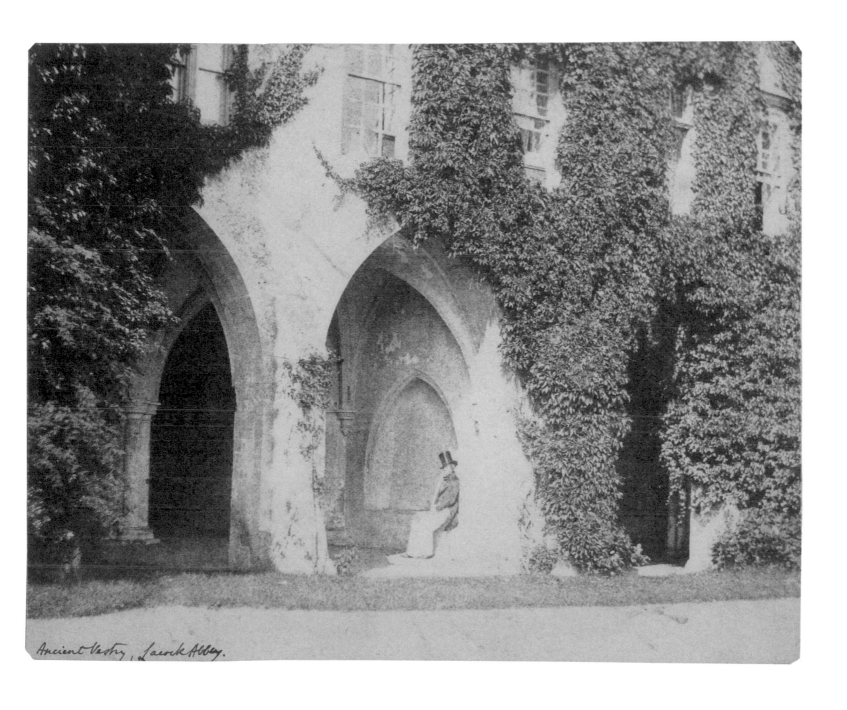

Ancient Vestry, Lacock Abbey.

"Mr. Jones in the Cloister"
Lacock Abbey, Lacock, England, early 1840s
Salt paper print from a calotype paper negative
18.6 x 22.9 cm

29

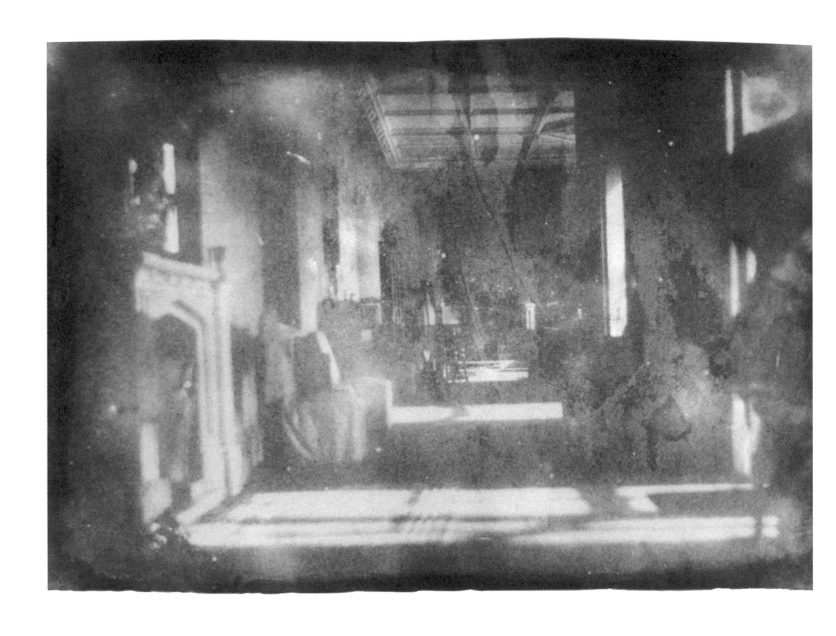

Interior of South Gallery
March 2, 1840
Digital facsimile made from unfixed, stabilized original
18.9 x 22.5 cm

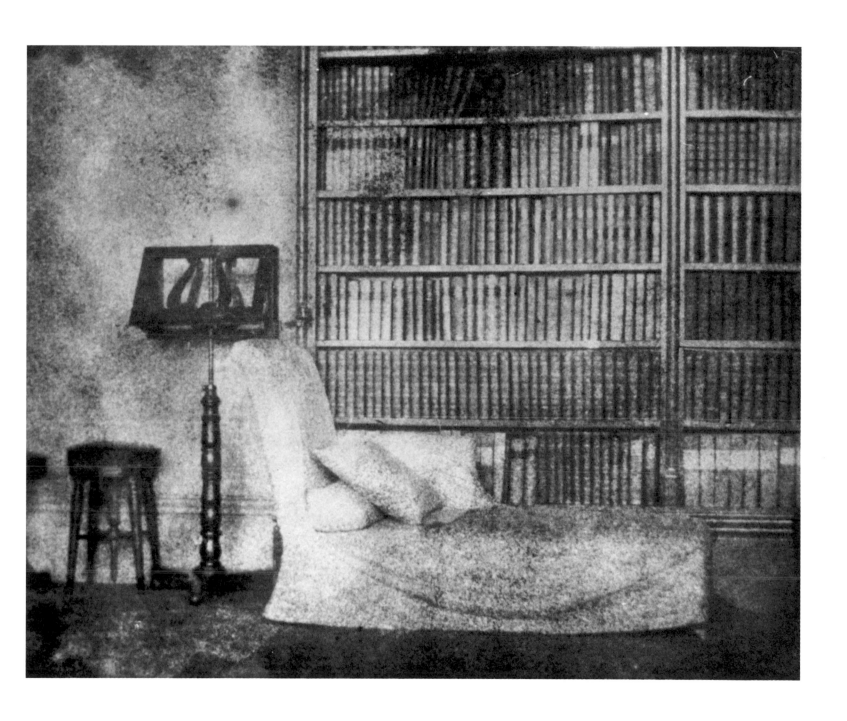

View of the Library at Lacock Abbey, Twelve Shelves
of Books Visible, Chaise Longue, Music Stand, and Stool
1842
Salt paper print from a calotype paper negative
18.7 x 22.7 cm

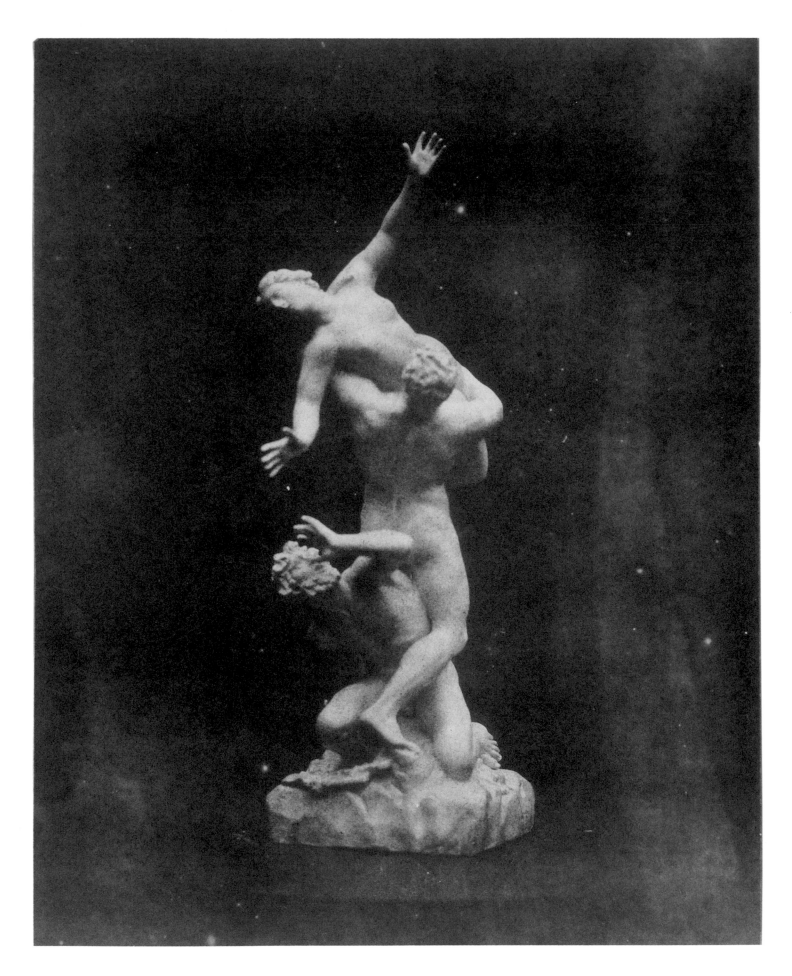

"Rape of the Sabines"
Lacock, England, early 1840s
Salt paper print from a camera paper negative
22.8 x 18.7 cm

"Rape of the Sabines"
Lacock, England, early 1840s
Calotype paper negative
17.5 x 14.8 cm

"Windowseat"
May 29 or 30, 1840
Digital facsimile made from unfixed, stabilized original
18.2 x 22.4 cm

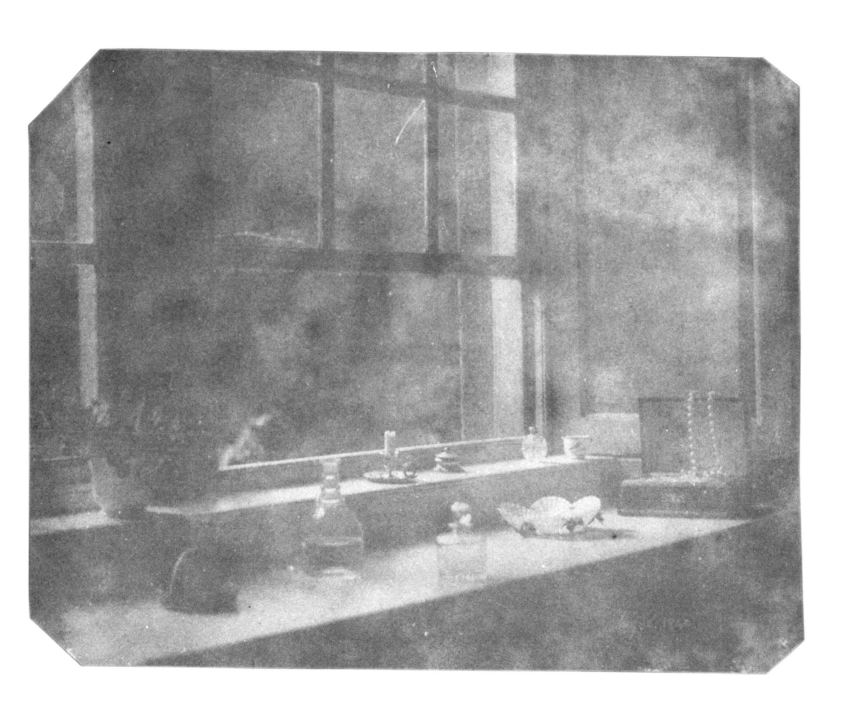

"Windowseat"
May 29 or 30, 1840
Digital facsimile made from unfixed, salt stabilized original
18.2 x 19.2 cm

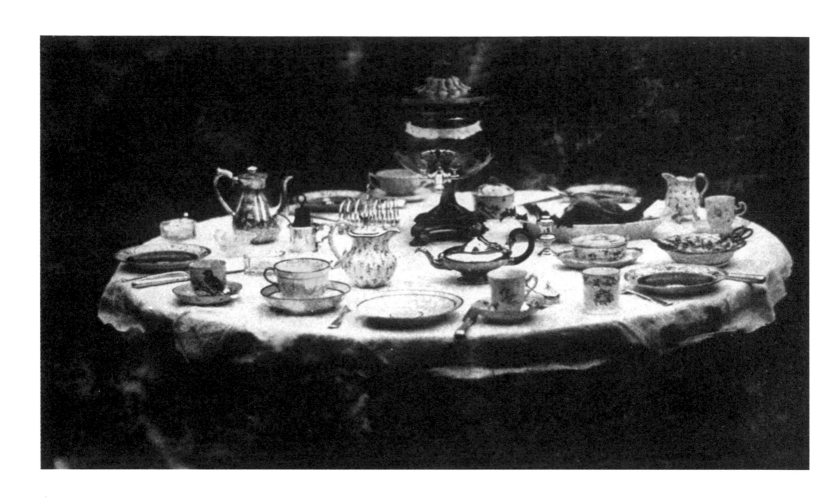

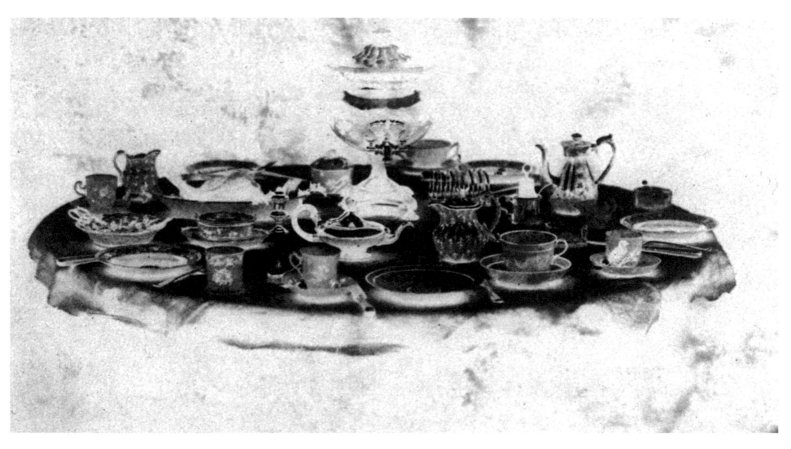

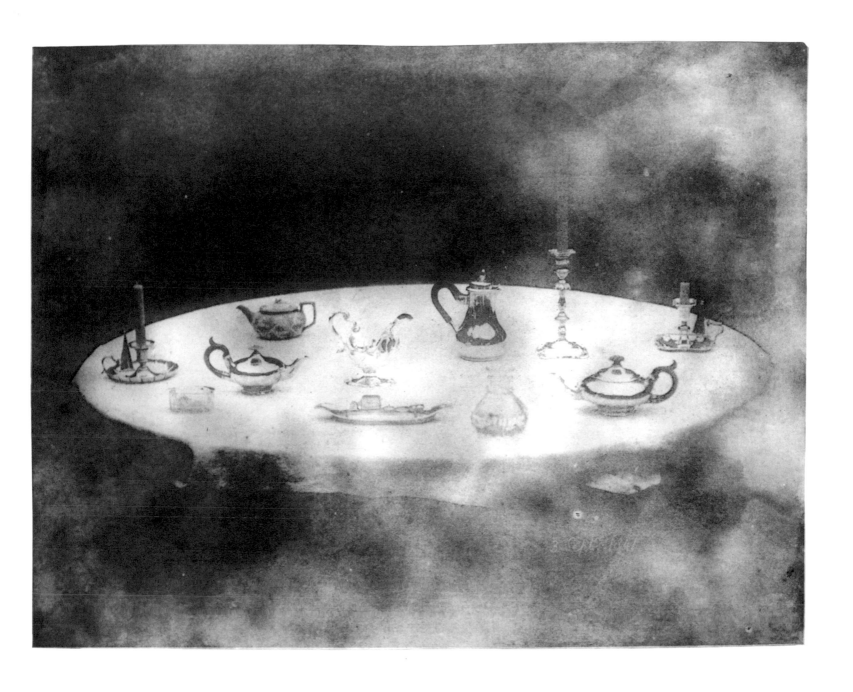

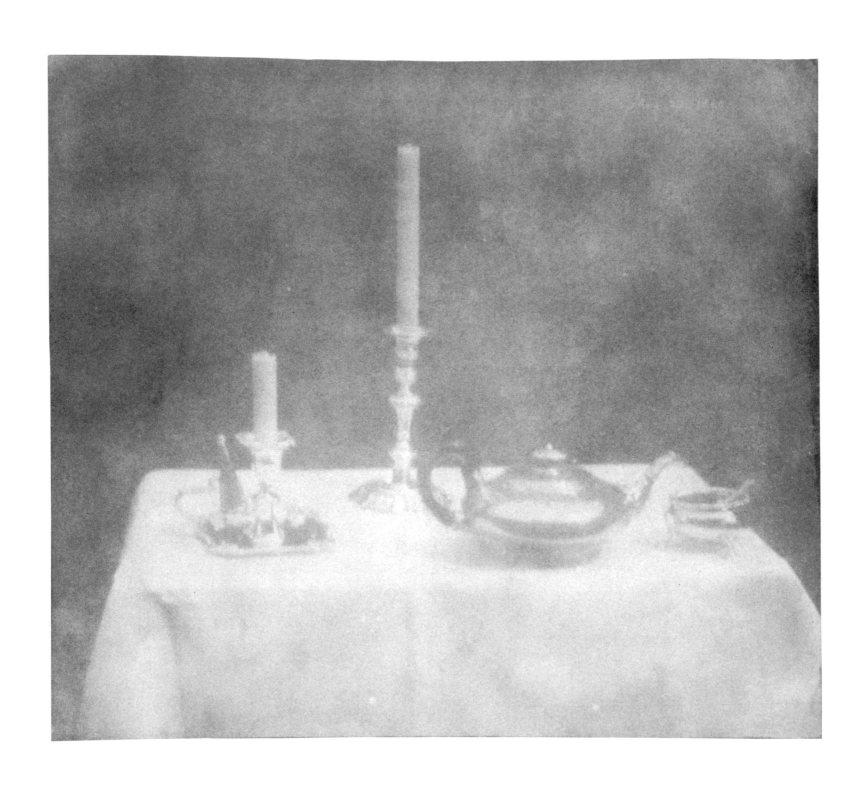

Domestic Interior Study
1840
Salt paper print from a calotype paper negative
18.7 x 23.1 cm

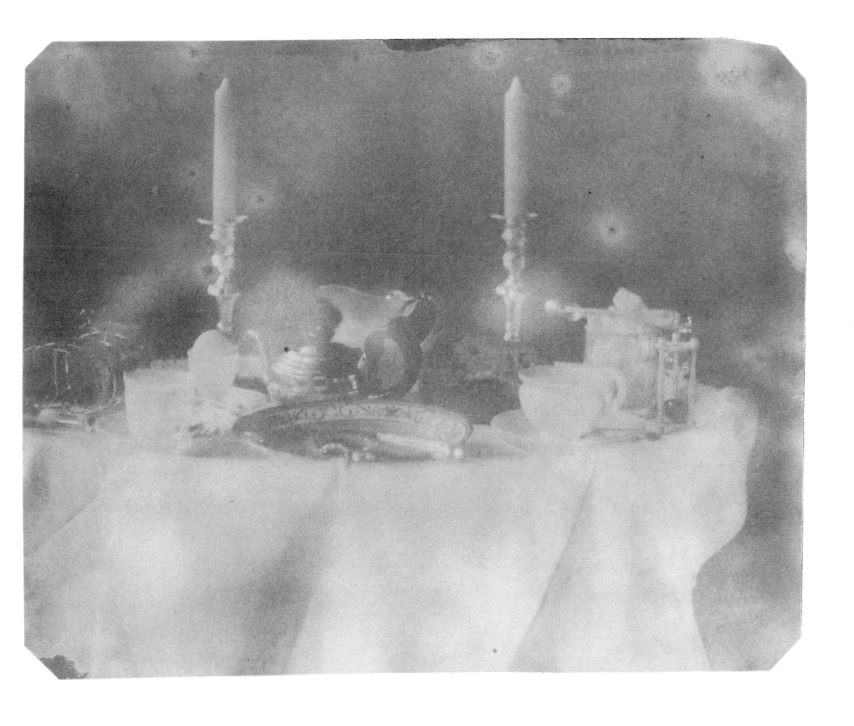

"Breakfast Table"
April 26, 1840
Digital facsimile made from unfixed, stabilized original
16.0 x 22.4 cm

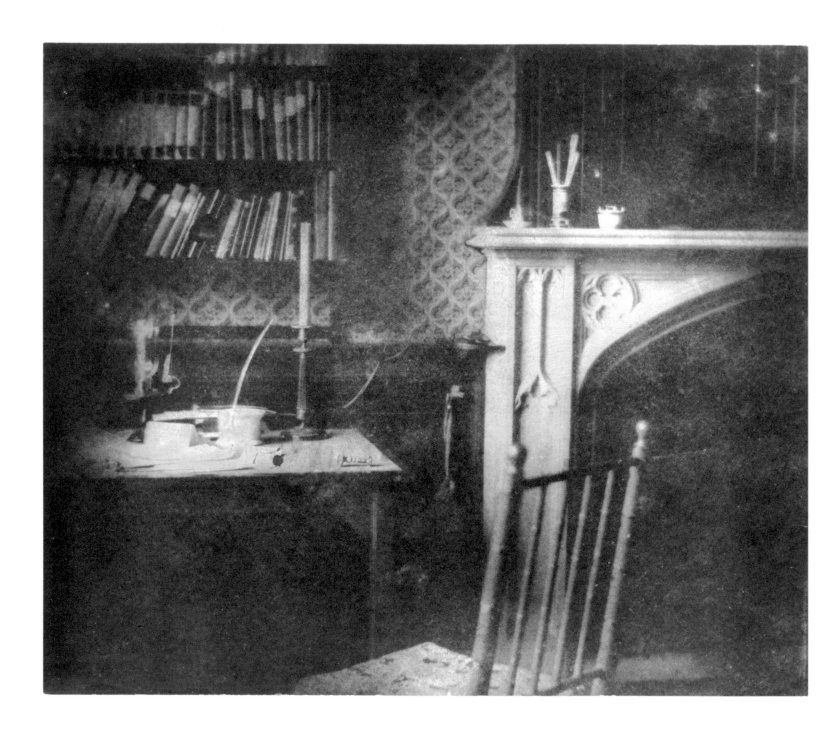

Top:
"Chimneypiece, South Gallery"
possibly October 8, 1840
Digital facsimile made from unfixed, stabilized original

Top right:
"China on Two Shelves"
Lacock, England, early 1840s
Salt paper print from a calotype paper negative
19.0 x 23.0 cm

Bottom right:
"The Milliner's Window"
Lacock Abbey, Cloister Court, Lacock, England, possibly June 1844
Salt paper print from a calotype paper negative
18.6 x 22.3 cm

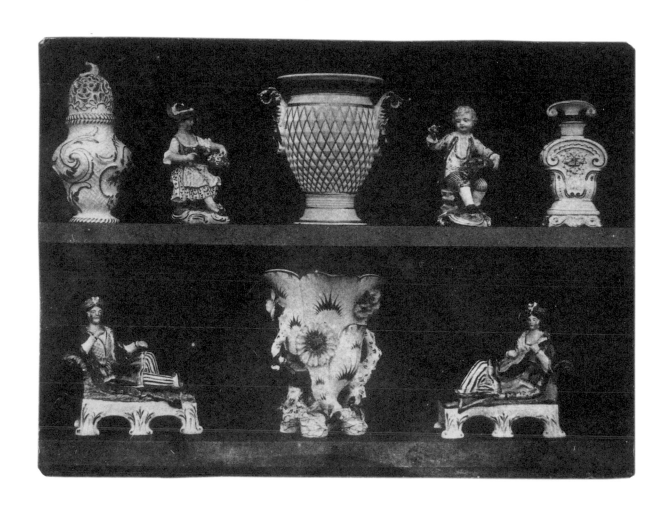

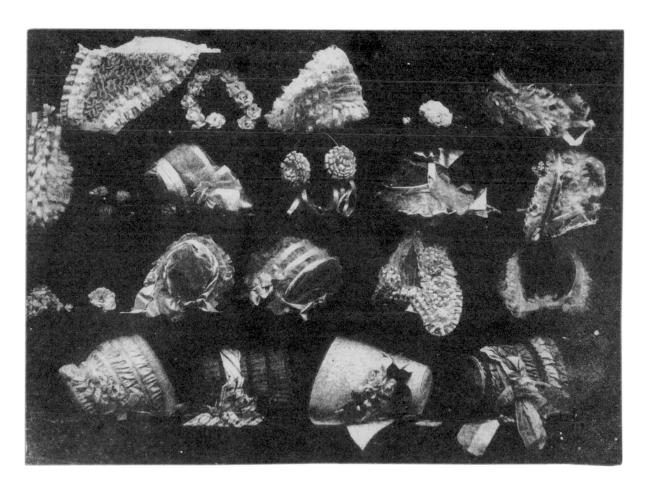

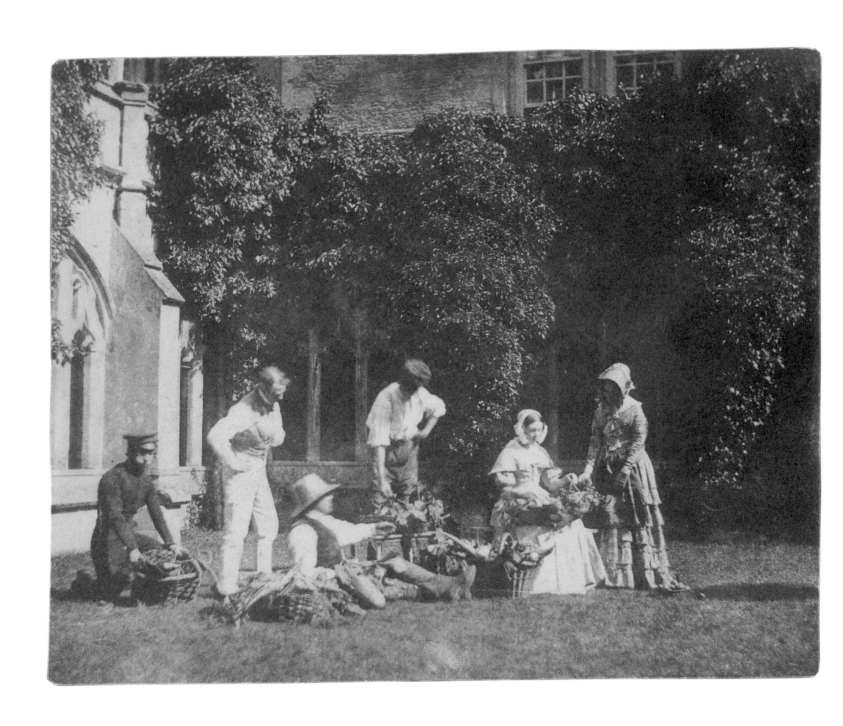

"The Fruit Sellers"
Lacock, England, early 1840s
Salt paper print from a calotype paper negative
18.5 x 22.5 cm

"The Woodcutters"
Lacock, England, early 1840s
Salt paper print from a calotype paper negative
18.8 x 22.6 cm

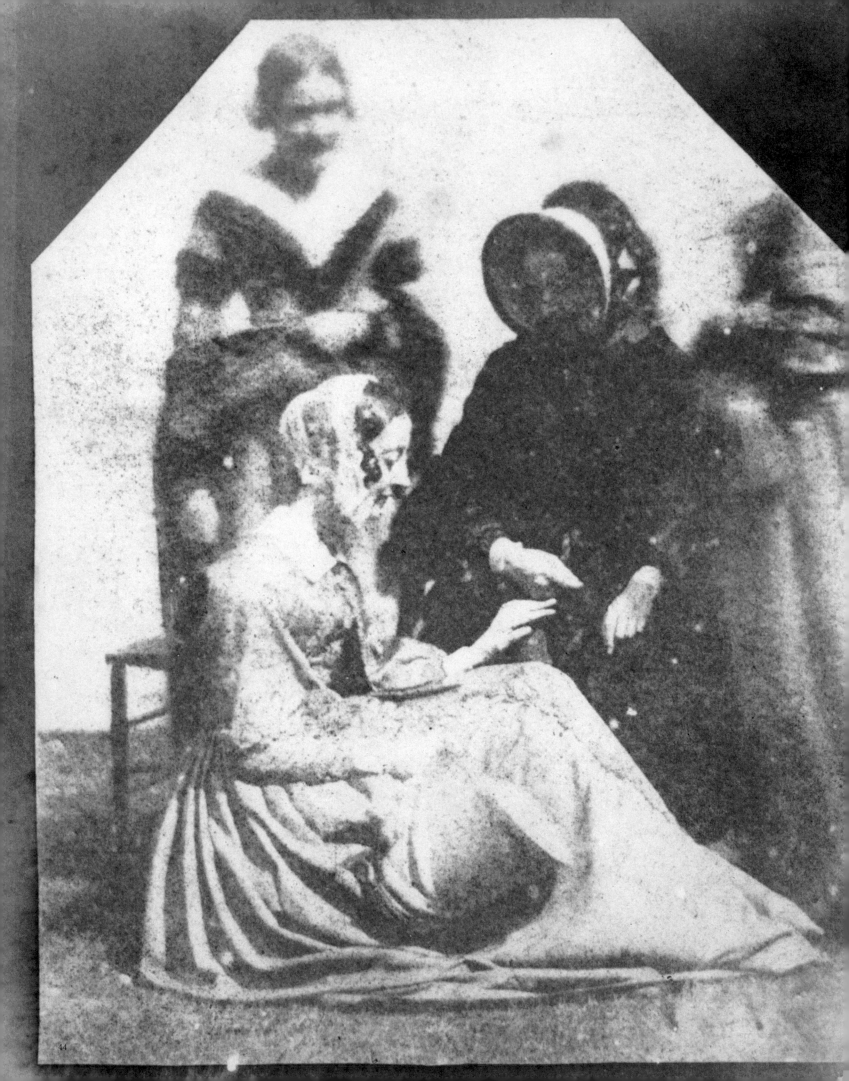

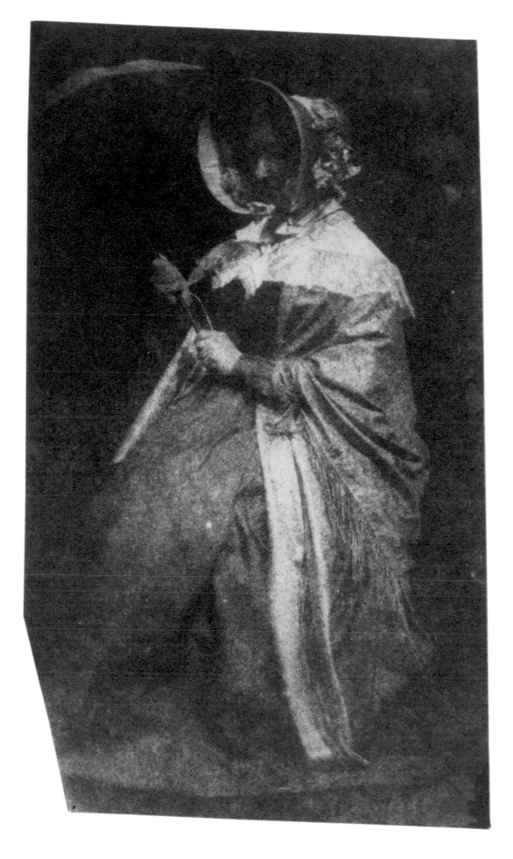

Left:
Portrait of Three Women, Fourth Woman Cropped Out, Horatia (Seated), Probably Lady Elisabeth (Right), Probably Caroline (Standing Left)
ca. 1843
Salt paper print from a calotype paper negative
16.5 x 13.0 cm

Top:
Lady Elisabeth with a Parasol
1841
Modern salt paper print from a calotype paper negative
15.7 x 9.1 cm (original negative image area)

Henrietta Horatia Maria Feilding
Lacock, England, mid 1840s
Salt paper print from a calotype paper negative
11.5 x 9.5 cm

Henrietta Horatia Maria Feilding
Lacock, England, mid 1840s
calotype paper negative
11.5 x 9.5 cm

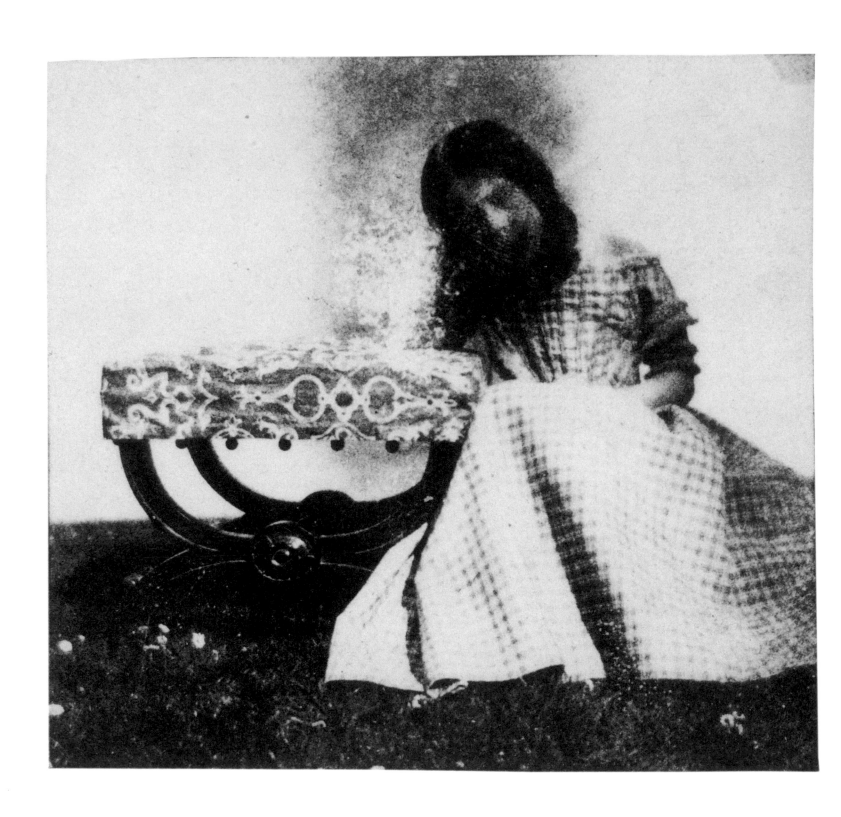

Rosamond Constance Talbot
Lacock, England, early 1840s
Salt paper print from a calotype paper negative
11.6 x 9.4 cm

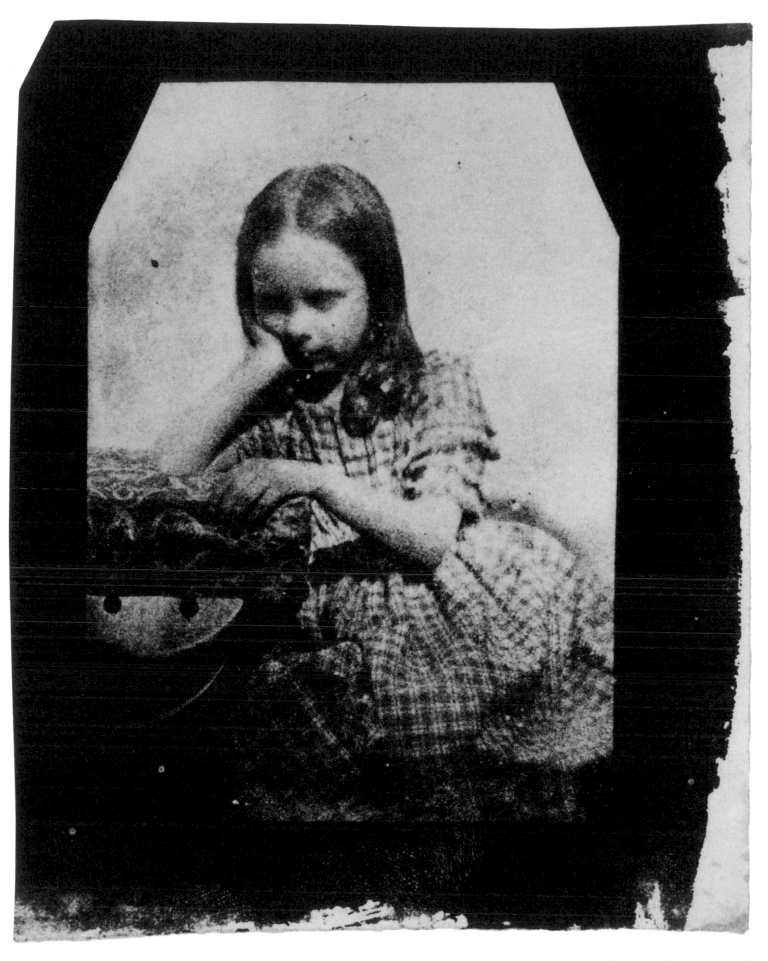

Rosamond Constance Talbot
Lacock, England, early 1840s
Salt paper print from a calotype paper negative
10.2 x 11.5 cm

Men of Science & the Reading Establishment

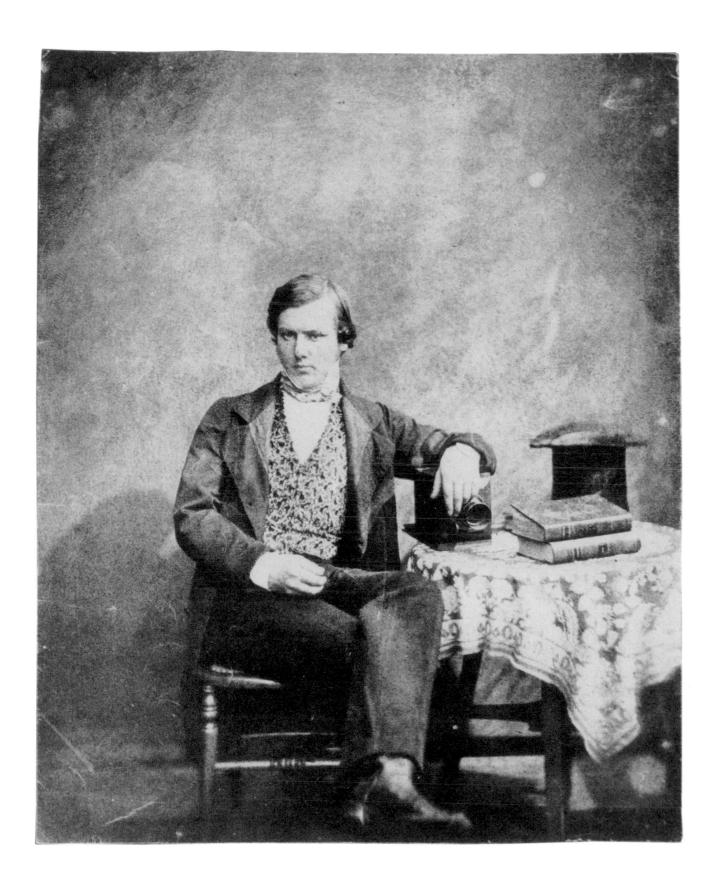

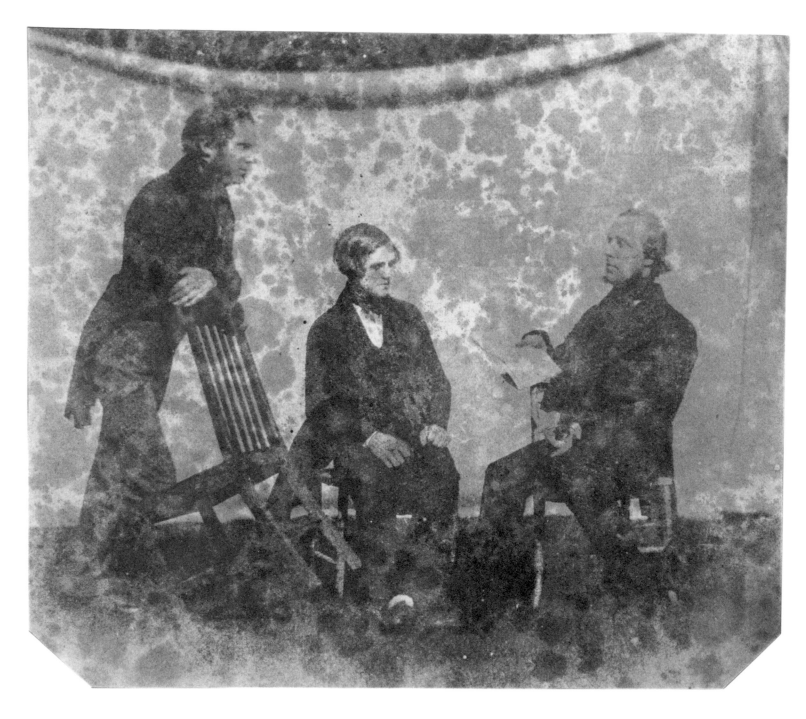

Previous page:
Portrait of Neville Story-Maskelyne
Regent Street, London, England, 1844-46
Modern salt paper print from the original calotype paper negative
22.1 x 16.6 cm

Top:
John Frederick Goddard Addresses Charles Porter and Nicolaas Henneman
April 8, 1842
Salt paper print from a calotype paper negative (hypo-fixed)
Collection of Michael Mattis and Judith Hochberg
18.8 x 22.7 cm

Top right:
John Frederick Goddard Addresses Charles Porter and Nicolaas Henneman
April 8, 1842
Salt paper print from a calotype paper negative (iodine-fixed)
Collection of Michael Mattis and Judith Hochberg
18.7 x 22.7 cm

Bottom right:
John Frederick Goddard Addresses Charles Porter and Nicolaas Henneman
April 8, 1842
Salt paper print from a calotype paper negative (salt-fixed)
Collection of Michael Mattis and Judith Hochberg
18.8 x 22.6 cm

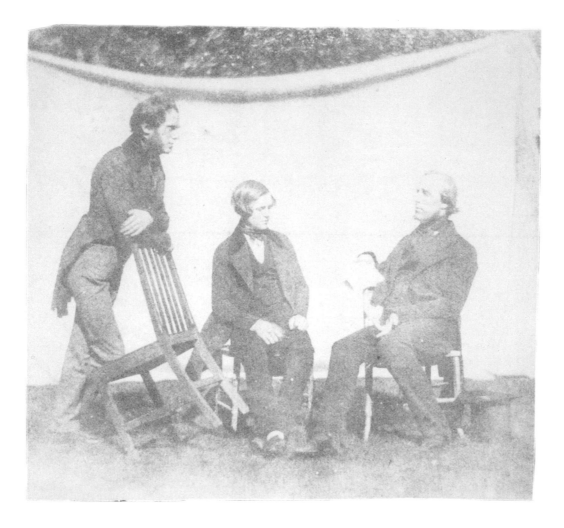

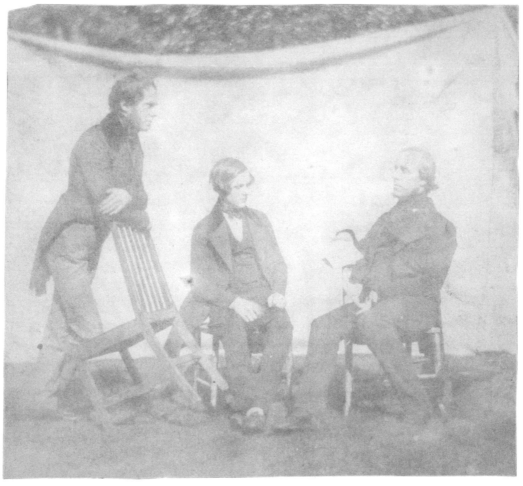

53

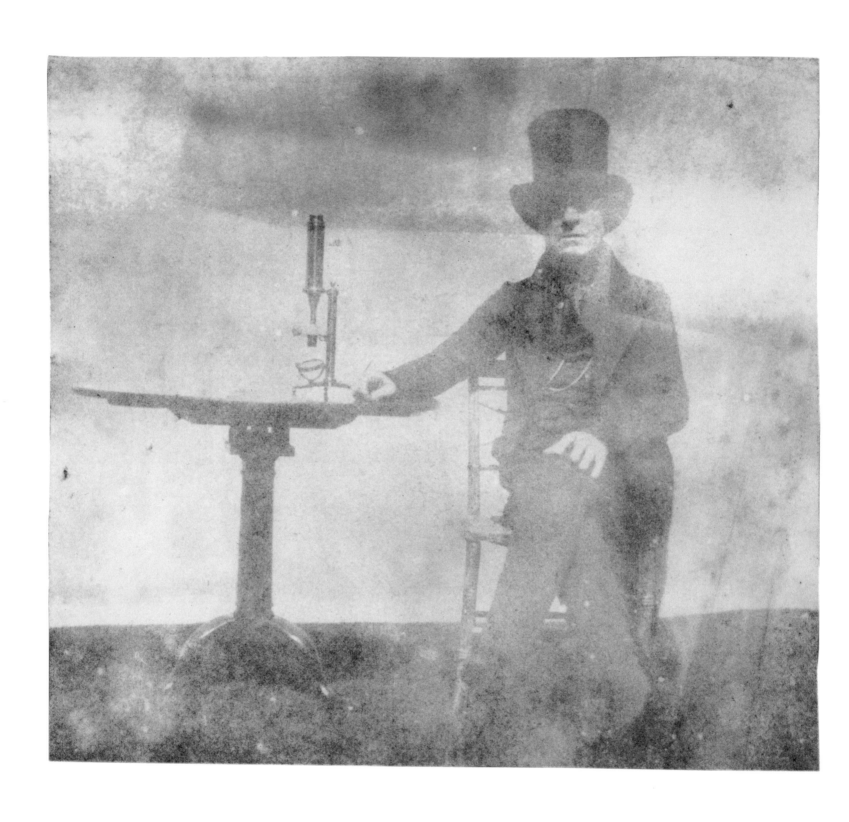

Sir David Brewster with Talbot's Microscope
July 1842
Salt paper print from a calotype paper negative
Collection of Michael Mattis and Judith Hochberg
18.8 x 22.6 cm

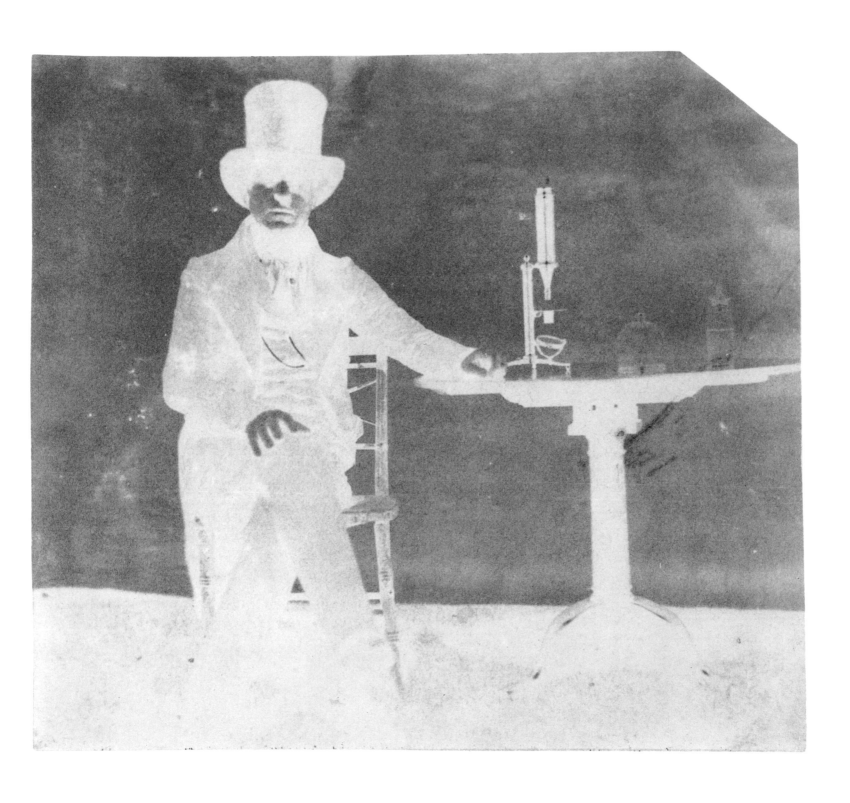

Sir David Brewster with Talbot's Microscope
July 1842
Calotype paper negative
Collection of Michael Mattis and Judith Hochberg
13.2 x 14.4

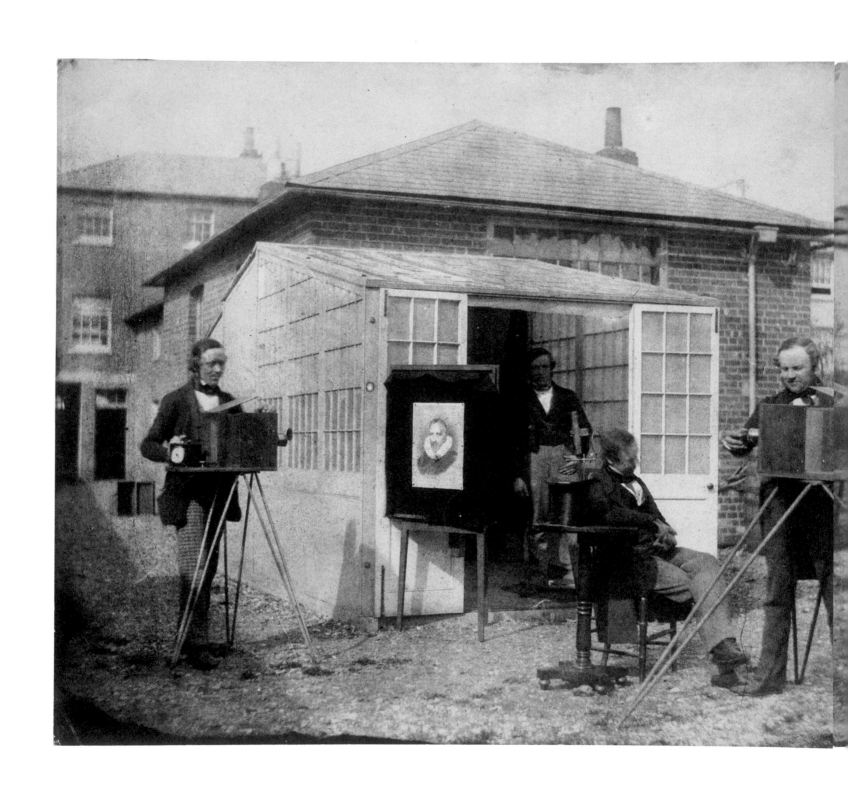

"The Reading Establishment," Panorama (Parts 1 and 2)
William Henry Fox Talbot and Nicolaas Henneman
Printing Works, Reading, England, 1846
Sulphide-toned gelatin silver print from the original calotype paper negative
Printed by Herbert Lambert of Bath, 1921 or 1934
18.0 x 20.5 cm (part 1)
18.0 x 20.5 cm (part 2)

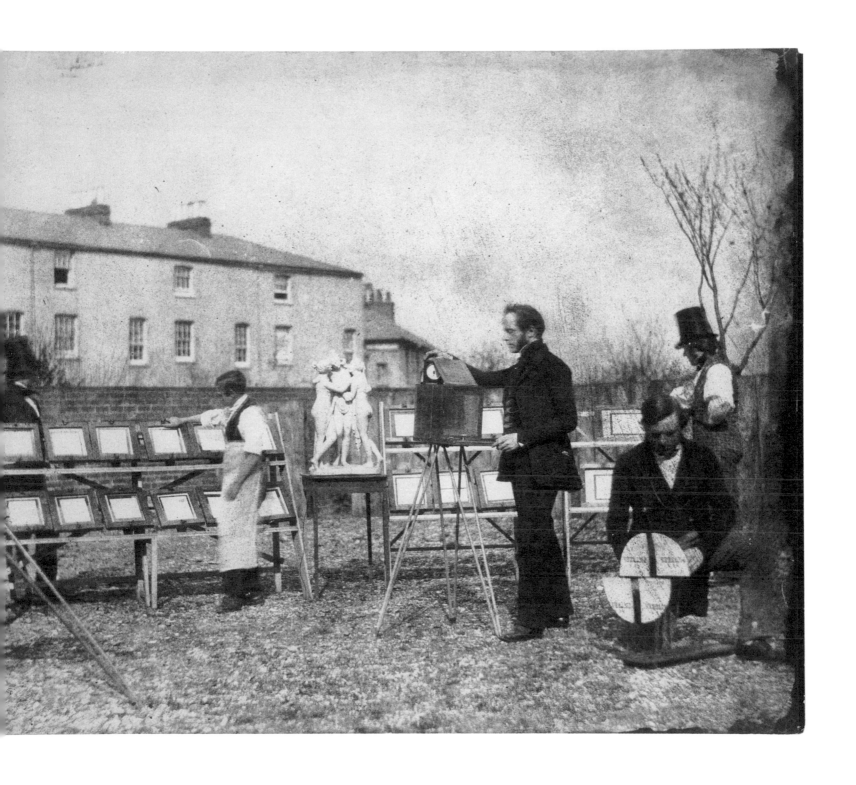

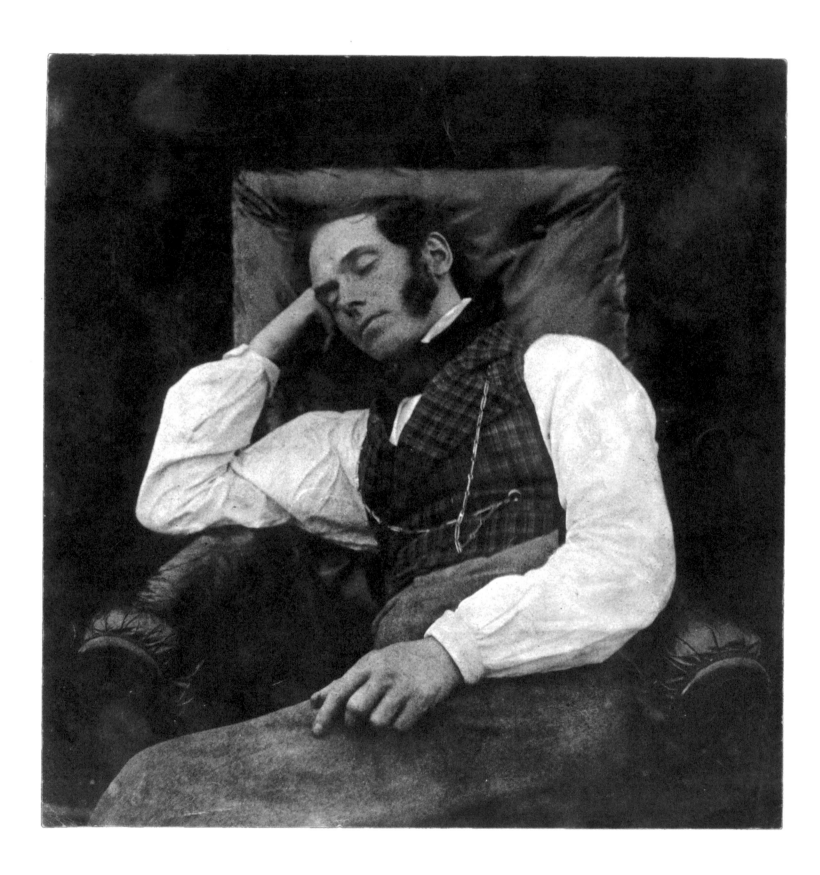

Nicolaas Henneman, Asleep
William Henry Fox Talbot and possibly Antoine Claudet
Lacock or Reading, England, early 1844-45
Modern salt paper print from the original calotype paper negative
15.3 x 14.7 cm

Nicolaas Henneman, Asleep
William Henry Fox Talbot and possibly Antoine Claudet
Lacock or Reading, England, early 1844-45
Calotype paper negative
15.3 x 14.7 cm

Unknown Male
Lacock, England, mid 1840s
Salt paper print from a calotype paper negative
9.8 x 8.6 cm

Edward Anthony
Nicolaas Henneman
London, England, after 1847
Salt paper print from a calotype paper negative
9.0 x 7.4 cm

The Pencil of Nature

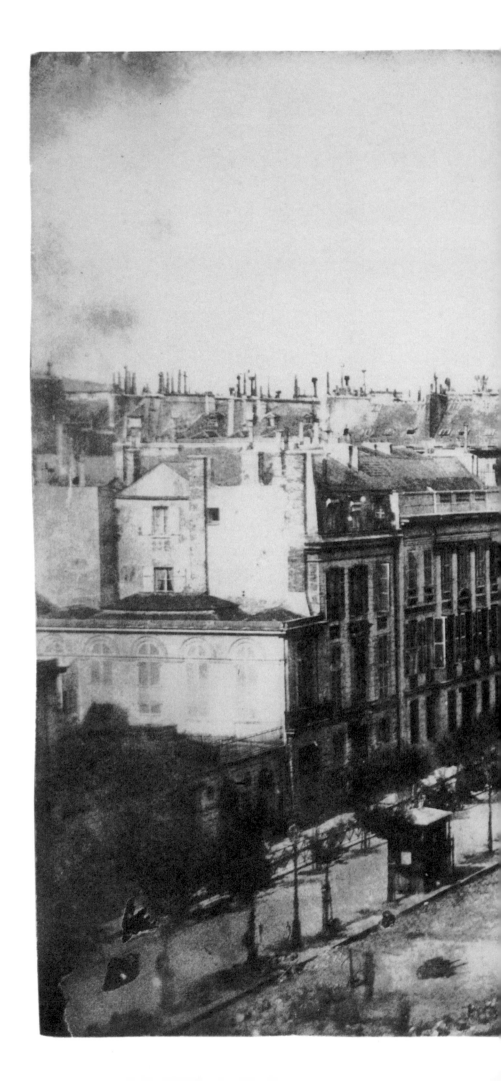

Previous page:

Part of Queens College, Oxford
September 4, 1843
Plate I, From *The Pencil of Nature*
Salt paper print from a calotype paper negative
18.8 x 22.5 cm

View of the Boulevards of Paris
May 1843
Plate II, From *The Pencil of Nature*
Salt paper print from a calotype paper negative
18.7 x 22.6 cm

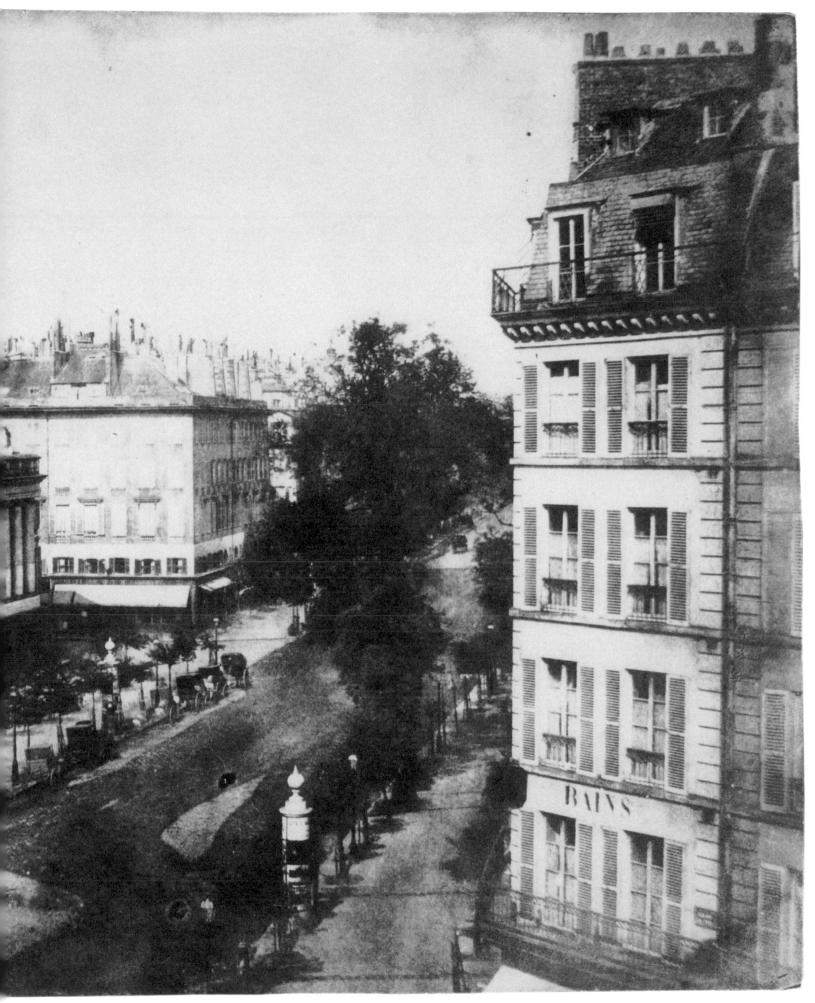

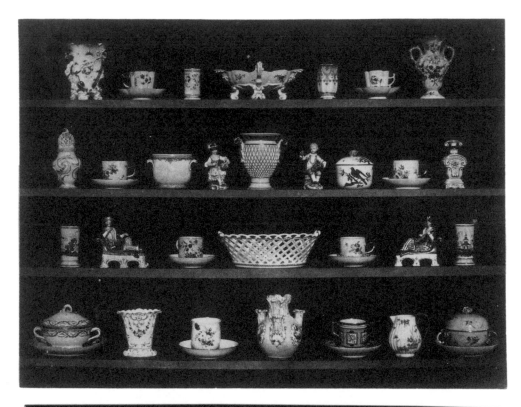

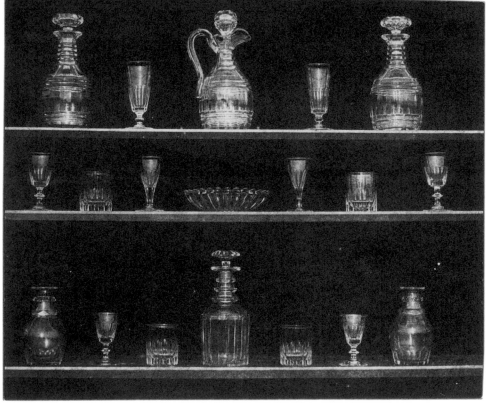

Top:
Articles of China
before January 1844
Plate III, From *The Pencil of Nature*
Salt paper print from a calotype paper negative
13.6 x 17.9

Bottom:
Articles of Glass
before June 1844
Plate IV, From *The Pencil of Nature*
Salt paper print from a calotype paper negative
18.9 x 23.2 cm

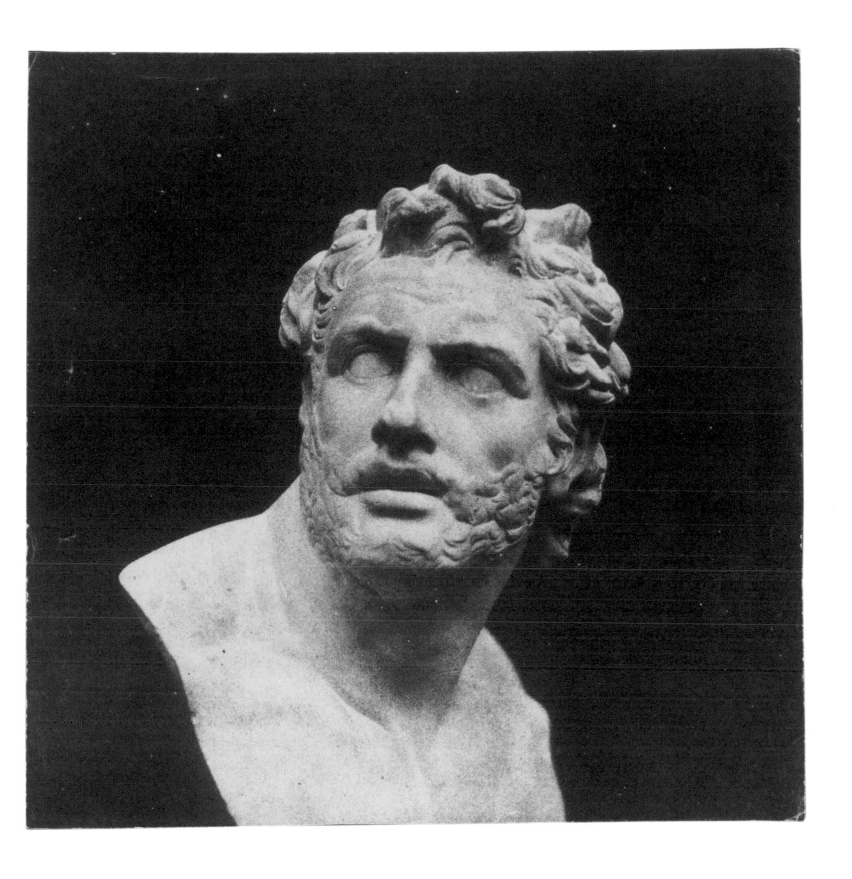

Bust of Patroclus
August 9, 1842
Plate V, From *The Pencil of Nature*
Salt paper print from a calotype paper negative
22.4 x 18.5 cm

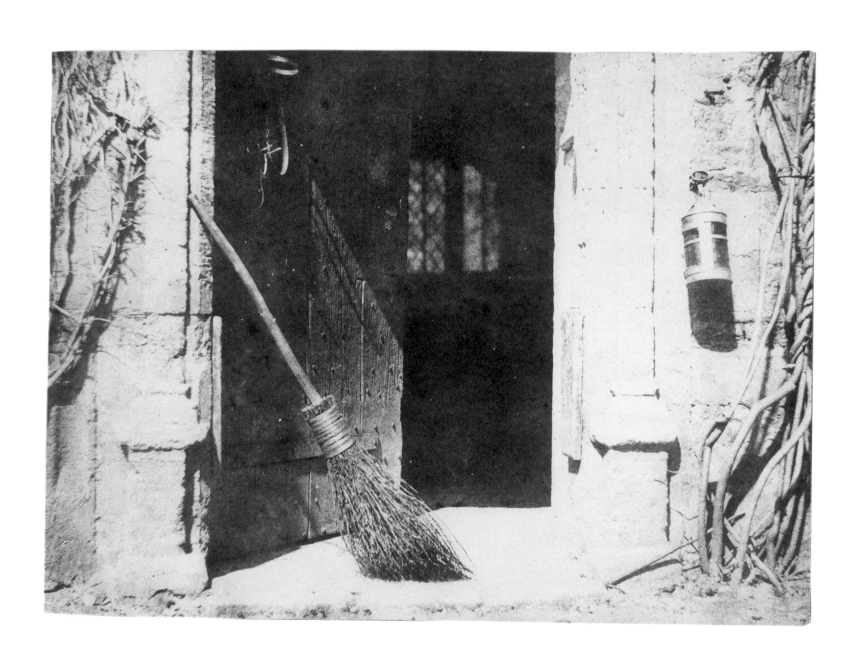

The Open Door
before May 1844
Plate VI, From *The Pencil of Nature*
Salt paper print from a calotype paper negative
18.6 x 22.3 cm

68

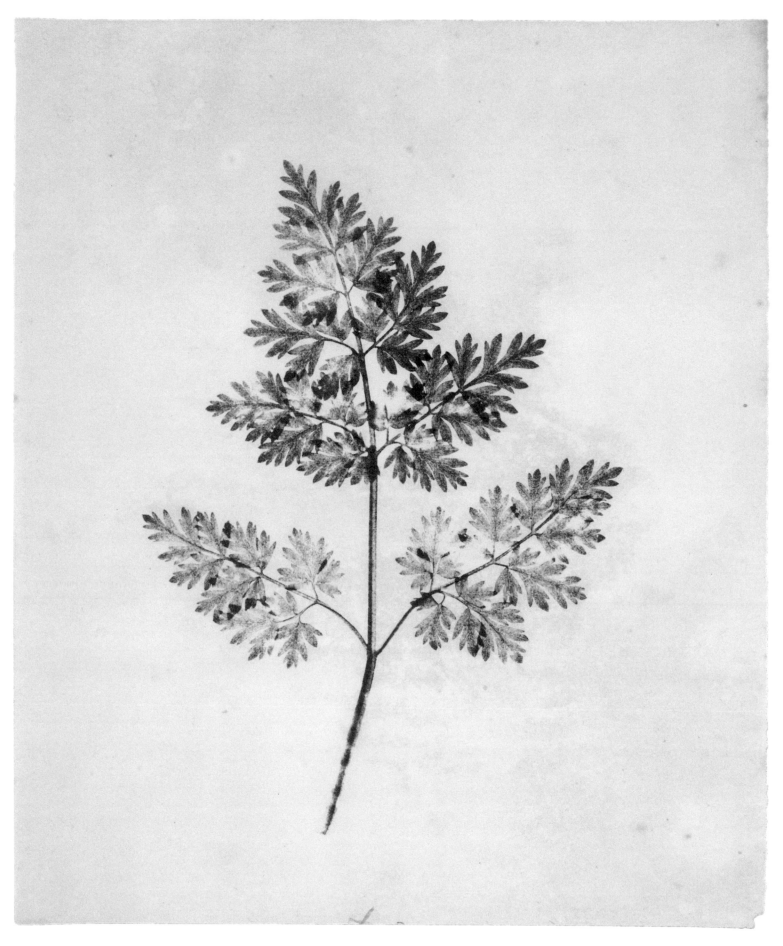

Leaf of a Plant, Negative
before February 14, 1844
Plate VII, From *The Pencil of Nature*
Salt paper print from a photogenic drawing paper negative
23.0 x 18.6 cm

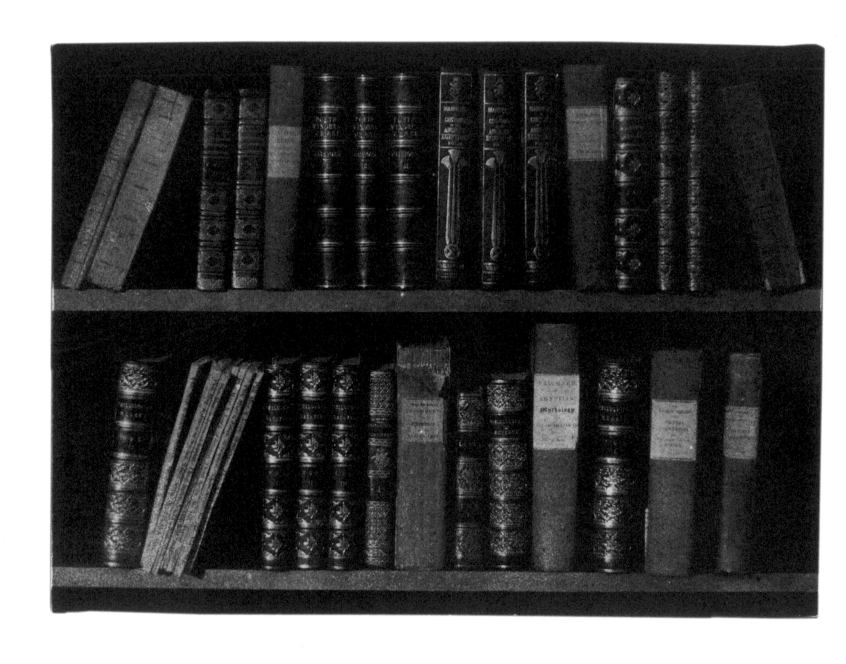

A Scene in a Library
before March 22, 1844
Plate VIII, From *The Pencil of Nature*
Salt paper print from a calotype paper negative
19.0 x 23.4 cm

Ricardi secundi

suruefer lez gortz molyns estankes estakes ⁊ kydeur auncienement fait
tes ⁊ leuez duraunt le dit temps du Roy Edward fitz au roy Henry
⁊ ceux qui trouerent trop enhauntz ou estretz de lez corriger abater ⁊ a
mendr en le manere ⁊ fourme suisoitz Saluaunt toutz foitz resonable
substaunce de lez dites gortz molyns estankez estakez ⁊ kideur suis
dites issint auncienement faites ⁊ leuez Et si ascuns tielx auoisancez dez
gortz molyns estankes estakes ⁊ kideur dez passagez ⁊ estroiturez aun
cienement faitz ⁊ leuez soient adiuggez ou agardez per lez ditz iustices
destre abatus ⁊ amendez celluy qui adr le fraunktenement dicell ferra
ent execucion a sez costagez deins vne demy an apres notificacion a luy
ent affaire sur peyne de C marcz a paiers au roy per lestretes en lescheqer
Et celluy qui lez face releuer ou enhauncer ou estretetz eucounter le dite
iugement ⁊ de ceo soit duement conuict encourge la peyne de C marces
apaiers au Roy per lestretez de leschequer suisdit Et en cas que ascun se
sente estre greuez per execucion ou autre voie en celle partie encounter
droit ⁊ remedie ¶ Ca xx ¶ Item le roy per mesme lassent de lez di
tes seignours ⁊ Chiualers ensy assignez per la dite auctorite du perlemet
voet ⁊ ad ordines que chescune qui pcure ou pursue de repeller ou reuer
ser ascuns dez dites estatuites ou ordinaunces faitz per le roy de lassnt dez
ditz seignours ⁊ chiualers issint assignez per poair ⁊ auctorite du perle
ment ⁊ ceo duement peue en perlement que il soit adiuggez ⁊ eit execu
cion come traitour au roy ⁊ a roialme en mesme le manere come ceux
qi pursuont ou pcuront de repeller lez estatuitz ⁊ ordinaunces faitz en le
temps du dit perlement duraunt

Expliciunt statuta Regis Ricardi secundi

Facsimile of an Old Printed Page
before August 1839
Plate IX, From *The Pencil of Nature*
Salt paper print from a calotype paper negative
22.2 x 17.8 cm

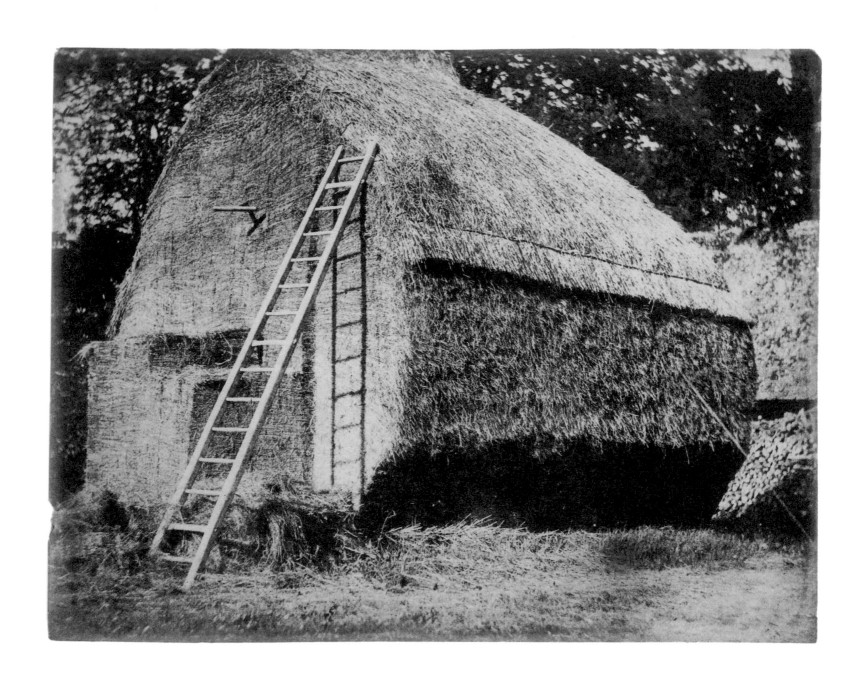

The Haystack
ca. 1841
Plate X, From *The Pencil of Nature*
Salt paper print from a calotype paper negative
16.2 x 21.0 cm

Copy of a Lithographic Print
before May 1844
Plate XI, From *The Pencil of Nature*
Salt paper print from a calotype paper negative
18.8 x 23.2 cm

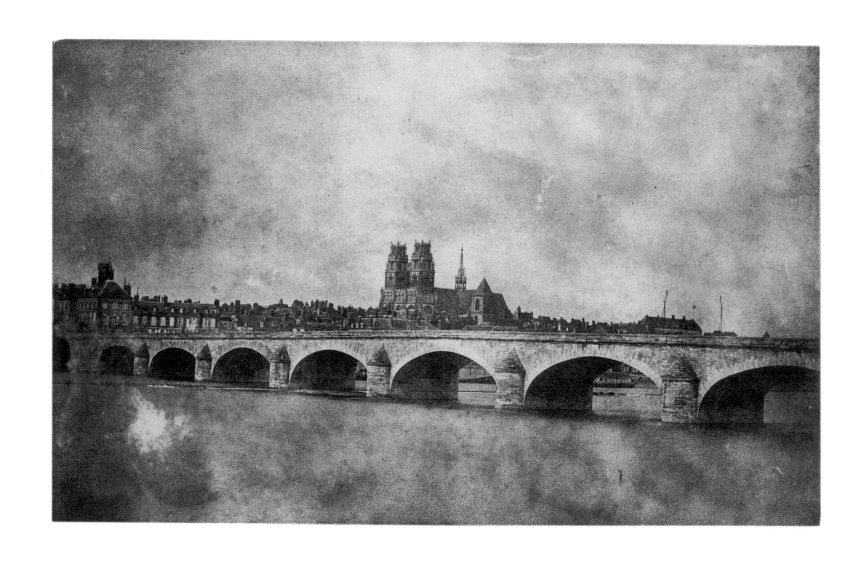

The Bridge at Orleans
June 14, 1843
Plate XII, From *The Pencil of Nature*
Salt paper print from a calotype paper negative
18.5 x 22.7 cm

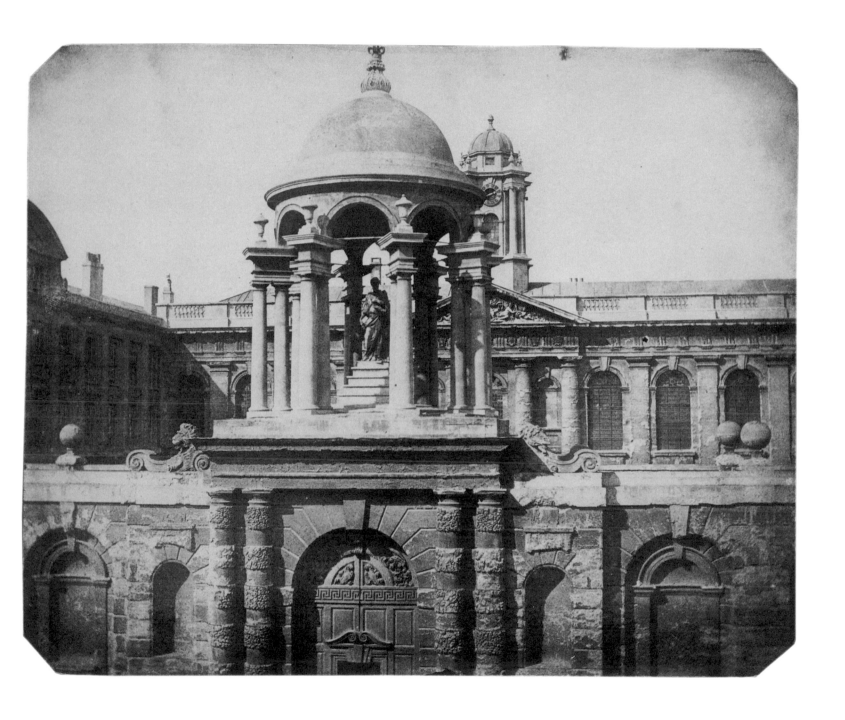

Queens College, Oxford, Entrance Gateway
April 9, 1843
Plate XIII, From *The Pencil of Nature*
Salt paper print from a calotype paper negative
19.5 x 24.7 cm

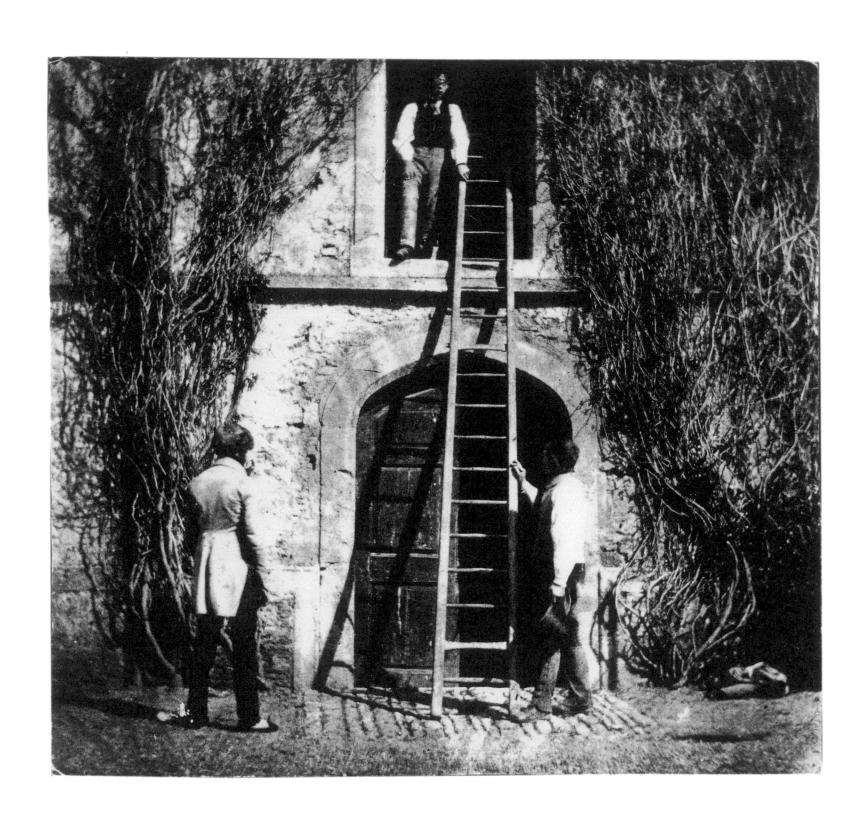

The Ladder
before April 1845
Plate XIV, From *The Pencil of Nature*
Salt paper print from a calotype paper negative, marked verso: IHW (Intensified Harold White)
22.5 x 18.7 cm

Lacock Abbey in Wiltshire
before September 1844, possibly May 1840
Plate XV, From *The Pencil of Nature*
Salt paper print from a calotype or photogenic drawing paper negative
19.3 x 24.1 cm

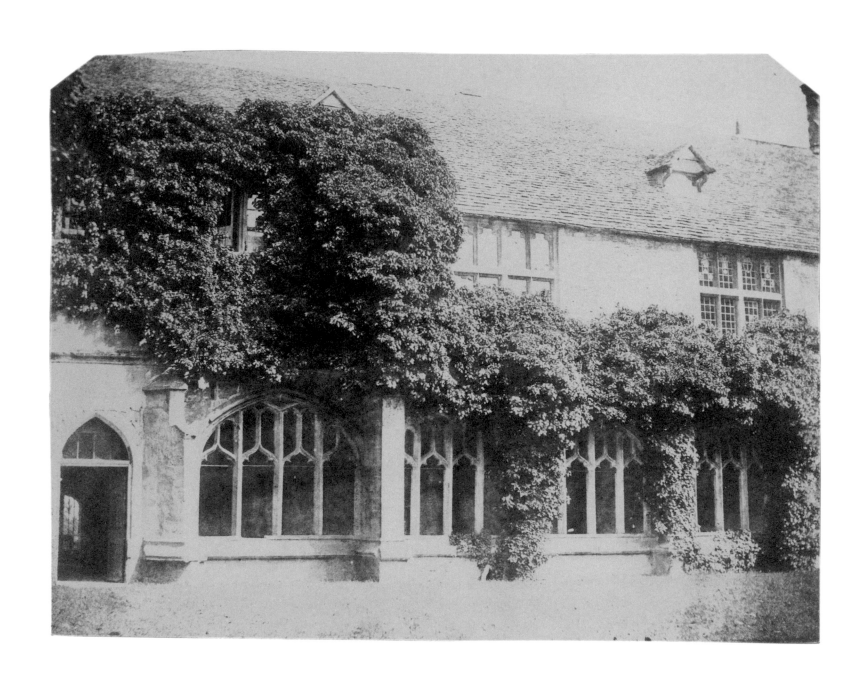

Cloisters of Lacock Abbey
1842
Plate XVI, From *The Pencil of Nature*
Salt paper print from a calotype paper negative
19.5 x 24.4 cm

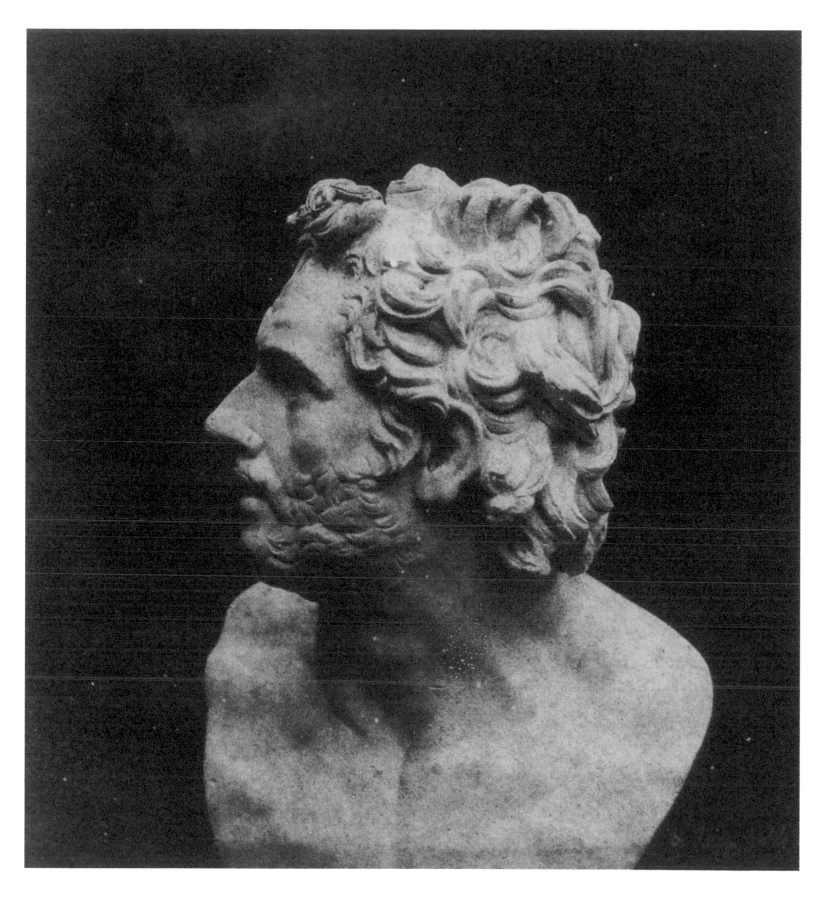

Bust of Patroclus
August 9, 1843
Plate XVII, From *The Pencil of Nature*
Salt paper print from a calotype paper negative
18.5 x 15.0 cm

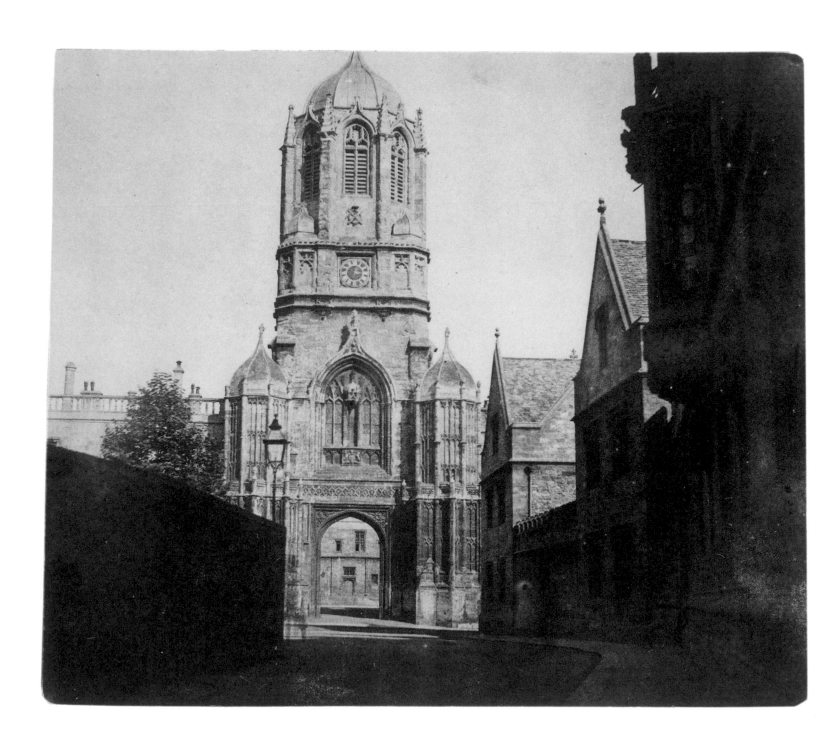

Gate of Christchurch
before September 1844
Plate XVIII, From *The Pencil of Nature*
Salt paper print from a calotype paper negative
18.4 x 22.4 cm

80

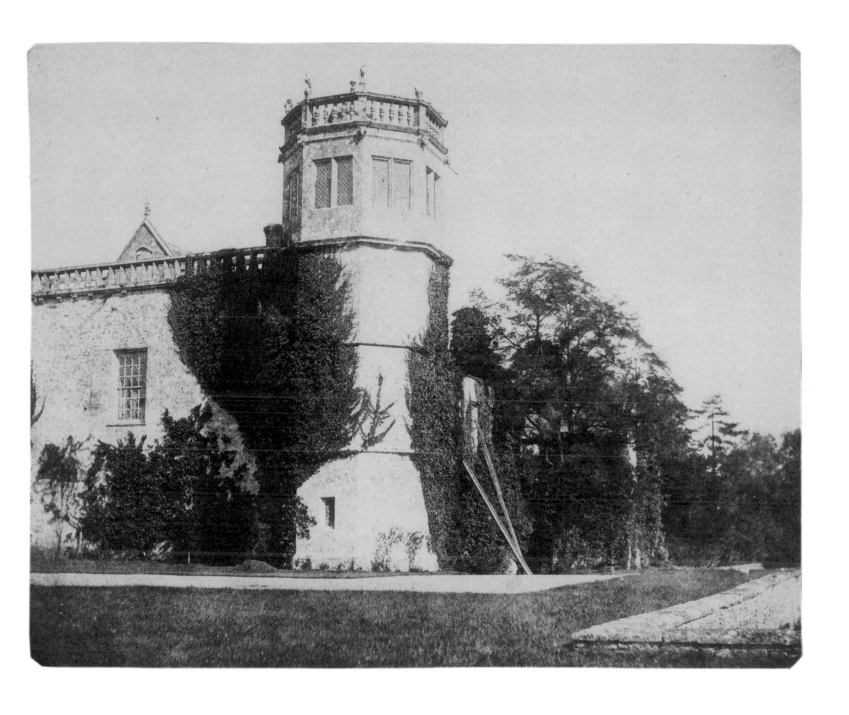

The Tower of Lacock Abbey
before February 1845
Plate XIX, From *The Pencil of Nature*
Salt paper print from a calotype paper negative
18.7 x 22.5 cm

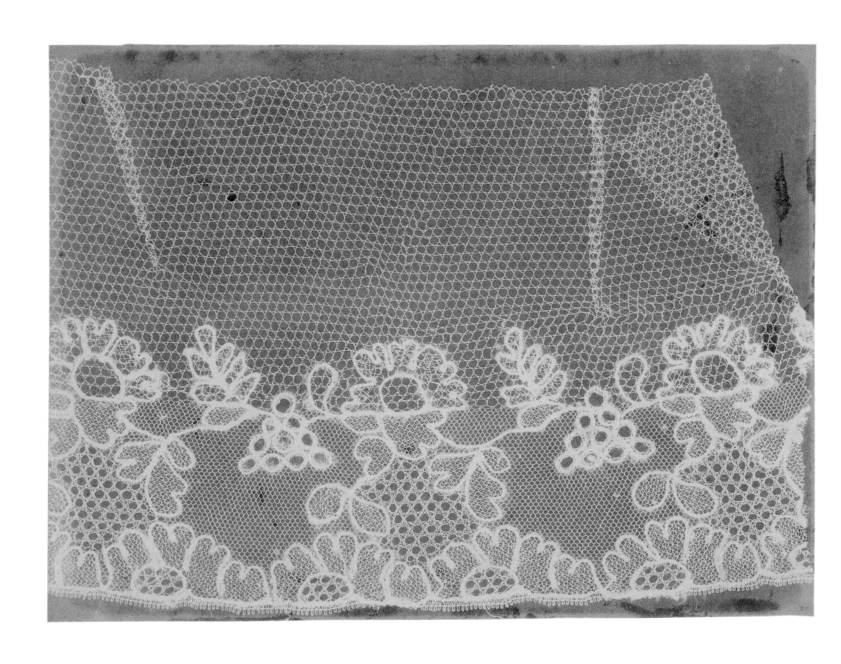

Lace
before February 1845
Plate XX, From *The Pencil of Nature*
Photogenic drawing negative, contact print made from an original piece of lace
15.9 x 21.3 cm

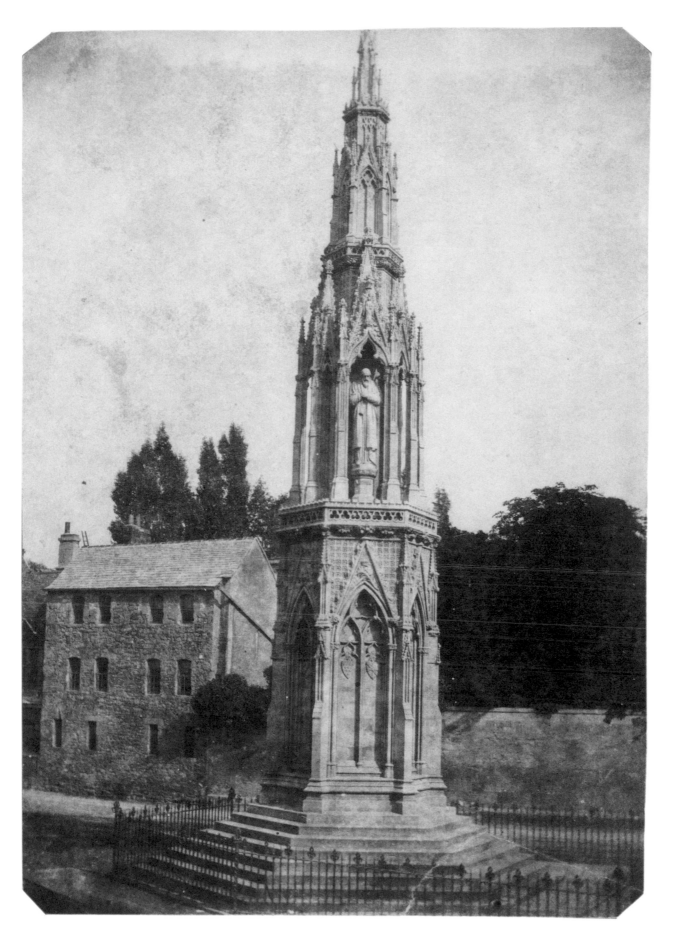

The Martyrs' Monument
September 7, 1843
Plate XXI, From *The Pencil of Nature*
Salt paper print from a calotype paper negative
22.4 x 18.8 cm

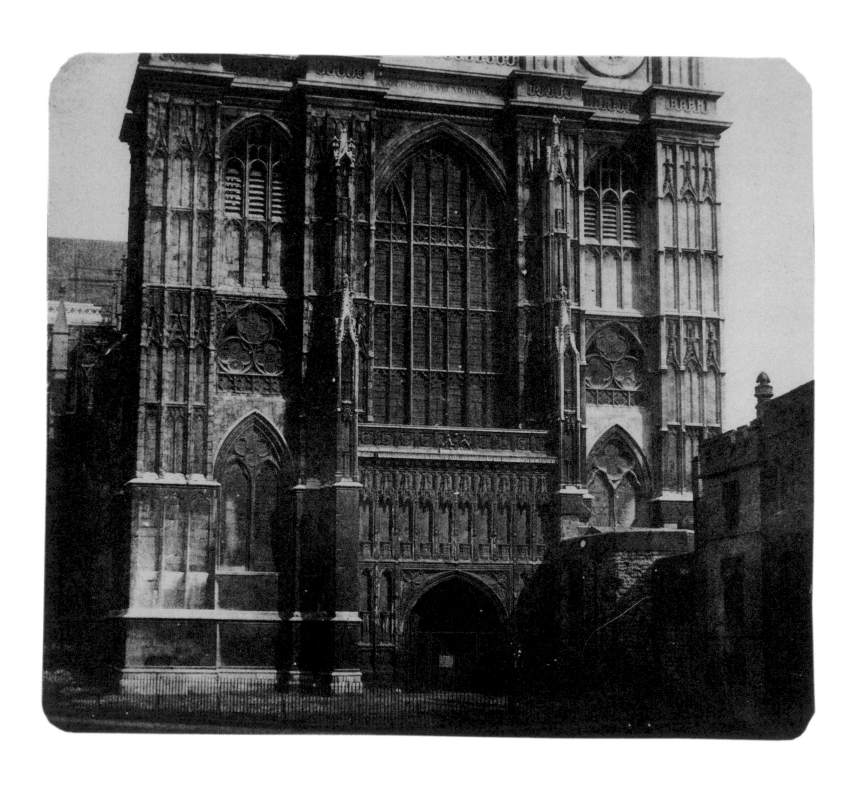

Westminster Abbey
before May 1844
Plate XXII, From *The Pencil of Nature*
Salt paper print from a calotype paper negative
18.7 x 22.8 cm

Hagar in the Desert
before March 1844
Plate XXIII, From *The Pencil of Nature*
Salt paper print from a photogenic drawing negative
16.4 x 20.7 cm

A Fruit Piece
June 1845
Plate XXIV, From *The Pencil of Nature*
Salt paper print from a calotype paper negative
18.5 x 22.5 cm

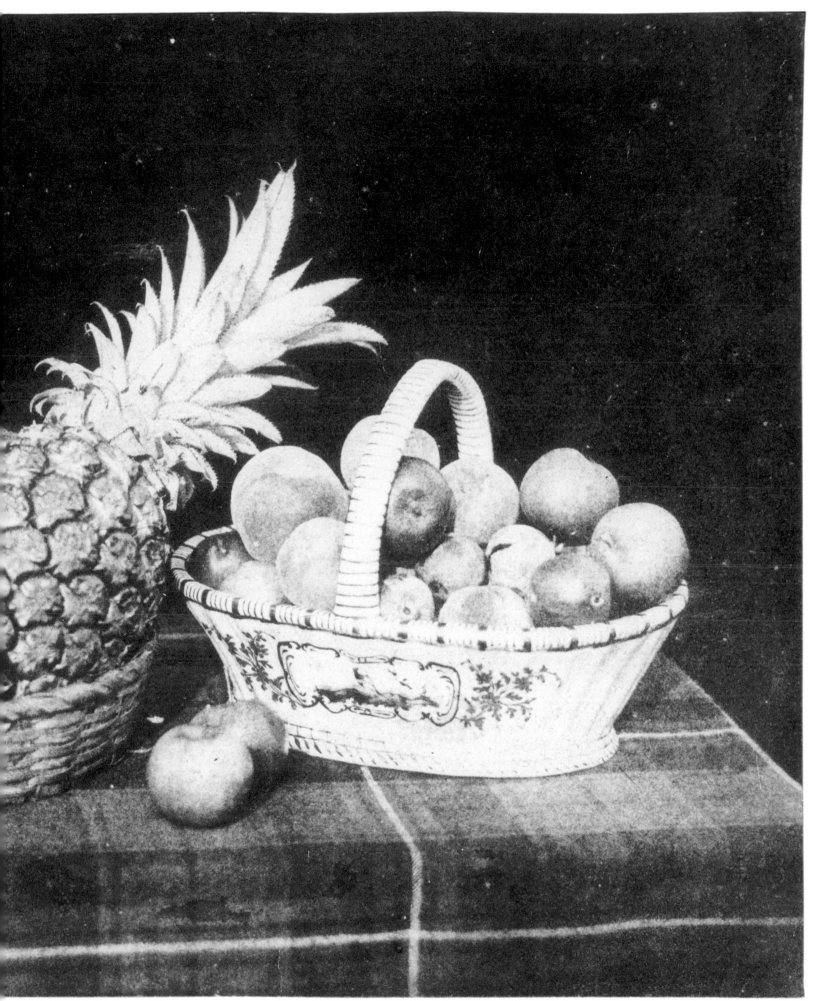

Objects of Admiration

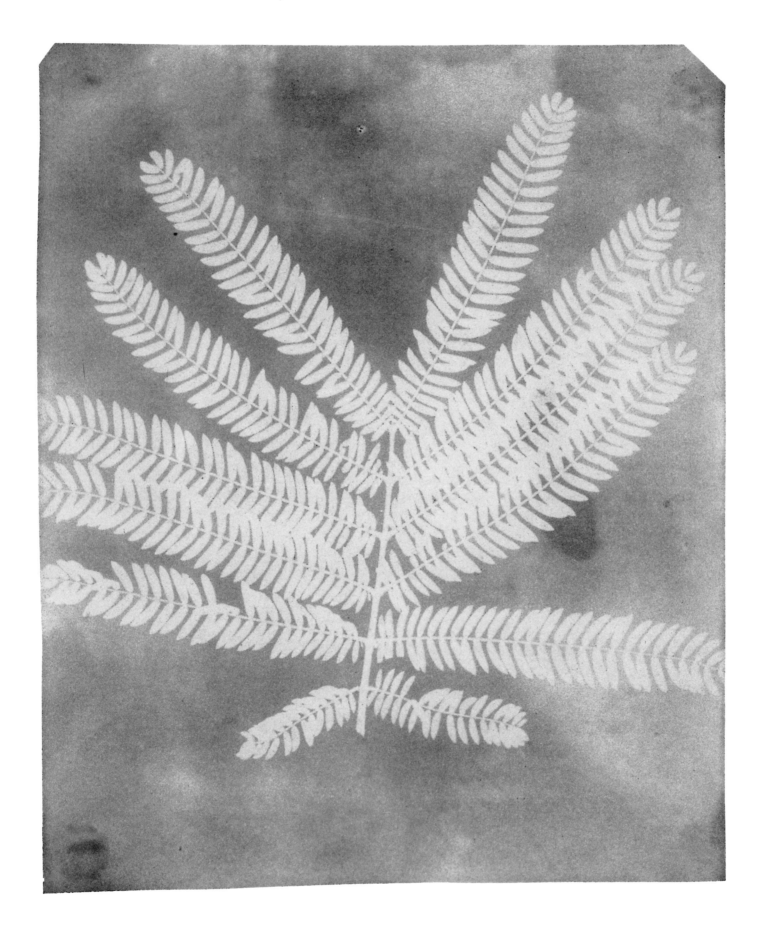

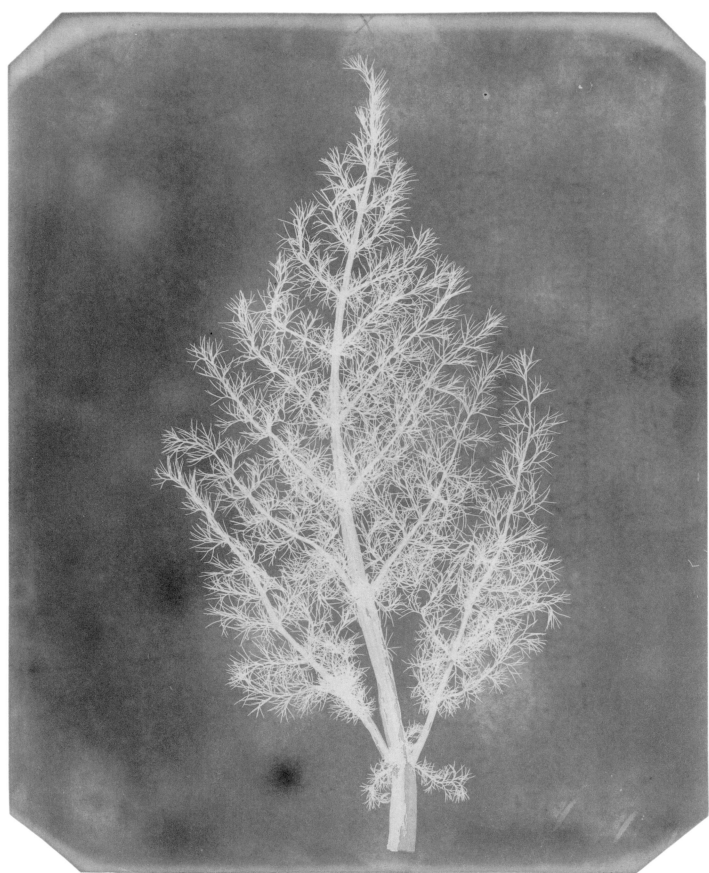

Previous page:
Photogenic Drawing, Sprig of Mimosa
1839-40
Digital facsimile made from unfixed, stabilized original
22.3 x 18.3 cm

Botanical Specimen, Sprig of Fennel
1839-40
Digital facsimile of an original salt-stabilized photogenic drawing negative
22.7 x 18.6 cm

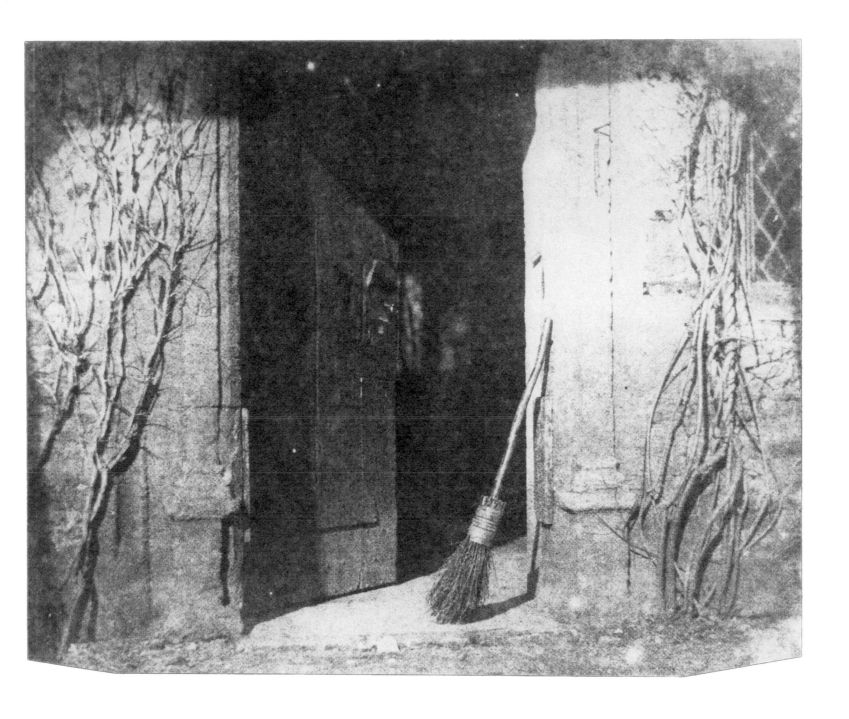

"The Soliloquy of the Broom"
Lacock Abbey, ca. 1843
Salt paper print from a calotype paper negative
18.6 x 22.4 cm

Top:
"5 cloudy, Sept. 1840"
Lacock Abbey Medieval Courtyard, Lacock, England, September (23rd?) 1840
Digitally generated negative image, location of original unknown
11.5 x 8.6 cm

Bottom:
"5 cloudy, Sept. 1840"
Lacock Abbey Medieval Courtyard, Lacock, England, September (23rd?) 1840
Digital facsimile of an original salt-stabilized paper print
11.5 x 8.6 cm

"Diogenes, without Sun, 17"
Lacock, Engand, early 1840s
Modern salt paper print from the original calotype paper negative
11.9 x 11.0 cm

Three Statues in the Grass
Cloister Court, Lacock Abbey, Summer 1840
Photogenic drawing from a camera paper negative

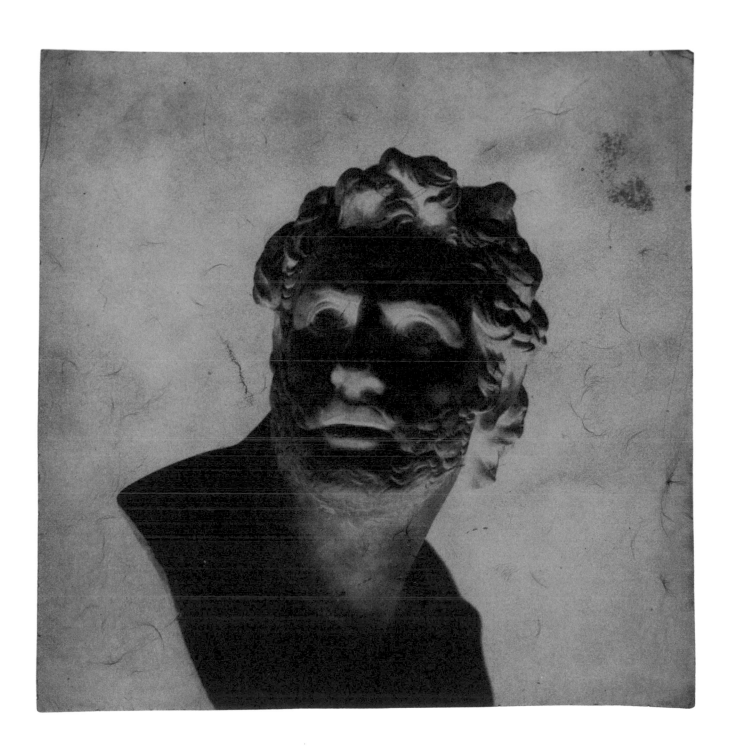

Bust of Patroclus
Lacock Abbey, Cloister Court, Lacock, England, early 1840s
Calotype paper negative
17.8 x 17.7 cm

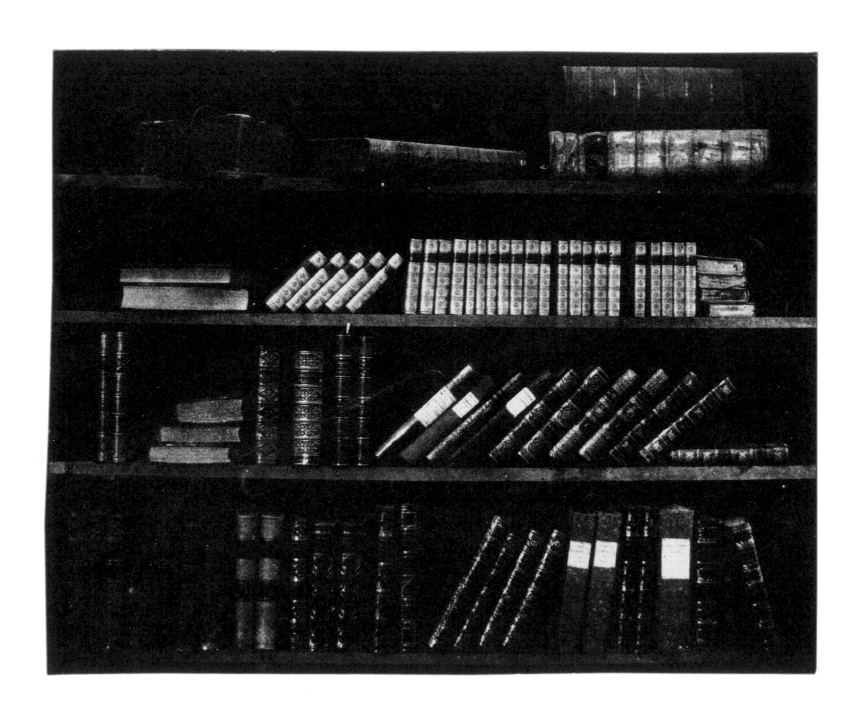

Four Shelves of Books
(Compositional Variant of Plate VIII, from *The Pencil of Nature*)
before March 22, 1844
Salt paper print from a calotype paper negative
18.8 x 23.0 cm

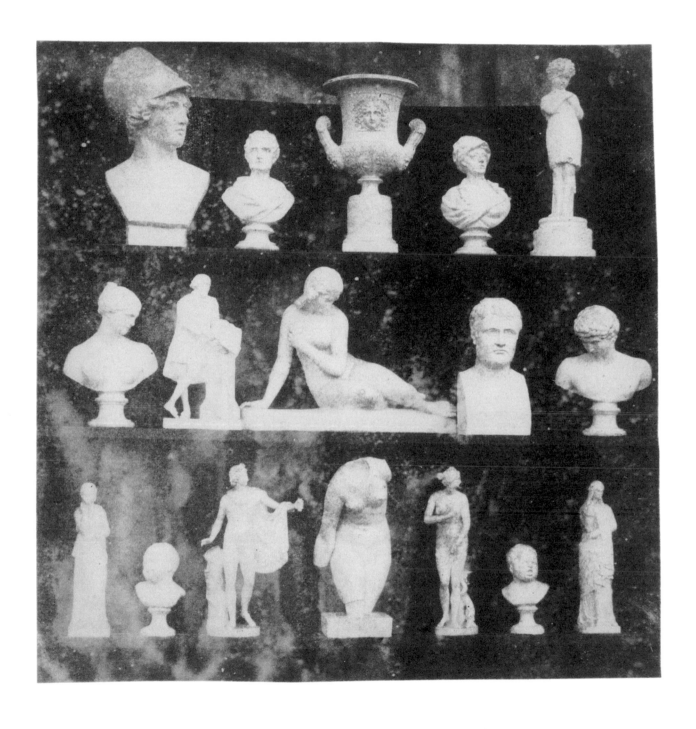

Statuary, Seventeen Items
Lacock Abbey, Cloister Court, Lacock, England, possibly May 1843
Salt paper print from a calotype paper negative
14.7 x 14.3 cm

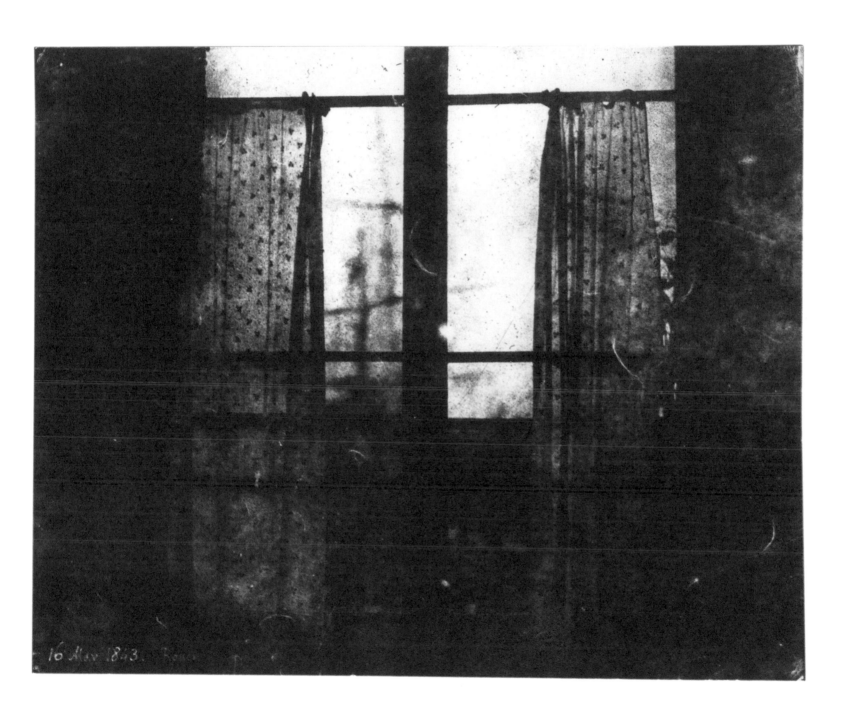

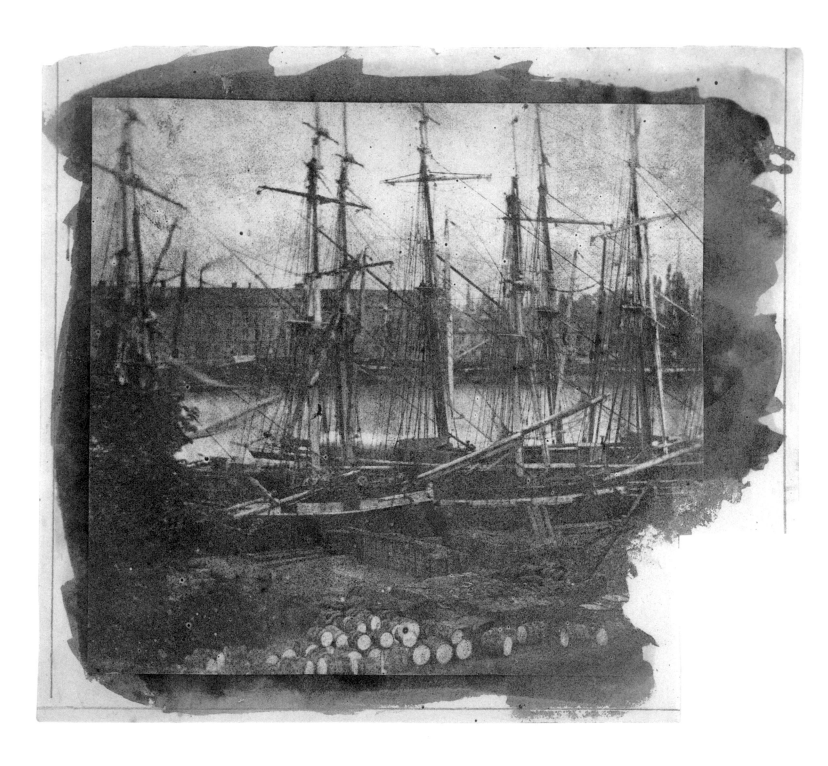

Previous page:
"Rouen, 16 May 1843"
France, May 16, 1843
Modern salt paper print from the original calotype paper negative
19.0 x 22.4 cm

Boats and Barrels
Rouen Harbor, France, 1843
Salt paper print from a calotype paper negative
18.5 x 22.5 cm

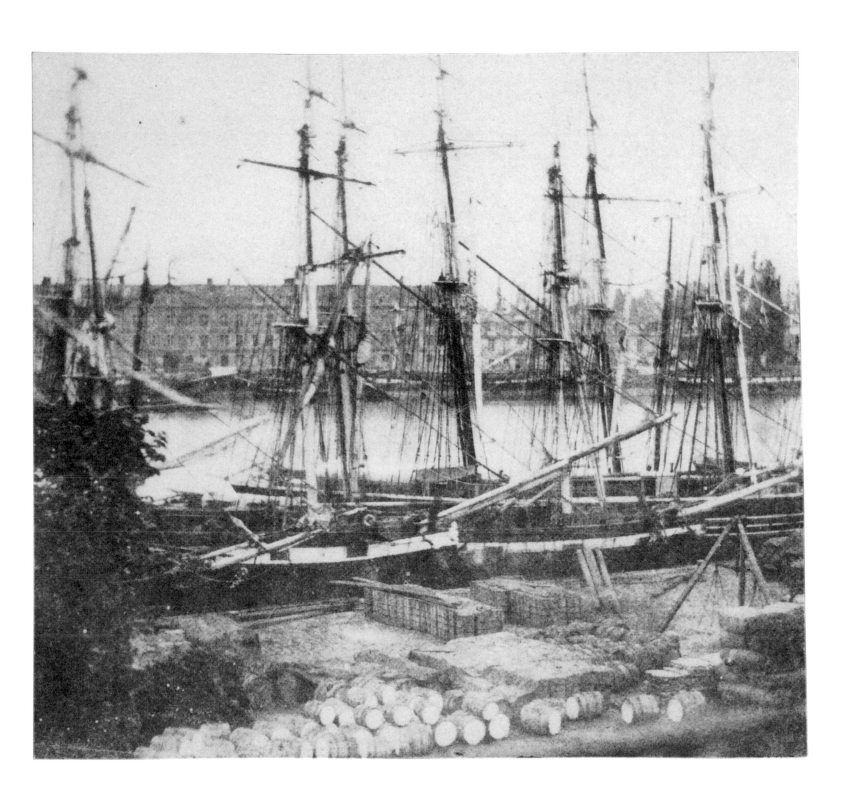

Boats and Barrels
Rouen Harbor, France, 1843
Salt paper print from a calotype paper negative
19.3 x 21.7 cm

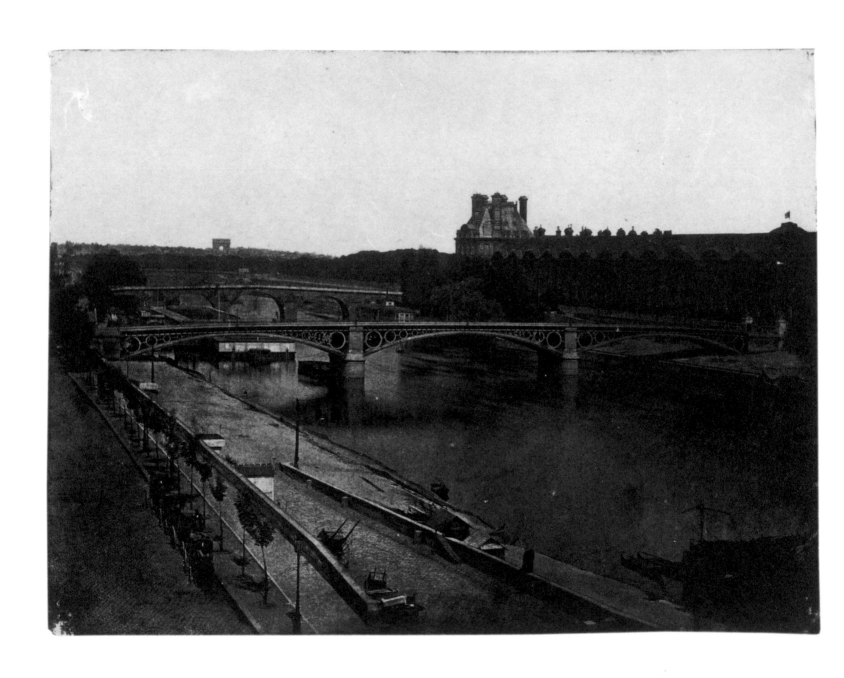

Seine
Unknown, possibly Thomas Augustus Malone
Paris, France, after 1846
Waxed, developed-out, salt paper print
18.0 x 22.0 cm

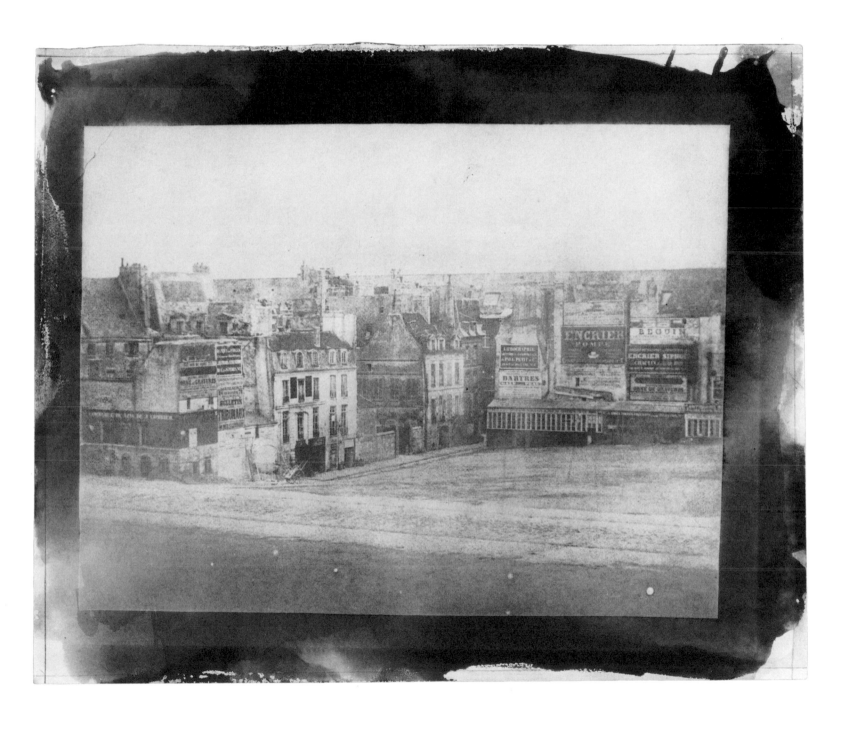

Place du Carrousel
William Henry Fox Talbot and/or Nicolaas Henneman,
in conjunction with Napoléon Joseph Hugues Maret, 2nd Marquis de Bassano
A derelict and abandoned group of buildings behind the Louvre, Paris, France, between May 22 and June 10, 1843
Untrimmed salt paper print from a calotype paper negative
19.0 x 22.8 cm

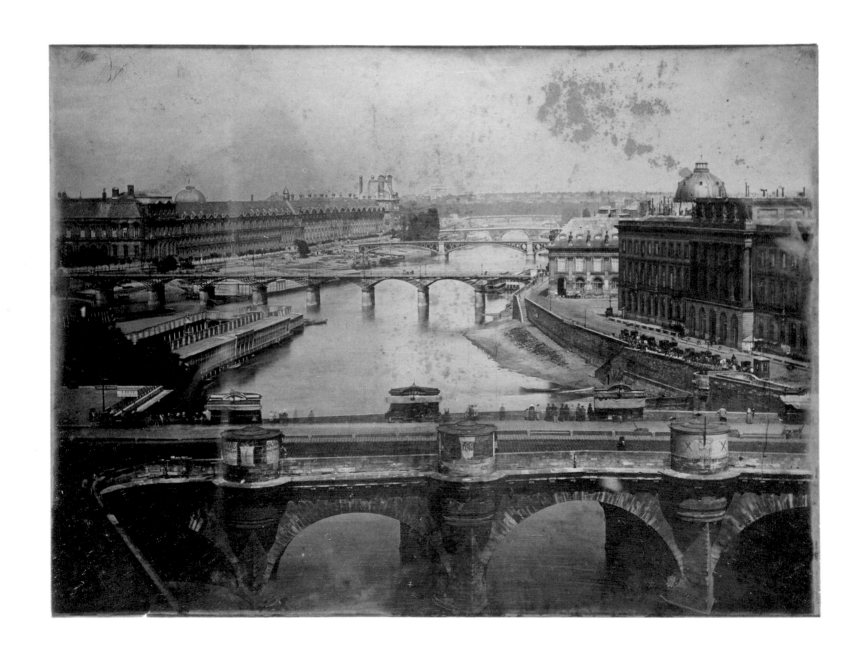

Pont Neuf
Charles Chevalier
Paris, France, May 15, 1843
Daguerreotype
16.8 x 21.8 cm

104

The glass of the original passe-partout framing of this daguerreotype having been broken, an oxydisation developed across the face. This was removed and the plate re-framed in February 1945 by Mr. Pledge, curator of Kodak's museum at Harrow. HW.

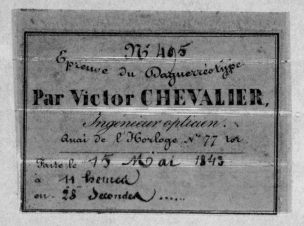

Nº 405
Épreuve du Daguerréotype
Par Victor CHEVALIER,
Ingénieur opticien.
Quai de l'Horloge Nº 77 rot.
Faire le 15 Mai 1843
à 11 heures
ou 28 Secondes

Pont Neuf
Charles Chevalier
Paris, France, May 15, 1843
Daguerreotype (label on case)
16.8 x 21.8 cm

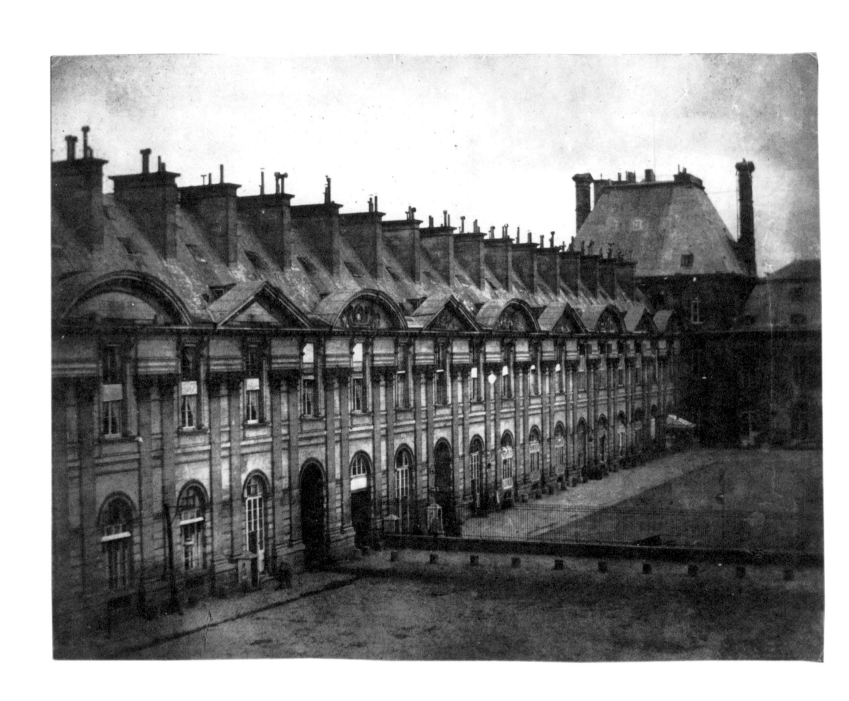

Elevated View of the Courtyard of the Louvre
William Henry Fox Talbot and Napoléon Joseph Hugues Maret, 2nd Marquis de Bassano
Paris, France, 1843
Salt paper print from a calotype paper negative
18.5 x 22.8 cm

Notre Dame
Paris, France, 1846
Salt paper print from a calotype paper negative
20.0 x 24.9 cm

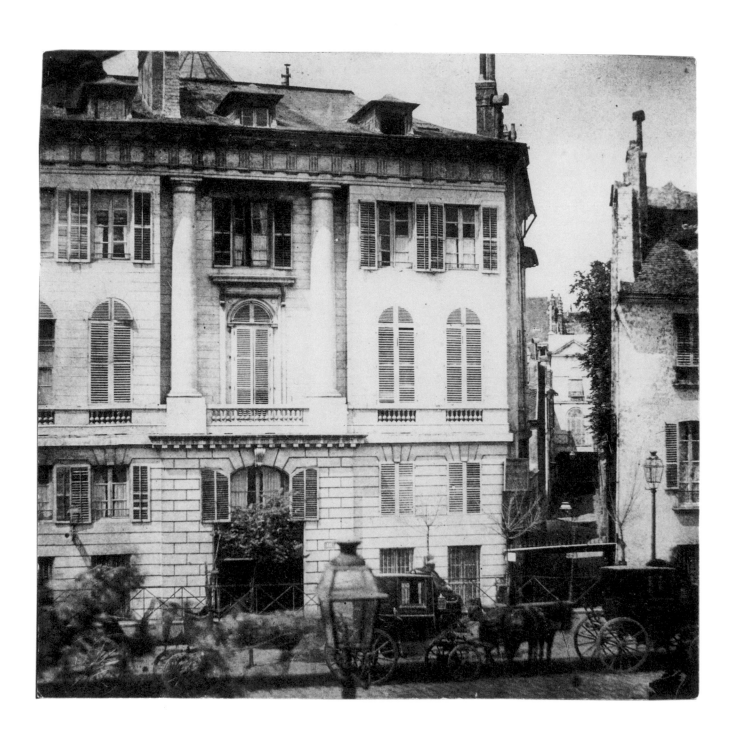

Boulevard des Italiennes
Paris, France, 1846
Salt paper print from a calotype paper negative
19.3 x 23.7 cm

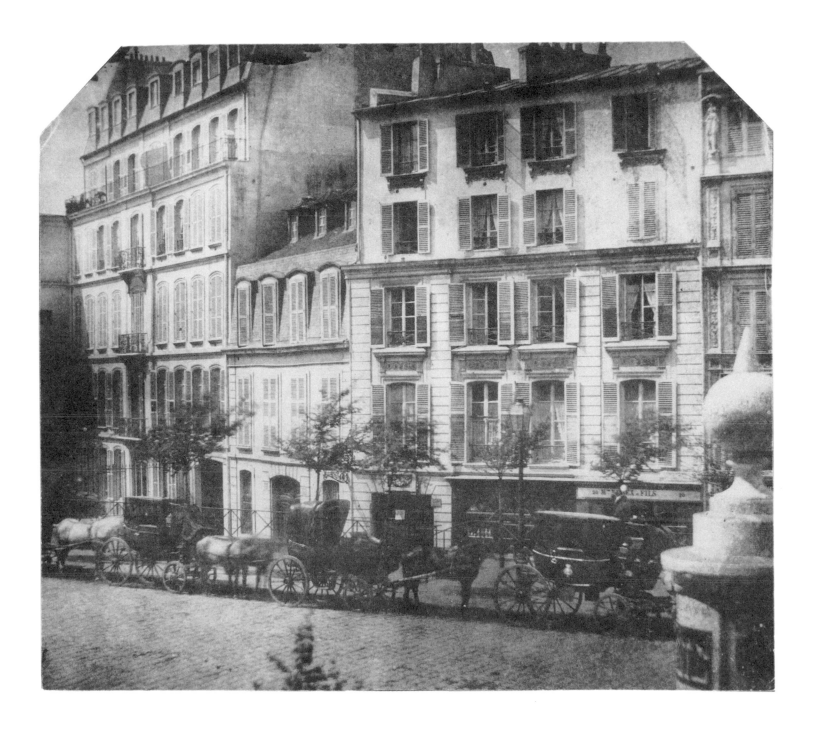

Paris Boulevard
France, 1843
Salt paper print from a calotype paper negative
18.8 x 22.4 cm

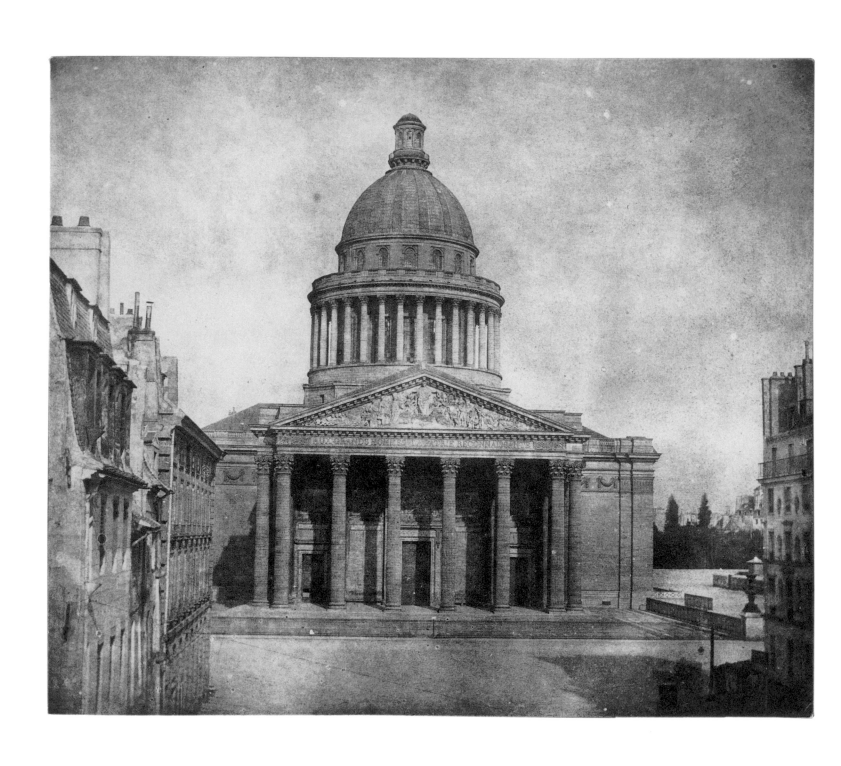

Panthéon
Paris, France, 1843
Salt paper print from a calotype paper negative
19.9 x 24.7 cm

Panthéon 1
Paris, France, 1843
Calotype paper negative
16.5 x 18.8 cm

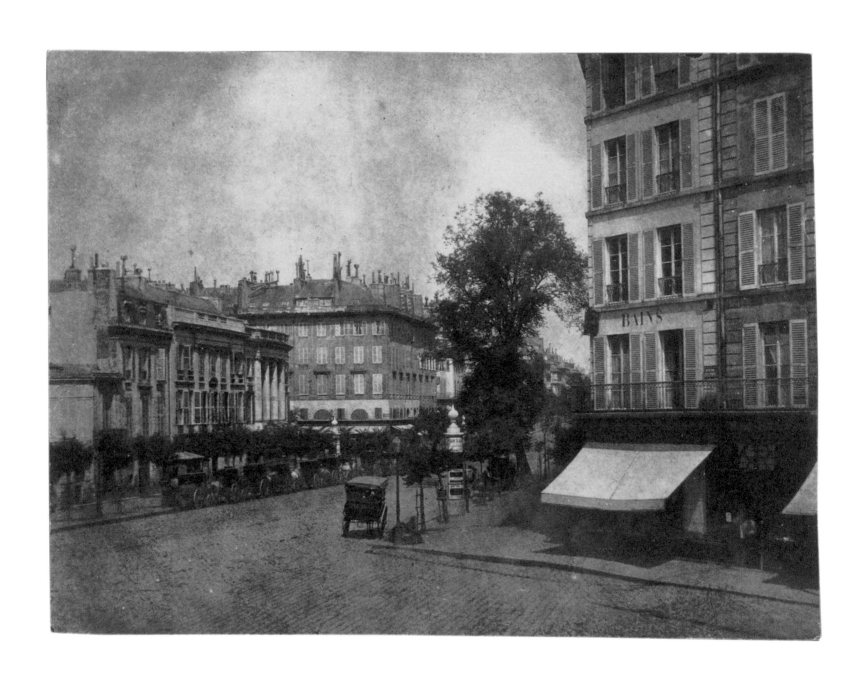

Rue des Capucines
Paris, France, 1846
Salt paper print from a calotype paper negative
18.5 x 22.5 cm

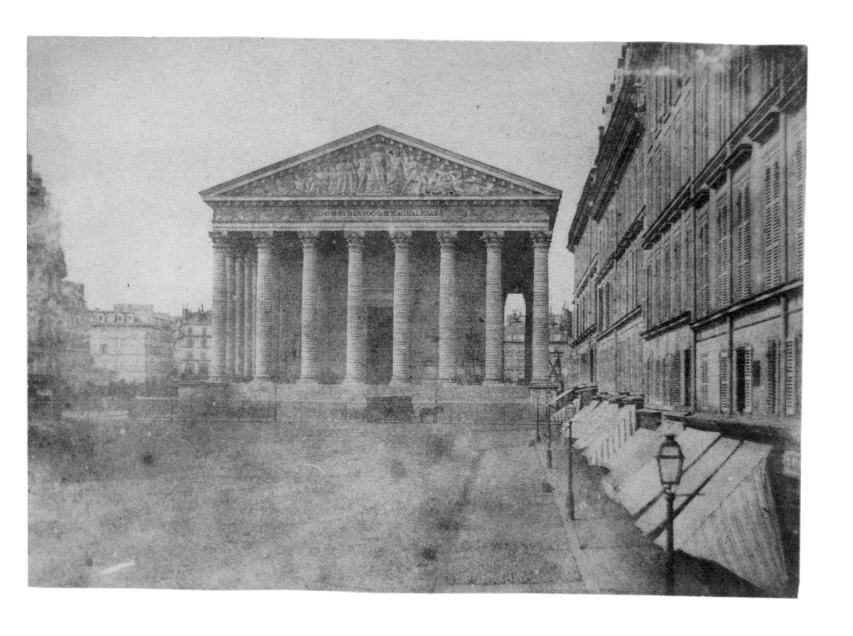

La Madeline
Paris, France, May-June 1843
Salt paper print from a calotype paper negative
18.7 x 23.0 cm

Corner of the rue de la Paix and rue de Danielle-Casanova
Paris, France, 1843
Salt paper print from a calotype paper negative
18.5 x 22.5 cm

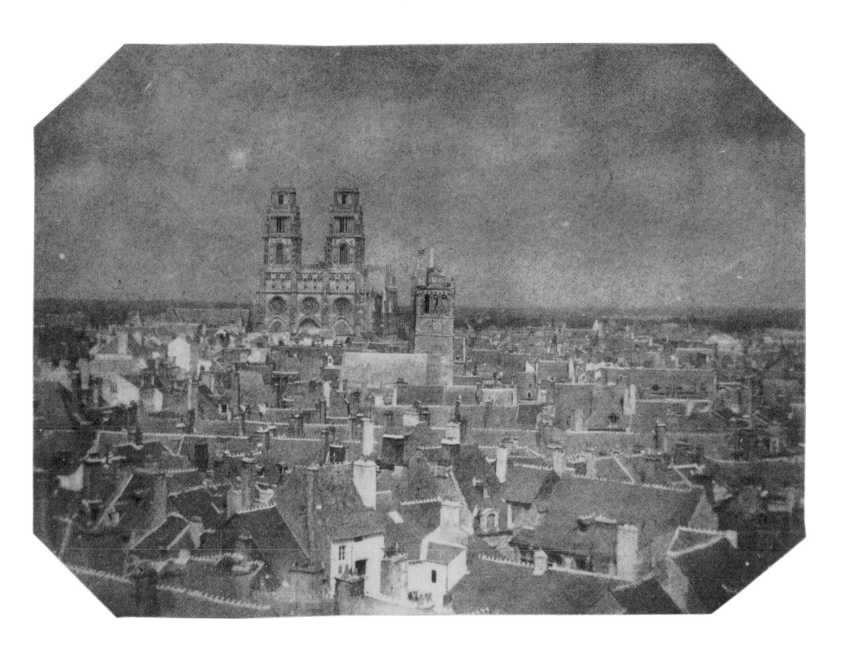

Orléans, Elevated View Showing Twin Towers of Cathedral
France, 1843
Salt paper print from a calotype paper negative
18.8 x 22.7 cm

Orléans, Elevated View Showing One Twin Tower of Cathedral
France, 1843
Salt paper print from a calotype paper negative
18.6 x 22.7 cm

116

Chateau de Chambord
France, 1843
Salt paper print from a calotype paper negative
18.8 x 23.1 cm

117

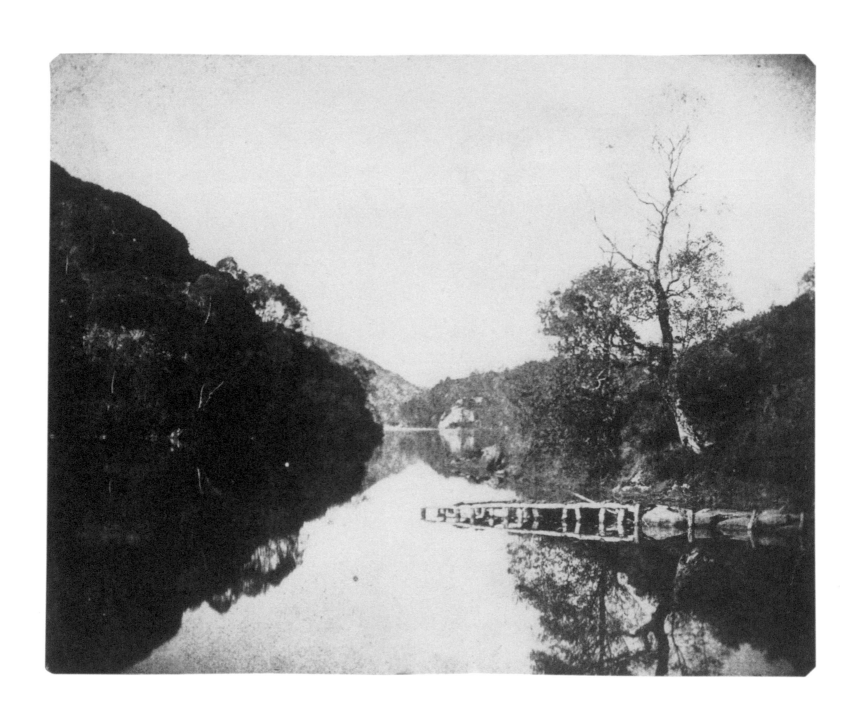

Lock Katrine, Ferry Landing Stage
Scotland, September 1845
From *Sun Pictures in Scotland*
Salt paper print from a calotype paper negative
18.8 x 22.6 cm

Stone Bridge near Hardon Castle
Outside Hawick, Scotland, mid October 1844
Salt paper print from a calotype paper negative
18.5 x 22.6 cm

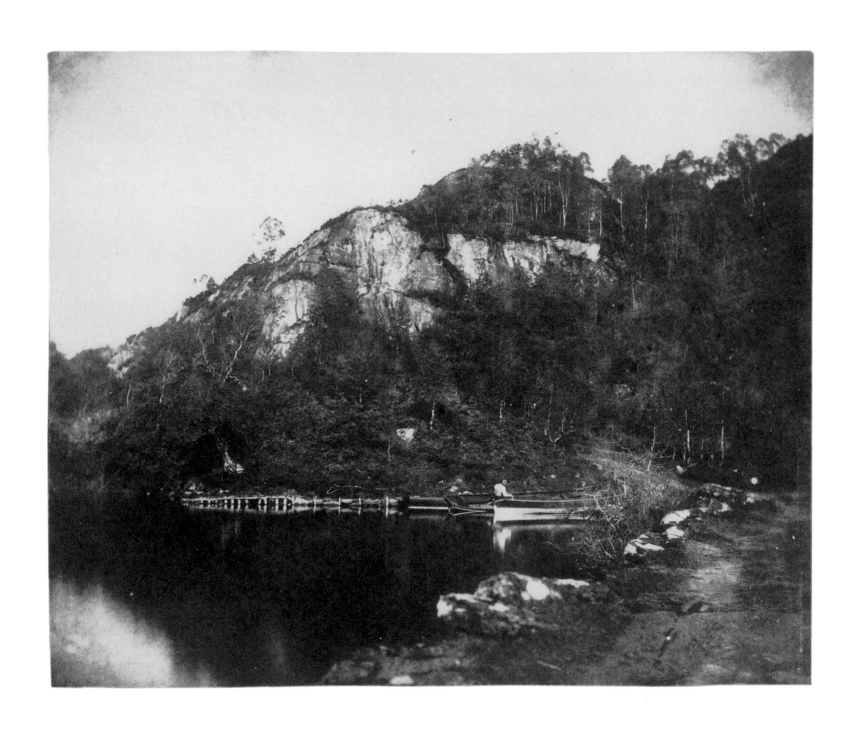

"Lock Katrine, in the Highlands, 'The Scene of the Lady of the Lake'"
Scotland, September 1845
From *Sun Pictures in Scotland*
Salt paper print from a calotype paper negative
9.5 x 11.2 cm

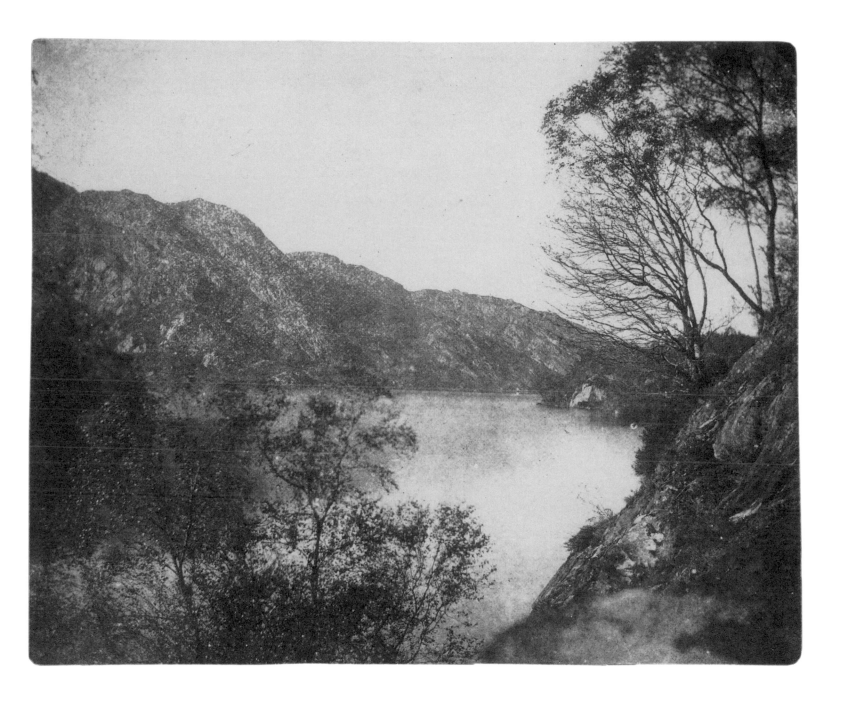

Lock Katrine with Foreground Woodland
Scotland, September 1845
From *Sun Pictures in Scotland*
Salt paper print from a calotype paper negative
18.5 x 21.6 cm

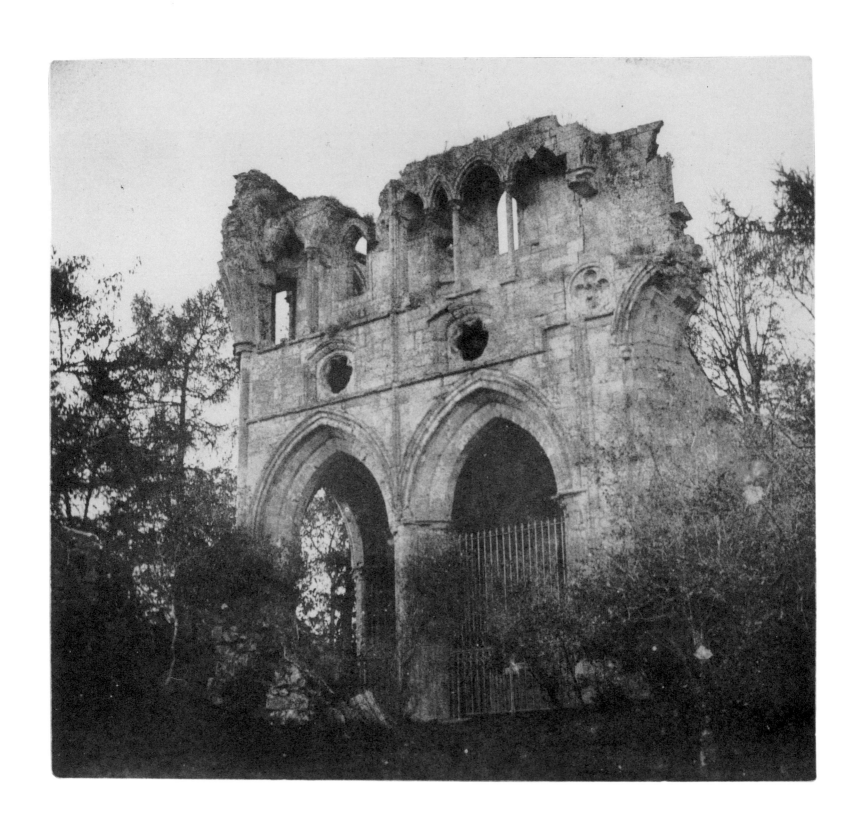

"The Tomb of Sir Walter Scott in Dryburgh Abbey, Taken Late in an Autumnal Evening"
Scotland, 1844
From *Sun Pictures in Scotland*
Salt paper print from a calotype paper negative
18.7 x 22.5 cm

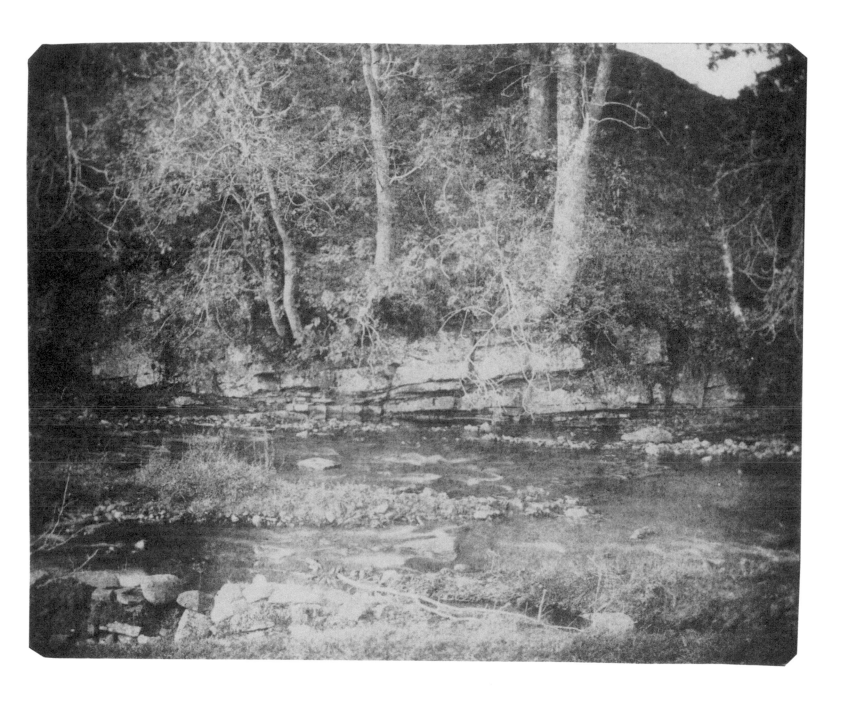

Highland Stream
Scotland, 1846
From *Sun Pictures in Scotland*
Salt paper print from a calotype paper negative
9.2 x 11.5 cm

WILLIAM HENRY FOX TALBOT, 1800–1877

MICHAEL GRAY

Henry Talbot made a number of important contributions across a wide range of disciplines, which included botany, physics, chemistry, optics, spectroscopy, crystallography, philology, photogravure, and the translation of Egyptian hieroglyphs and Assyrian cuneiform script. However, it was the discovery of the negative-to-positive photographic process that was undoubtedly his most important achievement. Talbot's discoveries formed not only the basis of modern photography, but also the foundation upon which the reprographic arts are based.

Talbot's genius lay in his ability to draw together the results of his own discoveries and the work of earlier proto-photographic pioneers— pharmacists, chemists, and physicists including Giacomo Battista Beccaria Beccarius, Carl Wilhelm Scheele, Johann Heinrich Schultze, Thomas Wedgwood, Humphry Davy, John Frederick William Herschel, Nicolas Wolfgang Fischer, Gustav Suckow, and others.

He discovered a method by which he was able to bring out a latent negative photographic image by chemical development, and realized that from this single image he could create a theoretically infinite number of identical copies, using his salt paper process "to return the shadows and lights to their correct disposition."[1] Only today is Talbot's negative-to-positive process being replaced by digital imaging technologies within the field of the graphic arts. What follows is a brief sketch of significant moments in Talbot's life and in the development of photography.

On April 17, 1796, William Davenport Talbot, son of John Ivory Talbot, married Lady Elisabeth Horner Fox-Strangways (1776–1846), eldest daughter of Henry Thomas Fox-Strangways, second Earl of Ilchester. Lady Elisabeth, according to Talbot's biographer, was "not only highly intelligent, but a seeker after knowledge, a natural linguist, a sparkling conversationalist, a Whig throughout her entire life,…strong willed, obstinate—and spoilt from her first year on."[2] Four years after the marriage, on February 11, 1800, William Henry Fox Talbot was born at Melbury House, Dorset, ancestral home of the Earls of Ilchester.

His father died when Henry was less than half a year old, leaving Lacock Abbey, his estate and village, in a state of disrepair and with accumulated debts amounting to £30,000 sterling—an enormous sum, equivalent to more than $3,000,000 in today's currency. Although Talbots had lived at Lacock Abbey since 1539, Davenport Talbot's heirs were unable to take possession of the estate until 1827—five years after Henry reached maturity at the age of twenty-six.

On April 24, 1804, Talbot's mother married Captain (later Rear-Admiral) Charles Feilding of the Royal Navy, with whom she later had two daughters, Caroline Augusta and Horatia Maria. Immediately after the marriage, Captain Feilding collaborated with the Ilchester family to reorganize and run the abbey estate and village. By 1810 virtually all outstanding and accrued debts had been cleared by reducing the size of the estate, by leasing the abbey to a Mr. Grossett for seventeen years, and by upgrading the remaining farm buildings and infrastructure. These new arrangements, which included the appointment of a land agent, generated sufficient regular annual income to pay for the education of Henry and his half-sisters, and to secure the family's future.

PENRICE, MELBURY, AND BOWOOD

The lack of a permanent home during Henry Talbot's formative years does not seem to have had any adverse effect on him. Although he and his mother continued to live in a series of semi-permanent homes, the relationships they enjoyed within these houses were close and secure. In the early years of the Feilding marriage the Rear-Admiral spent much of his time away at sea or in London on admiralty business while Lady Elisabeth and her son stayed for long periods with the Fox-Strangways at Melbury in Dorset, the Framptons at Morton Hall, Dorchester; the Lansdownes at Bowood, Wiltshire; and most of all at Penrice, on the quiet and breathtakingly beautiful Gower Peninsula in Wales, a few miles along the coast from Swansea. Here Talbot came under the benign influence of a second formidable female: his aunt, Lady Mary Lucy, wife of Thomas Mansel Talbot.

1. Royal Society Archives, London, Herschel Correspondence. Letter from William Henry Fox Talbot to John Frederick William Herschel dated February 11, 1839; received February 12. In this letter Talbot refers to his re-transfer process mentioned by him in his paper read to the Royal Society and subsequently published on February 9th: "But if the picture so obtained, is first preserved so as to bear sunshine, it may afterwards be itself employed as an object to be copied & by means of this second process the lights and shadows are brought back to their original disposition."
2. Arnold, H. J. P., *William Henry Fox Talbot: Pioneer of Photography and Man of Science* (London: Huchinson Benham, 1977), 21.

Penrice, Talbot's "fairy palace," occupied a special place in his childhood reminiscences and recollections in "providing happy memories he would never forget and warm friendships with aunts and cousins which lasted throughout life."[3] His innate love of learning and thirst for knowledge were nurtured not only by his mother but also by his aunt, whose particular interest in botany first awakened what became Talbot's lifelong interest in the subject.[4]

In 1808 Talbot's parents sent him to the Reverend (later Sir) William Hooker's preparatory school at Rottingdean, Sussex, in the South of England. It was a small school for boys where the classics, mathematics, and French were well taught. For the first six weeks of Henry's first term, Hooker generously allowed the boy to return home in the evenings to Brighton, where his mother had taken up temporary residence. In a letter to Lady Elisabeth dated May 20, 1808, the headmaster wrote that "I have not a moment's hesitation in pronouncing him to be of a very superior capacity....Everything should be done to induce him to play more and think less."[5] In Talbot's final year at Rottingdean, letters interspersed with and/or partially written in French, Latin, and Greek were already passing between ten-year-old Henry and his mother.

HARROW AND CAMBRIDGE

After three years at Rottingdean, in 1811, Henry Talbot entered Dr. Butler's House at Harrow School, Harrow, London. There he pursued his two major interests, chemistry and botany, and was soon banned from carrying out experiments within the precincts of the school. But Henry made other arrangements. In a letter to her sister, Lady Elisabeth wrote that "As he can no longer continue his experiments in Dr. Butler's House, he resorts to a good-natured blacksmith who lets him explode as much as he pleases."[6] It was while at Harrow that Talbot acquired his first substantial reference work on chemistry, Samuel Parks' *Chemical Catechism*, a very thorough and extended work based on a manuscript the author, a Unitarian minister, had written for the education of his daughter. Parks' philosophy was founded on the radical and enlightened ideas that Maria Edgworth had set out in her then popular and highly regarded work, *Practical Education*.

It was at Harrow that Talbot further developed his interest in botany and in chemistry. The school was also the setting for Henry's first scientific writing; he and his young friend Walter Trevelyan compiled an index of local flora and fauna.[7] According to the reports of his teachers at Harrow, he was an exceptionally gifted and brilliant pupil, so much so that at the age of fifteen, he was asked to leave school! It was a Harrow tradition for the brightest and most able student to be made head boy, but Talbot was only fourteen when he was recognized as the best student. His masters, apparently worried that he was not sufficiently mature to take on the responsibilities of being head boy, decided instead to ask him to leave!

After a short interval Talbot continued his studies, between 1811 and 1816, under private tutors. Then, in 1818, he entered Trinity College, Cambridge, where he studied classics and mathematics under the Reverend William Whewell and won the Porson Prize for Greek Iambics in 1820. In his final year at Cambridge, Talbot was a Chancellor's Medallist and received first-class honors in mathematics and classics when he graduated in 1821.

On February 11, 1821, Talbot came of age, and all "investments, consoles and annuities" passed directly to him. Lacock Abbey and its estate were now in sound condition, thanks to the efforts of his stepfather and uncle, and yielded an annual net income, on the order of $150,000 in today's money. As the head of the family, Talbot took all his obligations seriously. Following a visit to Lacock in 1821, he marked the occasion of his twenty-first birthday by allotting £1,000 for building a new school. The structure, completed in 1824, functions to this day as the Lacock Village (primary) School.

Between 1821 and 1834, Henry Talbot, with his mother and half-sisters, made regular extended journeys to Europe, visiting France, northern Spain, Switzerland, Italy, Austria, and the German states. Talbot, accompanied by his Italian manservant, Giovanni, took an extended trip through France and Italy and eventually to the Greek island of Corfu in 1836. Fluent in many languages and familiar with the arts and sciences in Europe, Talbot sought out and conversed with prominent scientists and cultural figures whose work and interests most closely related to his own. On almost all his journeys he carried with him optical instruments and drawing aids, among which were various types of camera obscurae, camera lucidae, and reflective devices (such as a Claude glass and concave mirror). His notebooks also contain sporadic references to a collimator, a sextant, and a theodolite.

3. Martin, Joanna, *The Fairy Palace*, (Aberyswyth: National Library of Wales, 1992). For an overview of the early education of the young Henry Talbot prior to 1810 and for background information on the Talbot's of South Wales prior to 1800, see also Martin, Joanna, *The Penrice Letters* 1768–1795, (Swansea and Cardiff: West Glamorgan County Archive Service and South Wales Record Society).
4. Writing to her sister Harriot Fox-Strangways some ten years before she was destined to find herself in charge of her nephew's early education, Lucy Mary Talbot described with great delight the contents of her dressing room at Penrice Castle, containing among other things: "…a beautiful satin wood bookcase full of delightful books, particularly on natural history. I have all the birds, all the fishes, all the insects, all the beasts, all the butterflies, all the shells, all the correlines, all ye zoophites, all the fungusses & all the poets bound so prettily." Refer to correspondence transcribed by Joanna Martin in The Penrice Letters 1768–1795, letter 83, 145.
5. Fox Talbot Museum, Lacock Abbey Correspondence, LA 08-03. Also see Arnold, H. J. P., *William Henry Fox Talbot: Pioneer of Photography and Man of Science*, 31.
6. Fox Talbot Museum, Lacock Abbey Correspondence. Also see Arnold, H. J. P., *William Henry Fox Talbot: Pioneer of Photography and Man of Science*, 34. The original letter has not been traced: it exists only as a copy.
7. Unpublished Mss compiled by Talbot & Trevelyan, *Plants indigenous to Harrow: Flora Harroviensis.* (London: Harrow School Library), 8.

The catalogue of the Royal Society alone lists fifty papers published by Talbot between 1822 and 1872 covering a range of disciplines. The first, "On the Properties of a Certain Curve Drawn from the Equilateral Hyperbola," was followed by six other papers on mathematics published in Gergonne's *Les Annales des mathématiques pures et appliqués* between 1822 and 1823. According to Scientific Notebook C, Talbot began to study the properties of light in 1825, and he was soon publishing the results of his research.[8] Talbot's interest in the behavior of light eventually led him to the discovery, made between May 1834 and September 1840, of the negative-to-positive photographic process.

The year 1827 marks the point at which Henry Talbot, his mother, his stepfather, and his two half-sisters, along with their French governess, took up residence at Lacock. Between 1827 and 1831 the family replanned and replanted the estate woodlands and gardens and made a number of major structural changes to the house in order to create a more comfortable domestic space. Alterations to the South Gallery were made in 1831 including three oriel windows that brought in an abundance of natural light and created a new social space. The smallest of the three windows, set immediately above the doorway that leads to the cloisters and the cloister court, has been immortalized as the subject of Talbot's first successful photographic camera paper negative, taken in August 1835.

Two diversions from Talbot's mathematical and scientific pursuits occurred in the early 1830s. First, he published his first book, *Legendary Tales in Verse and Prose* (1830) which was not well received by Lady Elisabeth Feilding, but Talbot's two half-sisters, Caroline Augusta and Horatia Maria, heaped extravagant praise on him for this collection of gothic romantic stories. Then, on December 10, 1832, Talbot was elected Member of Parliament for the borough of Chippenham, serving as a member of the Whig (liberal) party for a single five-year term.

Ten days after the election, William Henry Fox Talbot married Constance Mundy of Markeaton Hall, Derbyshire. Henry and Constance shared an interest in botany, and Talbot's new wife was also a keen amateur botanist, artist, and watercolor painter.

THE BEAUTY OF THE FIRST IDEA

In the early fall of 1833, while Talbot and Constance were on an extended wedding trip in northern Italy, his ideas about photography first crystallized and coalesced. He had what he later called a "philosophic dream"[9] that it might be possible to create images spontaneously, "without any aid whatsoever from the artist's pencil" and "by the agency of light alone."[10] His moment of insight was elegantly described by Neville Story Maskelyne in an unsigned article published in the *The North British Review*:

> "It was on that beautiful Italian water whose triple arms converge on the point of Bellagio that Mr. Talbot longed for a power to enable him to bear away an image of the soft silvery radiance of Lecco and Como. There he resolved to work out the problem by which Nature herself would be induced to perpetuate the outline of her own beauties in artistic form."[11]

This somewhat elegant and romanticized account was drawn from Talbot's own description of his inspirational breakthrough included in the introduction to *The Pencil of Nature*.

The following year, in the spring and early summer of 1834, at Lacock, Talbot began experimenting with light-sensitive salts of silver. At first he thought of photography as a simple and convenient way of making accurate records of his botanical specimens. Later, in the fall, when he traveled to Switzerland to join his family and continue his proto-photographic experiments at Les Grande Délices,[12] a house rented by the family staying at the small village of Copet (near Geneva, Switzerland), where he made several silver prints from plants, leaves, and feathers, and created at least two *cliché verre* negatives. Cliché verre is a process whereby a sheet of glass is smoked and coated with a resinous substance. The prepared surface can then be "drawn" upon with the point of a fine needle. Talbot created "positive" images from his original glass matrices by placing paper sensitized with silver chloride under the glass and exposing it to direct sunlight. At this point, he might well have realized that by this simple but primitive process it was possible to create an infinite number of identical copies. However, not until the first quarter of 1835 does Talbot appear to have set down a written description. Scientific Notebook M contains the following passage: "In the Photogenic or Sciagraphic Process if the paper is transparent the first drawing may serve as an object to produce a second drawing in which the lights would be reversed. If an object, as a flower, be strongly illuminated, & formed in the camera obscura, perhaps a drawing might be effected of it, in which case not its outline merely would be obtained, but other details of it."[13]

8. Including: "Some Experiments on Coloured Flames" (Dated March 1826), (*Edinburgh Journal of Science*, vol. 5, no. 1, June 1826), 445-52; "On Monochromatic Light," *Quarterly Journal of Science, Literature and the Arts*, vol. 22, (December 1826), 374; "On a Method of Obtaining Homogeneous Light of Great Intensity", *Philosophical Magazine*, ser.3, vol.3, no. 13 (July 1833) 35; and "On the Nature of Light", *Philosophical Magazine*, ser. 3, vol. 7, no. 38 (August 1835), 113-18 & 157; this is the same period of time during which he makes his earliest experiments on paper using light-sensitive silver salts.

9. Fox Talbot, H., *The Pencil of Nature*, (London: Longman, Brown, Green & Longman, 1844), "Brief Historical Sketch of the Invention of an Art," unpaginated. Alternatively refer to *William Henry Fox Talbot: Selected Texts and Bibliography*, ed. Mike Weaver (Oxford: Cleo Press, 1992), 78.

10. Fox Talbot, H., *The Pencil of Nature*. Talbot found it necessary to include a printed "Notice to the Reader," which I append verbatim: "The plates of the present work are impressed by the agency of light alone, without any aid whatsoever from the artist's pencil. They are the sun pictures themselves, and not, as some persons have imagined, engravings in imitation."

11. Annotated proof copy of an article published in *The North British Review*: "The Future of Photography," 1849, private collection. Now known to have been written by prominent scientific figure Neville Story Maskelyne whilst at Oxford.

12. The former residence of Voltaire when exiled in Switzerland.

13. Scientific Notebook M, folio 90, after February 28, before March 10 1835. The National Trust, Fox Talbot Museum, Lacock Abbey Collection.

Talbot later wrote: "How charming it would be, if it were possible to cause these natural images to imprint themselves durably, and remain fixed on the paper....And lest the thought should again escape me...I made a careful note of it...and also of such experiments as I thought would be most likely to realize it, if it were possible."[14]

Talbot used writing paper, which he bathed in a weak solution of sodium chloride (common salt), dried, and then treated with a strong solution of silver nitrate, which caused silver chloride to form in the pores of the paper. The first salt print images he made were of a leaf, a feather, and a piece of lace, which he laid on the paper and exposed to sunlight. Under the action of the light, the paper darkened and an exact representation of the subjects remained white.

In the "brilliant summer of 1835," as he described it, Talbot made significant advances. He created several kinds of photogenic drawing, starting with those made by superposition—contact prints taken from objects laid on treated papers and stabilized after exposure with sodium chloride, potassium iodide, or potassium bromide (the same process of photogenic drawing as described above but incorporating the use of two additional stabilizing agents). Such prints are lilac, burnt orange, or other similar shades, according to the chemicals used for stabilization. The second method Talbot used to create photogenic drawings involved the use of a solar microscope with silver nitrate paper to produce an enlarged image of a specimen that revealed details invisible to the naked eye. By this means he successfully illustrated the structure of crystals and plant sections with polarized light. He achieved this through the use of a solar microscope containing a specimen of Icelandic fluorspar. In his work with the solar microscope, Talbot identified photography's vitally important function in the gathering of accurate information. This led inevitably to the third and most far-reaching aspect of Talbot's work during the summer of 1835. As he wrote: "When I had succeeded in fixing the images of the solar microscope by means of peculiarly sensitive paper there appeared no longer any doubt that an analogous process would succeed in copying objects of external nature..."[15]

He then constructed a large box with a lens at one end, which formed an inverted image inside on a sheet of sensitized paper. The camera was placed "about one hundred yards from a building favorably illuminated by the sun."[16] In an hour or so he found "a very distinct representation of the building, with the exception of those parts of it which lay in the shade. A little experience in this branch of the art showed me that with smaller camerae obscurae the effect would be produced in a shorter time."[17] Talbot then made many small boxes—miniature cameras—which he placed about to receive the work of the sun.

In August that same year Talbot asked the village carpenter to make a series of small camera obscurae, and he is known to have used these to make at least three or four small paper negatives of the oriel window in the South Gallery of Lacock Abbey. This group of images includes the annotated specimen now held in the archives of The National Museum of Photography, Film & Television, the Science Museum, Bradford, England.[18] Using one or more of these small prototype miniature cameras Talbot took at lease three photogenic drawing negative images including the one illustrated in this publication and a second version now in the archives of the Bensusuan Museum of Photography, Johannesburg, South Africa.[19]

At the end of the summer of 1835 Talbot paused, perhaps feeling he had gone as far as he could for the moment and intending in good time to present the full details of his experimentation to the Royal Society. He was apparently not satisfied with the results he had achieved, and between 1836 and 1838 he seems to have suspended all practical photographic study and experimentation. He redirected his attention to his theoretical studies. In 1836 and the following year he published several scientific papers.[20] At the same time Talbot prepared for the publication of two new books, *The Antiquity of the Book of Genesis—Illustrated by some New Arguments* (1839) and *Hermes, or Classical and Antiquarian Researches, No. 1* (1838) and *No. 2* (1839).

ENTER DAGUERRE

On January 7, 1839, François Arago, Secretary of the French Chamber of Deputies and a well-known astronomer, announced the invention of the daguerreotype, though no detailed description of the process was given. A fuller report appeared the following week in *Comptes Rendus*, a journal that gave accounts of all the important scientific meetings and events in France. The following day, January 12, the announcement appeared in translation in London's *Literary Gazette*.

14. Fox Talbot, H., *The Pencil of Nature*, "Brief Historical Sketch of the Invention of an Art," unpaginated.
15. Fox Talbot, H., "*Some Account of the Art of Photogenic Drawing...,*" (London: Royal Society of London, Library) Mss AP23 20bis, (Delivered 28 January & read 31 January 1839), unpaginated.
16. Ibid.
17. Ibid.
18. This is in addition to the one now held in the Bensusan Museum of Photography, Johannesburg, South Africa.
19. The location and ownership of the third example is currently unknown.
20. For a full complete listing of all Talbot's scientific papers refer to Weaver, Mike, *Henry Fox Talbot: Selected Texts and Bibliography*, "Works written by or Connected with Henry Fox Talbot," 137-79.

Talbot was stunned. He immediately took action. Following the announcement of the discovery of his Photogenic Drawing Process by Michael Faraday at the Friday meeting of the Royal Institution, London, where a small selection of his photogenic drawings were displayed in the library, Talbot sent additional specimens that were shown at a meeting of the Royal Society of London on January 25th, six days before his paper was read at their meeting on the 31st.[21] Next Talbot published his now famous report *Some Account of the Art of Photogenic Drawing, or the Process by Which Natural Objects May Be Made to Delineate Themselves Without the Aid of the Artist's Pencil,* having previously submitted the report in handwritten form to the Society on January 28, 1839.

Talbot then promptly wrote to François Arago, Jean-Baptiste Biot, and Alexander von Humboldt, scientists who had verified and substantiated Daguerre's invention, informing them that he intended to submit a formal claim of priority to the French Academy. At the same time he notified all his close scientific associates in the United Kingdom, mainland Europe, and the United States. There was, however, disappointingly little support for Talbot in European scientific and cultural circles. Biot was the only member of the Academy of Sciences in Paris to encourage Talbot and give his work serious consideration. The matter took on greater political significance due to the long-term rivalry between France and England. In the wake of his announcement, Daguerre was awarded a state pension on the understanding that his invention be given free to the world. Even so, he soon engaged Miles Berry, a London agent, and took out an English patent that effectively forced Talbot to respond in kind.

When the details of Daguerre's process became known, it was apparent that it was substantially different from Talbot's. "The Frenchman" used metal plates and produced a single positive image. Nevertheless, Talbot was spurred to action, and over the course of the next eighteen months—between January 1839 and October 1840—he worked intensively to improve and to speed up his basic photogenic drawing process. His experiments came to fruition between September 23 and October 6, 1840, with his final seminal discovery: the development of the latent negative photographic image, the negative-to-positive process. He subsequently named the process "calotype," derived from the Greek kalos ("beautiful"), but an alternative meaning—"that which is good or useful"—seems to fit Talbot's idea as well.

We now know that between April 1839 and October 1840 Talbot made something between a thousand and twelve hundred experimental negatives. Those figures do not include the large number of photogenic drawings, negatives, and second-generation salt paper prints that he made and sent as specimens of his art to scientific bodies and individuals throughout Europe and the East Coast of the United States. He wrote in the *Literary Gazette* of taking steps "not with the intention of rivaling M. Daguerre in the perfection of his processes…but to preclude the possibility of its being said hereafter, that I had borrowed the idea from him, or was indebted to him, or to anyone….I hope it will be borne in mind by those who take an interest in the subject, that in what I have hitherto done, I do not profess to have perfected an Art, but to have commenced one; the limits of which it is not possible at present exactly to ascertain…."[22]

Yet Talbot's fellow scientists offered him little overt support. When in May 1839 the astronomer Sir John Herschel traveled to Paris to see the phenomenon, he is quoted as saying to Arago: "This (the daguerreotype) is a miracle…Talbot's drawing's are child's play in comparison."[23]

He then wrote (of Daguerre's works) to Talbot: "It is hardly too much to call them miraculous….The most elaborate engraving falls far short of the richness and delicacy of execution, every graduation of light and shade is given with a softness and fidelity which sets all painting at an immeasurable distance."[24]

The precision, clarity, and seamless tonal scale of Daguerre's images had never been seen before. All were entranced by the mysterious, holographic quality of the images, which changed from negative to positive, shadowy to bright, as they were tilted in the hand.

Certain clues suggest why Talbot's work did not seize the popular imagination. "I have found that the camera pictures transfer (i.e., print) very well," Talbot had written to Herschel on April 1839, "and the resulting effect is altogether Rembrandtish." This word may hold the key to the less than enthusiastic response given to Talbot's work. "Rembrandtish" brings to mind dark and light strokes laid down to suggest a face or figure, interior or landscape as it may be, and denotes an *expressive account* of what an artist wishes to communicate. Until 1839 images had only been experienced through the agency of an artist's hand (or the hands of nameless draftsmen or workshop engravers using a syntax of nets and lines) in which the textural quality of the paper or material base was common to all. This characteristic was also ineluctably woven into Fox Talbot's images, making them to a degree more familiar, but less magical than the extreme verisimilitude viewers experienced looking at daguerreotypes.

21. Talbot had neither the time nor the possibility to make new prints. Arago's announcement was made on behalf of Daguerre in mid-winter. All he could do was take out the specimens that he had originally made in 1834 and 1835 (including perhaps the single surviving specimen made in 1836) and submit them for viewing at this meeting.
22. Letter to the Editor of the *Literary Gazette* from Talbot written January 30, published February 2, 1839.
23. Quote by Potonniée, Georges, and trs. Edward Epstean, *Comptes Rendu* (New York: Tenant and Ward, 1936), 838.
24. Schaaf, Larry J., *Out of the Shadows: Herschel, Talbot & the Invention of Photography,* (Newhaven & London: Yale University Press, 1992), "IV Storm Clouds and Rainbows," Summer 1839–Spring 1840, 75. Quoting from a letter, date unspecified but probably September 1840, Herschel Correspondence, Royal Society Archives, London.

While the daguerreotype swept relentlessly across the world, creating a new industry, Talbot continued his work. "A great desideratum," he wrote to Herschel in 1840 "is more sensitive paper….I cannot say I have much improvement to boast of, of late, but the art remains in status quo since April or May."[25] In fact, as he wrote this, Talbot's breakthrough was only days away. In the third week of September 1840, he discovered that gallic acid in conjunction with silver nitrate would bring out a latent image. With indescribable elation on the 23rd of September he watched a picture gradually appear on a blank sheet of paper. The following February, Talbot sent an account of the discovery to the *Literary Gazette*:

> One day last September, I had been trying pieces of sensitized paper, prepared in different ways, in the camera obscura, allowing them to remain there only for a short time with a view of finding out which was the more sensitive. One of these papers was taken out and examined by candlelight. There was little or nothing to be seen upon it and I left it lying on a table in a dark room. Returning sometime after, I took up the paper and was very much surprised to see upon it a distinct picture. I was certain that nothing of the kind when I had looked at it before; and, therefore (magic apart) the only conclusion that could be drawn was that the picture unexpectedly *developed itself* by a spontaneous action.[26]

Prior to Arago's announcement of the invention of the daguerreotype in January 1839, Talbot had given little or no consideration to the possibility that he might patent his discoveries. Ironically, *had* he taken out a patent for his photogenic drawing process in 1839, for the following ten years he would have more effectively been able to defend his rights. After Daguerre patented on his own process in England, Talbot was placed in a virtually untenable position. When he had completed his work on the negative-to-positive process he had no alternative but to register the calotype at the Patent Office which he did in February 1841.

A Closer Look at September 1840

Much can be learned about the subtleties of the process that led up to Talbot's momentous discovery by close study of both his Notebooks P and Q and a letter he wrote the *Literary Gazette* in 1841 shortly after his patent was granted.[27]

Between April 1839 and mid-September 1840 Talbot was unable to radically improve upon what was still in essence his basic printing-out process. It was not until his attention turned to the possible use of gallic acid that he started to experiment with this organic reagent for a second time. The results improved dramatically.

Around September 18, Talbot realized that a much higher level of sensitivity was required in order to bring out a latent image. He discovered that the sensitivity of paper coated with silver bromide was greatly increased by washing it a second time with a solution of silver nitrate, acetic acid, and gallic acid. The effect was even greater on paper that had been first coated with silver iodide.

In a passage from Notebook P, dated September 20, 1840, Talbot described the effect of his sensitizer: "2 Waterloo paper washed with nit[rate] of silver + [gallic acid] is very sensitive, & turns very black. Waterloo paper also answers, but in a less degree. It also renders yellow paper (or fixed with much iodide) sensitive, which would be very useful if found manageable."[28] The next day Talbot made the following observation: "gallic acid [cut out] increases the sensibility of Waterloo or Bromine paper, but much more that of yellow or Iodine paper."[29] Talbot continues: "if the paper is only partially washed with the mixture, the edges of the part washed discolors the soonest. Paper washed with this & not exposed to light, does not materially discolor at first, but does so when it begins to get dry."[30]

On September 22 Talbot discovered that in preparing the paper it should be first washed: "with nitrate of silver (usual strength). Dry at fire. Dip in dish of iodide of potassium for 1/2 minute. Wash and dry at fire. There must not be too much nitrate of silver else the paper changes spontaneously as soon as it is touched by the exciting liquid. (Which is that described yesterday.)"[31]

After Talbot discovered the most effective combination of chemical coatings, it was necessary to expose the paper only briefly. Even if no image was visible when the moist paper was removed from the camera, it would start to appear immediately depending upon the temperature; if the paper was kept in the dark, the image continued to develop for several minutes.

25. Buckland, Gail, in *Fox Talbot and the Invention of Photography* (London: Scolar Press, 1980),61. Quoting from a letter dated September 1 1840, Herschel Correspondence, Royal Society Archives, London.
26. Two Letters on Calotype Photogenic Drawing to the editor of The *Literary Gazette* re-printed in the *Philosophical Magazine*, ser. 3, vol. 19 no.21 (July 1841), 88-92.
27. "Dilute gallic acid, & dilute nitrate of silver mixed turn dark in daylight (I believe Mr. Reade discovered this) If ammonia, or potash, (only one drop) be added the whole grows opaque." *Scientific Notebook P*, folio 35, entry dated April 13, 1840, The National Museum of Photography, Film & Television, the Science Museum, Bradford, England, Talbot Collection.
28. *Scientific Notebook Q*, folio 17, The National Museum of Photography, Film & Television, the Science Museum, Bradford and London, Talbot Collection.
29. Ibid.
30. Ibid.
31. Ibid. "The exciting liquid composed of: 1 part by measure nitrate of silver common strength; 1 part (as above) acetic acid; 1 part (as above) gallic acid [cut out] strong solution."

On September 23 Talbot wrote that "eight seconds are enough for a strong impression of the outline of a house in cloudy weather. Also the lighter tiles on the roof are very plainly depicted. If the impression is not strong enough, I find it may be strengthened by immersion in iod. pot. and then more of the G wash [Gallic Acid]. In three minutes a singular picture was obtained, the sky deep fiery red especially by transmitted light, against which the roof almost white contrasted as if covered with snow."[32]

Talbot also observed that if this spontaneous action was arrested by fixing the paper with a stablising solution of potassium iodide, and if the paper was washed for a second time with the same exciting liquid (developing solution), the action continued as though uninterrupted.

Talbot had discovered that a latent image was obtained after a comparatively short exposure and, more remarkably still, that it could be brought out, or developed, by further chemical treatment (later he found that he could use his method even to revive old, faded images). This principle formed the basis of the calotype process and indeed has continued to be fundamental to all subsequent photographic processes on glass and film up to and including the present time.

As early as 1842 Talbot proposed the use of the telephoto lens, the electronic flash, infrared photography, and phototypesetting. His later findings laid the foundation for photogravure printing technology. From his extensive notes, we can see that by 1843 he had already observed, noted, and employed many of the techniques that now form an integral part of contemporary photographic studio and darkroom practice.[33]

Between 1844 and 1847 Talbot produced *The Pencil of Nature*, the first photographically illustrated book, published in six parts. The photographic (salt paper) prints used to illustrate the work were produced by the Reading Establishment, the world's first photographic developing and printing facility. Talbot set up the shop at Reading, Berkshire, halfway between Lacock and London, and installed his former assistant and valet Nicolaas Henneman as manager. Over a three-year period the Reading Establishment produced between thirty thousand and fifty thousand prints.

In the decades after his groundbreaking discovery, Talbot built on the efforts of early chemical workers, including Ponton and Bequerel, to discover the light-sensitive properties of dichromated gelatine that eventually formed the basis upon which his two principal photogravure patents, dated October 29, 1852, and April 21, 1858, were based.

At the same time, Talbot was actively studying the rediscovery of the great Assyrian civilization, after millennia of obscurity. Working in conjunction with Sir Henry Rawlinson, Sir Edward Hinks, Edwin Norris, Jules Oppert, and others, Talbot made important contributions to the corpus of academic work and research through publications, academic journals, and privately printed papers, including notes "On Assyrian Inscriptions." These investigations engaged Talbot for the rest of his life. Weaver, working from the *Transactions of the Royal Society of Literature*, lists fifteen papers and articles on Assyria published by Talbot between 1850 and 1866.[34]

Then, between 1866 and 1877, Talbot produced forty-eight papers and articles, published in *Transactions of the Society of Biblical Archeology* and in the Royal Asiatic Society's publications *Transactions and Records of the Past*. Although he was no longer working on the cutting edge of mathematics, Talbot continued to research and publish several mathematical papers after 1861. His last published botanical work, dated 1866, was titled "Note on Vellozia Elegans, from the Cape of Good Hope."[35]

On September 17, 1877, at the age of seventy-seven, Talbot quietly passed away in his sleep. He was still working on the last section of a three-part appendix for a translation of Gaston Tissandier's *History and Handbook of Photography*, edited by John Thomson. In an anonymous obituary published in *Nature* on October 18, 1877, the author observed that "Orientalists will call to mind that Talbot was one of the first who, with Sir Henry Rawlinson and Dr. [Edward] Hincks, deciphered the cuneiform inscriptions bought from Nineveh. He was the author of several books of much interest and learning, and in *The Pencil of Nature*, a fine quarto published in 1844, and probably the first work illustrated by photographs, he describes the origin and progress of the conception which culminated in his invention:—Photography."

32. Ibid.
33. "On Assyrian Transcriptions," No. 2 (Dated February 1856) *Journal of Sacred Literature and Biblical Record*, ser. 2, vol. 3, no. 5 (April 1856), 188-94.
34. Weaver, Mike, *Henry Fox Talbot: Selected Texts and Bibliography*, "Works written by or connected with Henry Fox Talbot," 137-154.
35. *Edinburgh Botanical Society Transactions*, XXIV, 1867, 573-90.

CHRONOLOGY

A SHORT CHRONOLOGY OF WILLIAM HENRY FOX TALBOT'S SCIENTIFIC AND PHOTOGRAPHIC WORK OF 1821–1846 AND RELATING TO HIS WORK ON THE NEGATIVE-POSITIVE PHOTOGRAPHIC PROCESS

1821	Journal Makes first reference to a camera lucida and a camera obscura.
1822	Travel inventory Mentions acquiring a panorama of Milan, a camera lucida, and a pocket compass.
1823	Itinerary Lady Elisabeth, in her agenda book of the trip through France, Switzerland, and Italy, refers to a camera lucida.
1824	Pocketbook/Memoranda Makes a note to include the following items in his luggage: "object glass [a lens] 4 inches. Barometer—Camera obscura, Micrometer for large telescope, Eye Machine—Camera Lucida, Opera Glass, Amici's Microscope, and Studies of Trees Udine."
March 1825	Scientific Notebook C Records first series of experiments in which Talbot attempts to quantitatively measure the effect that light appears to have on a number of chemical compounds. Mentions "photometer/Icelandic Fluorspar/Camera lucida."
December 1825	Pocketbook/Memoranda Mentions "Camera Obscura Dolland-18."
June 1826	Publishes "Some Experiments on Coloured Flames," *Edinburgh Journal of Science*, vol. 5, no. 1, June 1826, pp. 77-82.
December 1826	Publishes "On Monochromatic Light," *Quarterly Journal of Science, Literature and the Arts*, vol. 22, December 1826, p. 374.
1826	Memoranda/notebook. Mentions, in an undated entry, "Camera [obscura], Plant Press, French tracing paper, Claude Glass." Talbot also book marks and notes a number of passages that particularly interest him in Athanasius Kircher's *Ars Magna Lucis et Umbrae* (Amsterdam, 1669).
December 1826	Invoice Billed for "1 Camera Lucida d'Amici, de Modena" by Vincent Chevalier, scientific instrument maker, Paris. Talbot later cancelled the purchase.
January 1827	Scientific Notebook E Records that "in using the Camera Obscura with thick common paper it should be covered with a thin stratum of spirits of wine. This renders it transparent, & when the drawing is finished and the spirits suffered to evaporate, the paper becomes opaque as before."
1827	Diary Mentions "Stand for Camera Obscura; Evening at ye Society met Mr. Arago [in Geneva]; Camera obscura for Wednesday; Camera Obscura 18 Napoleons [extant French currency]."
July 1829	Diary Mentions "Magic Mirror; Sextant—Camera lucida & Obscura, [draft of one stanza of *Legendary Tales*]."
March 1831	Correspondence Makes reference to "Sympathetic ink." Secret writing was one of several processes by which an image or words—a form of latent image—could be made to appear as a result of a simple chemical reaction. Talbot would have been familiar with at least two or three such processes, which were activated by the action of light.
March 1831	Publishes "On a Method of Obtaining Homogeneous Light of Great Intensity," *Philosophical Magazine*, vol. 1, no. 3, April 1831, pp. 359-60.
April 1831	Sends two latent-image drawings to his half-sister Horatia. One of these survived until the 1950s but is now lost. The other was photographed by Harold White, and its existence is verified by a photographic copy.

October 1833	**Travel journal** Notes: "Mon 7th Walked towards Asso, took a view of the lake of Lecco. [with the camera lucida?]." Talbot made a number of drawings using the camera lucida, which he himself described as being "melancholy to behold." At least six of these survive. Also, "Camera Lucida ÷ reflexion [a purchase]."
December 1833	**Travel journal** Notes that on a day "very rainy—called on [François] Arago, saw the new buildings of the Observatory [Paris]."
February 1834	**London** Publishes "Facts Relating to Optical Science, No. 1," *Philosophical Magazine*, ser. 3, vol. 4, no. 11, February 1834, pp. 112-14.
April 1834	**London** Publishes "Facts Relating to Optical Science, No. 2," *Philosophical Magazine*, ser. 3, vol. 4, no. 22, April 1834, pp. 289-90; "Experiments on Light," *Proceedings of the Royal Society*, vol. 3 (1830-37), no. 17, May 1834, p. 298. (Read June 12, 1834.)
May-June 1834	**Lacock Abbey** Conducts scientific experiment(s) using nitrate of silver on paper, initially as a means of recording the form and outline of botanical specimens.
June-July 1834	**Lacock Abbey** Conducts photographic experiments using a camera obscura to attempt to create photographic images "by the agency of light alone" on paper sensitized with silver chloride. Talbot was unable to fully form images on his sensitized paper and could only obtain or "fix" the outline or shape of a building.
August 1834	**Copet, near Geneva** Uses his basic photogenic process to make representations or outlines of botanical specimens from his herbaria as a means of classifying and recording botanical specimens he had collected. Makes additional trials using for the first time the process we now call cliché verre. (See the later addendum he submitted to the Royal Society in January 1839 as an adjunct to his main scientific paper, " Some Account of the Art of Photogenic Drawing.")
December 1834	**Correspondence** In a letter to Talbot, his sister-in-law Laura Mundy writes: "Thank you very much for sending me such beautiful shadows. I had grieved over the gradual disappearance of those you gave me in the summer & am delighted to have these to supply their place in my book." This is the first reference in a written correspondence to his contact paper negatives. These must have been created and given to the recipient in late spring 1834, at which point Talbot was unable to arrest the further action of light. (He had reached the same point Wedgwood and Davy had in 1802.)
Jan-Feb 1835	**Notebook M** Makes the first reference to taking plant impressions with light-sensitive silver chloride paper: "Paper washed with salt and silver (of a certain strength) and darkened in the sunshine: the figure of a plant remaining white. If the paper be washed again with the same solution of salt, then dried in the sun, the figure remains very beautifully white and fixed: but from some obscure cause, some parts of it are apt to blacken." "Paper washed with Nitrate of Silver (probably of some peculiar degree of strength) was held in the sunshine some time but darkened so little that the figure of a plant was hardly seen upon it. Hung up afterwards in ordinary daylight for an hour or two, the ground darkened, and not the figure, so that the latter became plainly visible!!! Hence it appears that the solar rays by darkening the silver somewhat predispose it to darken more, of its own accord, or in common daylight. Thus the effect is produced long after the cause has ceased to operate."
Feb-March 1835	**Lacock Abbey and London** Describes in Scientific Notebook M for the first time the photographic negative-to-positive process: "In the Photogenic or Sciagraphic process, if the paper is transparent, the first drawing may serve as an object, to produce a second drawing, in which the lights and shadows would be reversed. If an object, as a flower, be strongly illuminated, & its image formed by a camera obscura, perhaps a drawing might be effected of it, in which case not its outline merely would be obtained, but other details of it."
August 1835	**Lacock Abbey** Makes the earliest known series of negative photographic images. He takes at least three separate negative images of the oriel window in the South Gallery of Lacock Abbey using a number of small camera obscurae. Each instrument is fitted with a short focal-length lens, such as the lens on the eyepiece of a microscope. By this time Talbot had discovered a method by which he was able to both increase the sensitivity of his light-sensitive solutions and to prevent or arrest the continuing action of light.
January 7, 1839	**Paris** François Arago announces the invention of the daguerreotype at the meeting of the Academy of Sciences.

| Jan 22, 1839 | London |
| | Michael Faraday announces Talbot's process for making photogenic drawing at a meeting of the Royal Institution. Talbot exhibits a selection of his works at the meeting; these include the negative of the oriel window image made in August 1835. |

| Jan 28, 1839 | London |
| | Submits "Some Account of the Art of Photogenic Drawing By H. Fox Talbot Esquire F.R.S." to the Royal Society. |

| March 4, 1839 | London |
| | Shows specimens of his photogenic drawing process together with a number of Nicéphore Niépce's heliographic plates at Lord Northampton's Soirée. He and Charles Wheatstone have loaned and collected possibly two examples of Niépce's work from Francis Bauer, former secretary of the Royal Society, who was given them during the Frenchman's abortive visit to London in 1827. (Lord Northampton was President of the Royal Society of London at this time.) |

| 1839–1840 | Lacock Abbey |
| | Carries out over eighteen months many photographic and related scientific experiments in an attempt to increase the sensitivity of his basic process, during which time he is able to make only minor improvements. He even attempts to make photographic images on copper plates, but his main work is still directed toward making images on paper using the light-sensitive salts of silver. However, he had reached the limit of that particular line of investigation. Late in the month of September 1840 he is on the threshold of his final major photographic discovery relating to the negative-to-positive process in which he is able to draw together the results of all his earlier investigations. |

| Sept 21, 1840 | Lacock Abbey |
| | Discovers that a sensitizing solution containing gallic acid, an organic reagent, has the potential to develop out a latent negative photographic image. |

Sept 23, 1840	Lacock Abbey
	Finds that he was able to bring out, by a process of chemical development, the latent negative photographic image. He has discovered all the basic steps of the negative-to-positive photographic process.
	He takes his first negative image of the roofline of Lacock Abbey in five minutes: "When excited gives a picture in 5' cloudy weather exhibiting even the tiles on the roof &c. &c."
	Speaking of his exciting liquid (liquid developer): "The same exciting liquid was diluted with an equal bulk of water, and some very remarkable effects were obtained. Half a minute suffices for the Camera. The paper when removed is often perfectly blank but when kept in the dark the picture begins to appear spontaneously, and keeps improving for several minutes, after which it should be washed and fixed with iodide of potassium."

| October 6, 1840 | Lacock Abbey |
| | Takes the first portrait [of his wife] using the calotype negative process: "Constance's portrait, without sun, 5' small 6 October." |

| October 8, 1840 | Lacock Abbey |
| | Takes a second portrait of his wife: "Constance's portrait, 5' without sun," taken in the evening. |

| February 1841 | London |
| | Receives the first photographic patent for the calotype process. |

| May-June 1843 | France |
| | Takes a large number of negatives while traveling through France to Paris. Most of his photographic images are made in Paris, but he also takes a number of calotypes while in Rouen, Chambourg, Orleans, and Anviers. He attends a meeting of the Academy of Sciences and gives demonstrations of his process to the French savants there and at the Academy of Fine Arts. |

| 1844–1846 | Reading, England |
| | Founds the Reading Establishment, the world's first commercial photographic company to produce photographic prints from calotype paper negatives. Nicolaas Henneman, Talbot's former valet, is given the task of running the facility. It is here that the photographic images used to illustrate Talbot's seminal work of photography, *The Pencil of Nature*, are printed. |

EXHIBITION LIST

The International Center of Photography, New York City—December 13, 2002 to February 16, 2003
The Museum of Photographic Arts, San Diego—March 30 to June 15, 2003

Unless otherwise noted, all images are by William Henry Fox Talbot and are courtesy The National Trust, Fox Talbot Museum, Lacock Abbey Collection, Lacock, Wiltshire, England.

1
Plate I, PART OF QUEEN'S COLLEGE, OXFORD, September 4, 1843
From *The Pencil of Nature*
Salt paper print from a calotype paper negative
18.4 x 22.4 cm

2
Plate II, VIEW OF THE BOULEVARDS OF PARIS, May 1843
From *The Pencil of Nature*
Salt paper print from a calotype paper negative
18.7 x 22.6 cm

3
Plate III, ARTICLES OF CHINA, before January 1844
From *The Pencil of Nature*
Salt paper print from a calotype paper negative
13.6 x 17.9 cm

4
Plate IV, ARTICLES OF GLASS, before June 1844
From *The Pencil of Nature*
Salt paper print from a calotype paper negative
18.9 x 23.2 cm

5
Plate V, BUST OF PATROCLUS, August 9, 1842
From *The Pencil of Nature*
Salt paper print from a calotype paper negative
22.4 x 18.5 cm

6
Plate VI, THE OPEN DOOR, before May 1844
From *The Pencil of Nature*
Salt paper print from a calotype paper negative
18.6 x 22.3 cm

7
Plate VII, LEAF OF A PLANT, negative, before February 14, 1844
From *The Pencil of Nature*
Salt paper print from a photogenic drawing paper negative
23.0 x 18.6 cm

8
Plate VIII, A SCENE IN A LIBRARY, before March 22, 1844
From *The Pencil of Nature*
Salt paper print from a calotype paper negative
19.0 x 23.4 cm

9
Plate IX, FACSIMILE OF AN OLD PRINTED PAGE, before August 1839
From *The Pencil of Nature*
Salt paper print from a calotype paper negative
22.2 x 17.8 cm

10
Plate X, THE HAYSTACK, ca. 1841
From *The Pencil of Nature*
Salt paper print from a calotype paper negative
16.2 x 21.0 cm

11
Plate XI, COPY OF A LITHOGRAPHIC PRINT, before May 1844
From *The Pencil of Nature*
Salt paper print from a calotype paper negative
18.8 x 23.2 cm

12
Plate XII, THE BRIDGE AT ORLEANS, June 14, 1843
From *The Pencil of Nature*
Salt paper print from a calotype paper negative
18.5 x 22.7 cm

13
Plate XIII, QUEEN'S COLLEGE, Oxford, Entrance Gateway, April 9, 1843
From *The Pencil of Nature*
Salt paper print from a calotype paper negative
19.5 x 24.7 cm

14
Plate XIV, THE LADDER, before April 1845
From *The Pencil of Nature*
Salt paper print from a calotype paper negative, marked verso: IHW (Intensified Harold White)
22.5 x 18.7 cm

15
Plate XV, LACOCK ABBEY IN WILTSHIRE, before September 1844, possibly May 1840
From *The Pencil of Nature*
Salt paper print from a calotype or photogenic drawing paper negative
19.3 x 24.1 cm

16
Plate XVI, CLOISTERS OF LACOCK ABBEY, 1842
From *The Pencil of Nature*
Salt paper print from a calotype paper negative
19.5 x 24.4 cm

17
Plate XVII, BUST OF PATROCLUS, August 9, 1843
From *The Pencil of Nature*
Salt paper print from a calotype paper negative
18.5 x 15.0 cm

18
Plate XVIII, GATE OF CHRISTCHURCH, before September 1844
From *The Pencil of Nature*
Salt paper print from a calotype paper negative
18.4 x 22.4 cm

19
Plate XIX, THE TOWER OF LACOCK ABBEY, before February 1845
From *The Pencil of Nature*
Salt paper print from a calotype paper negative
18.7 x 22.5 cm

20
Plate XX, LACE, before February 1845
From *The Pencil of Nature*
Photogenic drawing negative, contact print made from an original piece of lace
15.9 x 21.3 cm

21
Plate XXI, THE MARTYRS' MONUMENT, September 7, 1843
From *The Pencil of Nature*
Salt paper print from a calotype paper negative
22.4 x 18.8 cm

22
Nicolaas Henneman (1813-98)
Plate XXII, WESTMINSTER ABBEY, before May 1844
From *The Pencil of Nature*
Salt paper print from a calotype paper negative
18.7 x 22.8 cm

23
Plate XXIII, Hagar in the Desert, before March 1844
From The Pencil of Nature
Salt paper print from a photogenic drawing negative
16.4 x 20.7 cm

24
Plate XXIV, A Fruit Piece, June 1845
From The Pencil of Nature
Salt paper print from a calotype paper negative
18.5 x 22.5 cm

25
Lock Katrine, Ferry Landing Stage, Scotland, September 1845
From Sun Pictures in Scotland
Salt paper print from a calotype paper negative
18.8 x 22.6 cm

26
Lock Katrine, in the Highlands. 'The Scene of the Lady of the Lake,'" Scotland,
September 1845
From Sun Pictures in Scotland
Salt paper print from a calotype paper negative
9.5 x 11.2 cm

27
Lock Katrine with Foreground Woodland, Scotland, September 1845
From Sun Pictures in Scotland
Salt paper print from a calotype paper negative
18.5 x 21.6 cm

28
"The Tomb of Sir Walter Scott in Dryburgh Abbey,
Taken Late in an Autumnal Evening," Scotland, 1844
From Sun Pictures in Scotland
Salt paper print from a calotype paper negative
18.7 x 22.5 cm

29
Highland Stream, Scotland, 1846
From Sun Pictures in Scotland
Salt paper print from a calotype paper negative
9.2 x 11.5 cm

30
William Henry Fox Talbot and/or Nicolaas Henneman (1813-98) in conjunction
with Napoléon Joseph Hugues Maret, 2nd Marquis de Bassano (1803-98)
Place du Carrousel, a Derelict and Abandoned Group of Buildings Behind
the Louvre, Paris, France, between May 22 and June 10, 1843
Untrimmed salt paper print from a calotype paper negative
19.0 x 22.8 cm

31
Corner of the rue de la Paix and rue de Danielle-Casanova, Paris, France,
1843
Salt paper print from a calotype paper negative
18.5 x 22.5 cm

32
Notre Dame, Paris, France, 1846
Salt paper print from a calotype paper negative
20.0 x 24.9 cm

33
William Henry Fox Talbot and Napoléon Joseph Hugues Maret, 2nd Marquis de
Bassano (1803-98)
Elevated View of the Courtyard of the Louvre, Paris, France, 1843
Salt paper print from a calotype paper negative
18.5 x 22.8 cm

34
Rue des Capucines, Paris, France, 1846
Salt paper print from a calotype paper negative
18.5 x 22.5 cm

35
Rue des Capucines, Elevated Three-quarter View, Paris, France, 1846
Salt paper print from a calotype paper negative
17.8 x 22.2 cm

36
Boulevard des Italiennes, Elevated Three-quarter View, Paris, France, 1846
Salt paper print from a calotype paper negative
19.3 x 23.7 cm

37
Paris Boulevard (Elevated View 1), France, 1843
Salt paper print from a calotype paper negative
18.8 x 22.4 cm

38
Panthéon, Paris, France, 1843
Salt paper print from a calotype paper negative
19.9 x 24.7 cm

39
Panthéon 1, Paris, France, 1843
Calotype paper negative
16.5 x 18.8 cm

40
Panthéon 2, Paris, France, 1843
Calotype paper negative
14.8 x 18.0 cm

41
Place du Carrousel, Paris, France, 1843
Calotype paper negative
14.2 x 1.8 cm

42
Unknown, possibly Thomas Augustus Malone (1823–?)
Seine, Paris, France, after 1846
Waxed, developed-out, salt paper print
18.0 x 22.0 cm

43
Market Place, Orléans, France, June 1843
Salt paper print from a calotype paper negative
18.4 x 22.5 cm

44
Orléans, Elevated View Showing Twin Towers of Cathedral, France, 1843
Salt paper print from a calotype paper negative
18.8 x 22.7 cm

45
Orléans, Elevated View Showing One Twin Tower of Cathedral, France, 1843
Salt paper print from a calotype paper negative
18.6 x 22.7 cm

46
Boats and Barrels, Rouen Harbour, France, 1843
Salt paper print from a calotype paper negative
18.5 x 22.5 cm

47
Boats and Barrels, Rouen Harbour, France, 1843
Salt paper print from a calotype paper negative
18.0 x 20.7 cm

48
Boats and Barrels, Rouen Harbour, France, 1843
Salt paper print from a calotype paper negative
18.6 x 22.7 cm

49
Boats and Barrels, Rouen Harbour, France, 1843
Salt paper print from a calotype paper negative
19.3 x 21.7 cm

50
CHATEAU DE CHAMBORD, France, 1843
Salt paper print from a calotype paper negative
18.8 x 23.1 cm

51
Botanical Specimen, TWO LEAF STEMS, Lacock, England, 1839-40
Photogenic drawing negative, contact printed
18.4 x 22.3 cm

52
Botanical Specimen, SINGLE FERN LEAF STEM, Lacock, England, 1839-40
Photogenic drawing (or) calotype paper negative
22.1 x 17.1 cm

53
Botanical Specimen, FOUR LEAF SPECIMENS, Lacock, England, 1839-40
Photogenic drawing (or) calotype paper negative
21.1 x 16.9 cm

54
Fabric Sample, SPECIMEN OF GAUZE, Lacock, England, 1839-40
Salt paper print from a calotype paper negative
21.1 x 16.9 cm

55
GRECIAN REPRODUCTION URN WITH ARRANGEMENT OF SUMMER FLOWERS, 1844-45
Salt paper print from a calotype paper negative
16.3 x 18.8 cm

56
LACE PHOTOGENIC DRAWING NEGATIVE, 1839-40
Contact paper negative
19.0 x 23.2 cm

57
Plate I, PART OF QUEEN'S COLLEGE, Oxford, September 4, 1843
From *The Pencil of Nature*
Salt paper print from a calotype paper negative
18.8 x 22.5 cm

58
STONE BRIDGE NEAR HARDON CASTLE, outside Hawick, Scotland, mid October
1844
Salt paper print from a calotype paper negative
18.5 x 22.6 cm

59
TRINITY COLLEGE SPIRES, Cambridge, England, ca. 1843
Salt paper print from a calotype paper negative
19.4 x 24.7 cm

60
THE BRIDGE OF SIGHS, St. John's College, Cambridge, England, ca. 1843
Salt paper print from a calotype paper negative
18.5 x 22.8 cm

61
MAN LEANING ON A BUTTRESS ADJACENT TO AN ORIEL WINDOW, Cambridge,
England, ca. 1844
Salt paper print from a calotype paper negative
15.6 x 19.5 cm

62
BODLEIAN LIBRARY WITH THE RADCLIFFE CAMERA DOME BEHIND, Oxford, England,
September 1843
Salt paper print from a calotype paper negative
19.5 x 22.4 cm

63
KING'S COLLEGE CHAPEL, GOTHIC DOORWAY, Cambridge, England, ca. 1843
Salt paper print from a calotype paper negative
18.9 x 17.1 cm

64
"THE SOLILOQUY OF THE BROOM," Lacock, England, ca. 1843
Salt paper print from a calotype paper negative
18.6 x 22.4 cm

65
"CHINA ON TWO SHELVES," Lacock, England, early 1840s
Salt paper print from a calotype paper negative
19.0 x 23.0 cm

66
A LINE OF TREES REFLECTED IN A POND, Lacock, England, early 1840s
Salt paper print from a calotype paper negative
19.6 x 22.8 cm

67
FLOWERING BUDS (HYDRANGEA), Lacock, England, early 1840s
Salt paper print from a calotype paper negative
18.4 x 22.5 cm

68
WALL, IVY, RAKE, BASKET, Lacock, England, ca. 1842
Salt paper print from a calotype paper negative
18.6 x 22.5 cm

69
WALL, IVY, RAKE, BASKET, Lacock, England, early 1840s
Calotype paper negative
15.9 x 20.2 cm

70
"BEECH TREES IN SUNLIGHT," Lacock, England, early 1840s
Salt paper print from a calotype paper negative
19.7 x 24.8 cm

71
MULTI–BOLED TREE, CARCLEW PARK, Cornwall, England, early 1840s
Varnished salt paper print from a calotype paper negative
18.5 x 22.5 cm

72
SINGLE TREE (ELM) IN MEADOW, Lacock, England, early 1840s
Salt paper print from a calotype paper negative
22.7 x 18.7 cm

73
WOODEN BRIDGE AND LEAFLESS TREES, Lacock Abbey Estate, Lacock, England, early
1840s
Salt paper print from a calotype paper negative
18.7 x 22.6 cm

74
"MR. JONES IN THE CLOISTER," Lacock Abbey, Lacock, England, early 1840s
Salt paper print from a calotype paper negative
18.6 x 22.9 cm

75
"THE FRUIT SELLERS," Lacock, England, early 1840s
Salt paper print from a calotype paper negative
18.5 x 22.5 cm

76
William Henry Fox Talbot and Nicolaas Henneman (1813-98)
"THE READING ESTABLISHMENT," Panorama (Part 1), Printing Works, Reading,
England, 1846
Sulphide-toned gelatin silver print from the original calotype paper negative
Printed by Herbert Lambert of Bath, 1921 or 1934
18.0 x 20.5 cm

77
William Henry Fox Talbot and Nicolaas Henneman (1813-98)
"THE READING ESTABLISHMENT," Panorama (Part 2), Printing Works, Reading,
England, 1846
Sulphide-toned gelatin silver print from the original calotype paper negative
Printed by Herbert Lambert of Bath, 1921 or 1934
18.0 x 20.5 cm

78
"The Woodcutters," Lacock, England, early 1840s
Salt paper print from a calotype paper negative
18.8 x 22.6 cm

79
William Henry Fox Talbot and possibly Antoine Claudet (1797–1867)
Nicolaas Henneman Asleep, Lacock or Reading, England, early 1840s
Calotype paper negative
15.3 x 14.7 cm

80
Sir David Brewster with Talbot's Microscope, July 1842
Salt paper print from a calotype paper negative
Collection of Michael Mattis and Judith Hochberg
18.6 x 22.6 cm

81
Sir David Brewster with Talbot's Microscope, July 1842
Calotype paper negative
Collection of Michael Mattis and Judith Hochberg
13.2 x 14.4 cm

82
John Frederick Goddard Addresses Charles Porter and Nicolaas Henneman,
April 8, 1842
Digital facsimile of an original salt-fixed, salt paper print
Collection of Michael Mattis and Judith Hochberg
18.8 x 22.6 cm

83
John Frederick Goddard Addresses Charles Porter and Nicolaas Henneman,
April 8, 1842
Digital facsimile of an original iodine-fixed, salt paper print
Collection of Michael Mattis and Judith Hochberg
18.7 x 22.7 cm

84
John Frederick Goddard Addresses Charles Porter and Nicolaas Henneman,
April 8, 1842
Hypo-fixed, salt paper print from a calotype paper negative
Collection of Michael Mattis and Judith Hochberg
18.8 x 22.7 cm

85
Nicolaas Henneman (1813-98)
Edward Anthony, London, England, after 1847
Salt paper print from a calotype paper negative
9.0 x 7.4 cm

86
Unknown Male, Lacock, England, mid 1840s
Salt paper print from a calotype paper negative
9.8 x 8.6 cm

87
Rosamond Constance Talbot, Lacock, England, early 1840s
Salt paper print from a calotype paper negative
11.6 x 9.4 cm

88
Henrietta Horatia Maria Feilding, Lacock, England, mid 1840s
Salt paper print from a calotype paper negative
11.5 x 9.5 cm

89
Rosamond Constance Talbot, Lacock, England, early 1840s
Salt paper print from a calotype paper negative
10.2 x 11.5 cm

90
Portrait of Nicolaas Henneman, ca. 1842
Salt paper print from a calotype paper negative
10.0 x 7.1 cm

91
Mount Edgcumbe, Plymouth, England, September 1845
Salt paper print from a calotype paper negative
18.6 x 22.5 cm

92
Mount Edgcumbe, Plymouth, England, September 1845
Salt paper print from a calotype paper negative
18.5 x 22.8 cm

93
Nelson's Column under Construction, Trafalgar Square, London, England,
ca. 1845
Salt paper print from a calotype paper negative
18.6 x 22.6 cm

94
West Front, Lacock Abbey, Lacock, England, ca. 1841
Salt paper print from a calotype paper negative
18.6 x 22.5 cm

95
South Front, Lacock Abbey, Lacock, England, ca. 1840
Salt paper print from a calotype paper negative
11.3 x 20.8 cm

96
Antoine Claudet and Unidentified Sitter, Regent Street, London, England, mid
1840s
Salt paper print from a calotype paper negative
24.9 x 19.7 cm

97
John Moffat (1818-94)
William Henry Fox Talbot, Edinburgh, Scotland, 1866
Trimmed and mounted gold-toned albumen print (Carte-de-Visite)
9.0 x 5.7 cm

98
E. W. Dallas (active 1860-78)
Constance Talbot, Edinburgh, Scotland, 1866
Trimmed and mounted gold-toned albumen print (Carte-de-Visite)
9.0 x 5.7 cm

99
Silverware on Three Shelves, Cloister Court, Lacock Abbey, Lacock, England,
June 1844
Salt paper print from a calotype paper negative
19.0 x 23.0 cm

100
Decorative Silver Vase, Cloister Court, Lacock Abbey, Lacock, England, June 1844
Salt paper print from a calotype paper negative
20.0 x 12.8 cm

101
"The Milliner's Window," Lacock Abbey, Cloister Court, Lacock, England,
possibly June 1844
Salt paper print from a calotype paper negative
18.6 x 22.3 cm

102
Statuary, Seventeen Items, Lacock Abbey, Cloister Court, Lacock, England,
possibly May 1843
Salt paper print from a calotype paper negative
14.7 x 14.3 cm

103
Bust of Patroclus, Lacock Abbey, Cloister Court, Lacock, England, early 1840s
Salt paper print from a calotype paper negative
18.3 x 11.0 cm

104
Bust of Patroclus, Lacock Abbey, Cloister Court, Lacock, England, early 1840s
Calotype paper negative
17.8 x 17.7 cm

105
MAQUETTE OF THE LAOCOÖN, Lacock Abbey, Cloister Court, Lacock, England, early 1840s
Salt paper print from a calotype paper negative
18.6 x 17.8 cm

106
MAQUETTE OF THE LAOCOÖN, Lacock Abbey, Cloister Court, Lacock, England, early 1840s
Calotype paper negative
15.2 x 18.8 cm

107
William Henry Fox Talbot and/or Nicolaas Henneman (1813-98)
"THE THREE GRACES," Reading, England, mid 1840s
Salt paper print from a calotype paper negative
18.6 x 14.7 cm

108
William Henry Fox Talbot and/or Nicolaas Henneman (1813-98)
"THE THREE GRACES," Reading, England, mid 1840s
Calotype paper negative
21.7 x 17.0 cm

109
"RAPE OF THE SABINES," Lacock, England, early 1840s
Salt paper print from a camera paper negative
22.8 x 18.7 cm

110
"RAPE OF THE SABINES," Lacock, England, early 1840s
Calotype paper negative
17.5 x 14.8 cm

111
COACH (BROUGHAM) IN STABLEYARD, Lacock, England, possibly October 1840
Salt paper print from a calotype paper negative
18.9 x 23.0 cm

112
William Henry Fox Talbot and Nicolaas Henneman (1813-98)
LIEUTENANT BROOKES on the deck of HMS SUPERB, Plymouth, England, 1845
Calotype paper negative
8.4 x 4.7 cm

113
William Henry Fox Talbot and Nicolaas Henneman (1813 98)
UPPER GUN DECK, HMS SUPERB, Plymouth, England, 1845
Calotype paper negative
8.4 x 9.9 cm

114
William Henry Fox Talbot and Nicolaas Henneman (1813-98)
HMS SUPERB, CAPTAIN CORREY, Plymouth, England, 1845
Calotype paper negative
8.4 x 10.4 cm

115
William Henry Fox Talbot and Nicolaas Henneman (1813-98)
HMS SUPERB, LIEUTENANT BROOKES AND UNIDENTIFIED OTHER, Plymouth, England, 1845
Calotype paper negative
9.9 x 11.0 cm

116
CLOCK TOWER IN MEDIEVAL QUADRANGLE, Lacock, England, early 1840s
"Waterloo" camera paper negative
14.2 x 18.7 cm

117
Richard Beard (1803-85)
PORTRAIT OF WILLIAM HENRY FOX TALBOT, ca. 1842
Cased daguerreotype using Wolcott's reflecting camera
7.8 x 6.5 cm

118
Antoine Claudet (1797–1867)
PORTRAIT OF WILLIAM HENRY FOX TALBOT, ca. 1845
Cased daguerreotype
7.8 x 6.5 cm

119
Charles Chevalier (1804-59)
PONT NEUF, Paris, France, May 15, 1843
Daguerreotype
16.8 x 21.8 cm

120
Richard Beard (1803-85)
ROSAMOND, ELA, AND MATILDA TALBOT, ca. 1845
Daguerreotype housed in a paper passe-partout
7.8 x 6.5 cm

121
READING ESTABLISHMENT PRINTING FRAME, 1844
Softwood, metal, and glass
24.5 x 20.1 x 8.5 cm

122
Andrew Ross (1798–?)
PORTRAIT CAMERA, ca. 1843
3-element, F1.2, 140mm (5.5-inch lens without stops), mahogany, glass, and brass
20.0 x 17.5 x 24.2 cm

123
DIRECT VISION SPECTROSCOPE
Brass and optical glass
30.0 x 3.4 x 13.4 cm

124
SOLAR MICROSCOPE, London, 1828-40
Brass, optical glass, and mahogany
28.0 x 11.0 x 11.0 cm

125
SIX INTERFERENCE PATTERN GRATINGS, ca. 1831-38
Steel sheet, tin, and lead
3.0 x 3.0 cm

126
SMALL CLASSICAL STATUETTE, early 1840s
Parianware figure standing on small plinth
William Henry Fox Talbot acquisition, ca. 1839
Private collection
30 x 150 x 150 cm

127
HEROIC GREEK HEAD, "PATROCLUS," copy purchased by Talbot in 1839
Plaster copy (replica) of heroic Greek marble head from the original now in the British Museum, Sir Charles Townley Collection
Modern plaster cast of marble original
Private collection
50.0 x 40.0 x 30.0 cm

128
CAMERA LUCIDA, ca. 1833
Optical drawing instrument with case
Courtesy of the Robert E. Lassam Collection
25.0 x 6.0 x 2.0 cm

129
John Chester Earle (1809–?)
PAIR OF MINIATURE PAINTINGS OF A YOUNG GIRL, ca. 1820s
Enamel on ivory, framed in folding case left and right
Fox Talbot Museum, Elisabeth Mallet Bequest, Lacock, Wiltshire, England

130
FRAMED SHADOWGRAPH, 1813
Paper, wood, and glass
Fox Talbot Museum, Elisabeth Mallet Bequest, Lacock, Wiltshire, England

131
John Chester Earle (1809–?)
CASED MINIATURE PAINTING OF A MAN, IN ENAMEL, 1820s
Enamel on ivory sheet
Fox Talbot Museum, Elisabeth Mallet Bequest, Lacock, Wiltshire, England

132
SOME ACCOUNT OF THE ART OF PHOTOGENIC DRAWING, 1839
Printed leaflet

133
THE PROCESS OF CALOTYPE PHOTOGENIC DRAWING, 1841
Printed leaflet

134
LAURA MUNDY TO WILLIAM HENRY FOX TALBOT, December 12, 1834
Correspondence, four-page letter, two leaves

135
HORATIA MARIA FEILDING TO WILLIAM HENRY FOX TALBOT, March 20, 1832
Correspondence, two-page letter, one leaf

136
WILLIAM HENRY FOX TALBOT TO M DE BASSANO, 1843
Correspondence, two-page letter, one leaf

137
MATHEMATICS AND CHEMICAL RESEARCH NOTES, Notebook M, 1835
Scientific notebook, hardback, marbled covers, 140 pp

138
"S.S.," Philological Work, Terminology, etc., 1836 onward
Manuscript notebook, embossed and patterned buckram cover cloth, unpaginated, entries in ink

139
"MEMORANDA," 1840
Manuscript notebook, paginated, entries in ink

140
LIST OF SUBJECTS TAKEN BETWEEN…, 1840
Manuscript original

141
"THE BEAUTY OF THE FIRST IDEA," *The Pencil of Nature* (draft), 1843
Manuscript original

142
DIARY MEMORANDA COVERING VISIT TO FRANCE, 1843
Pocket Diary

143
"LEGENDARY TALES," 1831
Printed book (Talbot's first publication)

144
HERMES, (PARTS 1 AND 2), 1838 and 1839
Softbound, tinted coverpaper, letterpress printed text pages

145
THE ORIGIN OF THE BOOK OF GENESIS, 1829
Softbound, tinted coverpaper, letterpress printed text pages

146
WFT (W. Fallon Thornthwaite?) (active 1841–1870)
PHOTOGRAPHIC MANIPULATION, 1842
Hardback, marble covered boards, letterpress printed text pages

147
"DIOGENES," SMALL, Lacock, England, October 6, 1840
Modern salt paper print from the original calotype paper negative
11.9 x 11.0 cm

148
"'DIOGENES,' WITHOUT SUN, 17," Lacock, England, early 1840s
Modern salt paper print from the original calotype paper negative
11.9 x 11.0 cm

149
"ROUEN, 16 MAY 1843," France, May 16, 1843
Modern salt paper print from the original calotype paper negative
19.0 x 22.4 cm

150
CAIUS AND GONVILLE COLLEGE, Cambridge, England, ca. 1843–1844
Modern salt paper print from the original calotype paper negative
22.1 x 19.0 cm

151
PORTRAIT OF HORATIA MARIA FEILDING AND THOMAS GAISFORD, after 1843
Modern salt paper print from the original calotype paper negative
10.5 x 35.0 cm

152
PORTRAIT OF NEVILLE STORY-MASKELYNE, REGENT STREET, London, England, 1844-46
Modern salt paper print from the original calotype paper negative
22.1 x 16.6 cm

153
JARDINIER, LADY ELISABETH'S ROSE GARDEN, Lacock, England, early 1840s
Modern salt paper print from the original camera paper negative
19.4 x 23.7 cm

154
THE SUSPENSION BRIDGE AT ROUEN, France, May 16, 1843
Modern salt paper print from the original calotype paper negative
Original in private collection
22.8 x 18.4 cm

155
NORTH-WEST QUADRANT OF THE CLOISTER COURT, LACOCK ABBEY, Lacock, England, May 1840
Modern salt paper print from the original camera paper negative
22.8 x 18.4 cm

156
William Henry Fox Talbot and possibly Antoine Claudet (1797–1867)
PORTRAIT OF NICOLAAS HENNEMAN, ASLEEP, Regent Street, London, England, 1844/45
Modern salt paper print from the original calotype paper negative
15.3 x 14.7 cm

157
"NEW PAPER," Lacock, England, September 22, 1840
Digital facsimile
7.5 x 9.2 cm

158
"5 CLOUDY, SEPT. 1840," Lacock Abbey Medieval Courtyard, Lacock, England, September (23rd?) 1840
Digital facsimile of an original salt-stabilized paper print
11.5 x 8.6 cm

159
"5 CLOUDY, SEPT. 1840," Lacock Abbey Medieval Courtyard, Lacock, England, September (23rd?) 1840
Digitally generated negative image, location of original unknown
11.5 x 8.6 cm

160
UNTITLED, Botanical Specimen, Sprig of Fennel, 1839-40
Digital facsimile of an original salt-stabilized photogenic drawing negative
22.7 x 18.6 cm

161
HEAD OF A SAINT, Fragment from a Medieval Stained Glass Window, 16th Century, 1839-40
Digital facsimile of a photogenic drawing positive

162
HEAD OF A SAINT, Fragment from a Medieval Stained Glass Window, 16th Century, 1839-40
Digital facsimile of a contact paper negative
14.5 x 13.0 cm

163
PHOTOGENIC DRAWING, Sprig of Honeysuckle, 1839
Digital facsimile made from unfixed, salt-stabilized original
23.0 x 18.2 cm

164
PHOTOGENIC DRAWING, Sprig of Blossom, 1839-40
Digital facsimile made from unfixed, stabilized original
22.2 x 17.0 cm

165
PHOTOGENIC DRAWING, Sprig of Mimosa, 1839-40
Digital facsimile made from unfixed, stabilized original
22.3 x 18.3 cm

166
PHOTOGENIC DRAWING, Sprig of Mimosa, 1839-40
Digital facsimile made from unfixed, stabilized original
22.9 x 18.5 cm

167
"BREAKFAST TABLE," April 26, 1840
Digital facsimile made from unfixed, stabilized original
16.0 x 22.4 cm

168
"COVERED TABLE WITH VASES, CANDLESTICK, AND CONCH," March 1, 1840
Digital facsimile made from unfixed, salt-stabilized original
16.8 x 19.5 cm

169
UNTITLED, Domestic Interior Study, 1840
Digital facsimile made from unfixed, salt-stabilized original

170
UNTITLED, Domestic Still Life, 1840
Digital negative facsimile made from a salt-stabilized original
18.7 x 23.1 cm

171
"BREAKFAST TABLE," October 3, 1840
Digital facsimile made from unfixed, stabilized original
19.2 x 22.8 cm

172
UNTITLED, Table Laid for Breakfast, March 2, 1840
Digital facsimile made from unfixed, stabilized original
19.0 x 22.8 cm

173
"WINDOWSEAT," May 29 or 30, 1840
Digital facsimile made from unfixed, stabilized original
Ikonscentre 00617 (facsimile of)
LA 2268
18.2 x 22.4 cm

174
"WINDOWSEAT," May 29 or 30, 1840
Digital facsimile made from unfixed, salt stabilized original
Ikonscentre 00618 (facsimile of)
LA 2269
18.2 x 19.2 cm

175
UNTITLED, Interior of South Gallery, March 2, 1840
Digital facsimile made from unfixed, stabilized original
18.9 x 22.5 cm

176
"VIEW FROM THE SMALL END IN THE SOUTH GALLERY, LARGE," Interior of South
Gallery, possibly October 3, 1840
Digital facsimile made from unfixed, stabilized original
18.9 x 22.6 cm

177
'CHIMNEYPIECE, S.(OUTH) GALLERY," possibly October 8, 1840
Digital facsimile made from unfixed, stabilized original

178
UNTITLED, an Arrangement of Pine Needles, 1839-40
Digital facsimile made from unfixed, potassium iodine-stabilized original
18.4 x 22.9 cm

179
UNTITLED, Botanical Specimen, 1839-40
Digital facsimile made from unfixed, salt-stabilized original
22.8 x 18.7 cm

180
UNTITLED, Botanical Specimen, 1839-40
Digital facsimile made from unfixed, salt-stabilized original
22.8 x 18.7 cm

181
UNTITLED, Botanical Specimen, 1839-40
Digital facsimile made from unfixed, salt-stabilized original
22.9 x 18.4 cm

182
UNTITLED, Botanical Specimen, 1839-40
Digital facsimile made from unfixed, salt-stabilized original
18.7 x 22.8 cm

FIRST PHOTOGRAPHS
William Henry Fox Talbot and the Birth of Photography

Published in the United States by powerHouse Books,
a division of powerHouse Cultural Entertainment, Inc.
180 Varick Street, Suite 1302, New York, NY 10014-4606
telephone 212 604 9074, fax 212 366 5247
e-mail: info@powerHouseBooks.com
web site: www.powerHouseBooks.com

First edition, 2002

Library of Congress Cataloging-in-Publication Data:

Talbot, William Henry Fox, 1800–1877.
 First Photographs : William Henry Fox Talbot and the birth of photography / texts by
Michael Gray, Arthur Ollman, and Carol McCusker.
 p. cm.
 ISBN 1-57687-153-3
 1. Photography, Artistic. 2. Photography--Great Britain--History--19th century. 3.
Talbot, William Henry Fox, 1800-1877. I. Gray, Michael. II. Ollman, Arthur. III.
McCusker, Carol. IV. Title.

TR651 .T3397 2002
770'.92--dc21
[B] 2002068437

Exhibitions for *First Photographs* to be held at:
The International Center of Photography, New York City —December 13, 2002 to February 16, 2003
The Museum of Photographic Arts, San Diego—March 30 to June 15, 2003

Hardcover ISBN 1-57687-153-3

Book Design by Heidi Beatrice Thorsen

Separations, printing, and binding by Steidl, Göttingen

A complete catalog of powerHouse Books and Limited Editions is available upon request;
please call, write, or visit our web site.

10 9 8 7 6 5 4 3 2 1

Printed and bound in Germany

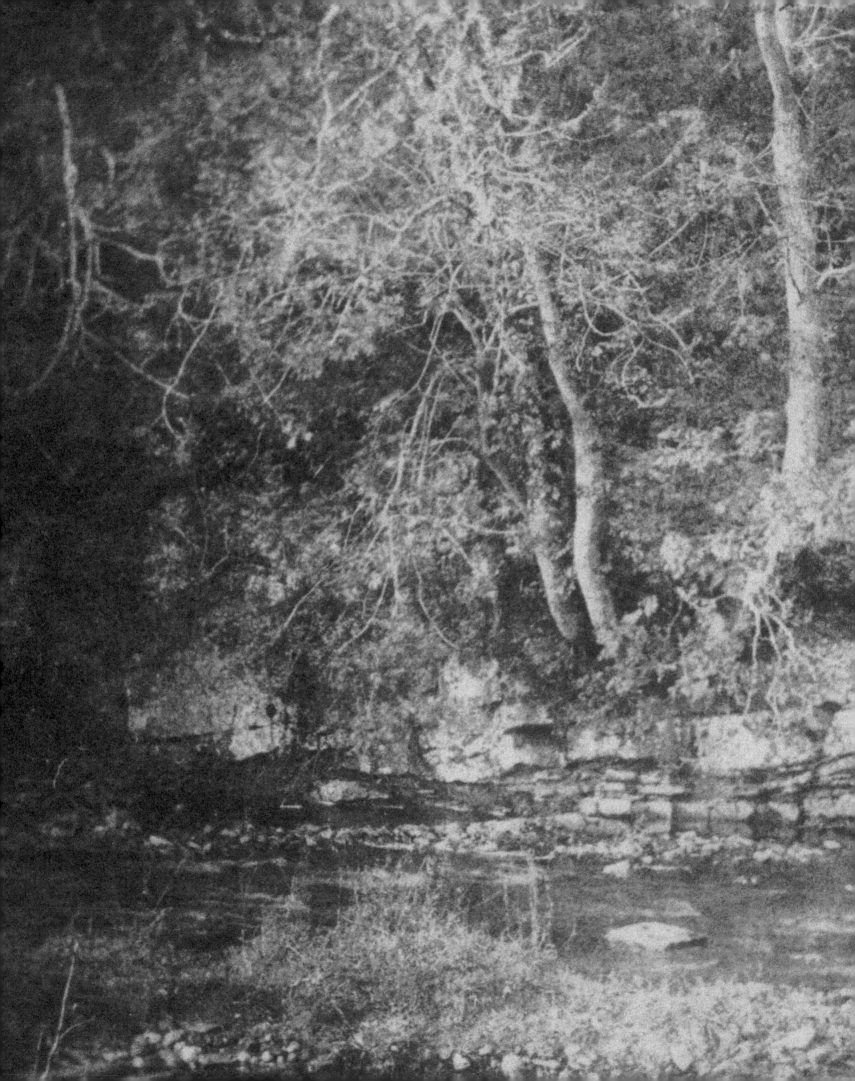